ELECTRONIC LITERATURE

UNIVERSITY OF NOTRE DAME WARD-PHILLIPS
LECTURES IN ENGLISH LANGUAGE AND LITERATURE

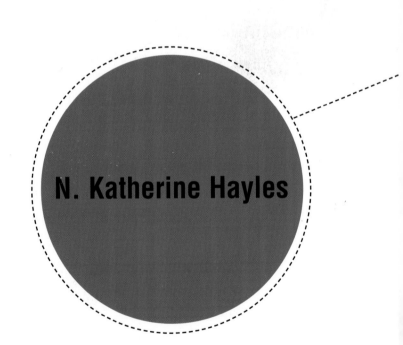

N. Katherine Hayles

Electronic Literature

New Horizons for the Literary

University of
Notre Dame Press

Notre Dame,
Indiana

For additional resources
in teaching
electronic literature, visit:

http://newhorizons.eliterature.org

Library of Congress Cataloging in-Publication Data

Hayles, N. Katherine.
Electronic literature : new horizons for the literary / By N. Katherine
Hayles.
p. cm. — (University of Notre Dame Ward-Phillips lectures
in english language and literature)
Includes bibliographical references and index.
ISBN-13: 978-0-268-03084-1 (cloth : alk. paper)
ISBN-10: 0-268-03084-7 (cloth : alk. paper)
ISBN-13: 978-0-268-03085-8 (pbk. : alk. paper)
ISBN-10: 0-268-03085-5 (pbk. : alk. paper)
1. Literature, Modern—20th century—History and criticism.
2. Literature, Modern—21st century—History and criticism.
3. Literature and the Internet. I. Title.
PN771.H37 2007
776'.7—dc22

 2007050405

∞ *The paper in this book meets the guidelines for permanence
and durability of the Committee on Production Guidelines for Book
Longevity of the Council on Library Resources.*

CONTENTS

(insert)
CD-ROM: *The Electronic Literature Collection*, Volume 1
Edited by N. Katherine Hayles, Nick Montfort,
Scott Rettberg, and Stephanie Strickland

FIGURES

READ ME

This book, with its related website and accompanying CD featuring volume 1 of the *Electronic Literature Collection*, is intended to help electronic literature move into the classroom. For someone teaching a course on contemporary literature, for example, it can be used along with a unit on electronic literature as an increasingly important part of the twenty-first-century canon. The book may also serve courses devoted to the digital arts or those focusing specifically on electronic literature. While the *Electronic Literature Collection* is also available at the Electronic Literature Organization's website (http://collection.eliterature.org), its inclusion here is meant to facilitate access for students who do not find it convenient to have internet connections while on campus or at other times. There is also a long tradition in the literary community of cherishing the book as a physical object, and the CD, with its silk-screened original design, helps usher that tradition into the digital realm.

While accommodating readers new to electronic literature, the book is also structured to appeal to those familiar with the digital arts and electronic literature. The initial chapter, to my knowledge the first attempt to survey systematically the entire field of electronic literature, identifies the major genres and central theoretical issues. The novice will find it a useful introduction to the diversity and scope of electronic literature, while the experienced practitioner may discover some works, writers, or issues she has not otherwise encountered.

The second chapter proposes a theoretical framework in which electronic literature can be understood as a practice that mediates between human and machine cognition; the term I suggest for this orientation is "intermediation," also discussed in my recent book *My Mother Was a Computer: Digital Subjects and Literary Texts.*[1] Its implications are explored through discussions of Michael Joyce's *afternoon: a story,* an early work heavily influenced by print paradigms compared to Joyce's later Web work *Twelve Blue,* along with work by digital artist Maria Mencia and *The Jew's Daughter* by Judd Morrissey. The third chapter broadens the discussion to consider the contexts in which electronic literature is created, played, interpreted, and taught. Focusing on whether the machine or the body should provide the primary theoretical ground for understanding electronic literature—approaches represented respectively by German media theorist Friedrich A. Kittler and American theorist of embodiment Mark B. N. Hansen—chapter 3 argues that both perspectives are incomplete in themselves. They require a third approach focusing on the intermediation that inextricably entwines body and machine, without giving either absolute theoretical priority. The approach is exemplified through discussions of Talan Memmott's *Lexia to Perplexia* and Young-Hae Chang Heavy Industries' *Nippon.* The fourth chapter further elucidates this approach by considering the ways in which the embodied practices of electronic literature revalue computational practice, illustrated with discussions of William Poundstone's *Project for Tachistoscope,* Millie Niss's *Sundays in the Park,* and John Cayley's *Translation* and related works. The final chapter, ambitiously titled "The Future of Literature: Print Novels and the Mark of the Digital," argues that almost all contemporary literature is already digital in the sense that it has existed mostly as digital files. Digitality leaves its mark on many contemporary experi-

mental print novels through visual and graphic strategies that require digital processing, as well as through narrative plots that explore the implications for literature and language of having computer code underlie virtually all contemporary communications except face-to-face talk. Novels discussed include Salvador Plascencia's *The People of Paper,* Jonathan Safran Foer's *Extremely Loud and Incredibly Close,* and Mark Danielewski's brilliant hypertext novel *House of Leaves.*

Many of the electronic works discussed in these pages are also featured in the first volume of the *Electronic Literature Collection.* Co-edited by Nick Montfort, Scott Rettberg, Stephanie Strickland, and me, the *Collection* features sixty recent and new works of electronic literature, all offered under a Creative Commons license (Attribution-NonCommercial-NoDerivs 2.5) that allows the works to be freely shared, distributed, and transmitted as long as they are attributed, not used for commercial purposes, or altered. The *Collection* includes a searchable keyword index, comments by the author(s), and a brief introductory head note by the editors. Moreover, the *Collection* has been engineered to run cross-platform on Macintosh, PC, or Linux. The CD with the *Collection* is also available without cost from the Electronic Literature Organization, which sponsored the project.

The accompanying website for this book (http://new horizons.eliterature.org), a collaboration between Christopher Mott, Jacob Burch, and me, offers resources for teaching courses on electronic literature, including sample syllabi, authors' biographies, and several original essays, commissioned specifically for this project, that discuss such matters as navigation as a signifying strategy, finding and interpreting the code, architecture as trope and visualization, and a host of other topics relevant to understanding and interpreting electronic literature. We hope that teachers will find the website useful

both for themselves as they construct their courses and for their students as they encounter the new ways to experience the literary art that electronic literature offers.

A multipronged project such as this book, with the CD and website, necessarily is a collaborative effort and entails contributions from many hands. For comments and corrections to the manuscript, I am grateful to Mark Danielewski, John Cayley, Robert Coover, Martha Deed, Michael Joyce, Matthew Kirschenbaum, Alan Liu, Marjorie Luesebrink, Nick Montfort, Judd Morrissey, Millie Niss, William Poundstone, Rita Raley, Scott Rettberg, Stephanie Strickland, and Thom Swiss, as well as to the board and directors of the Electronic Literature Organization, who agreed to sponsor a version of chapter 1 and host it on their website. helen DeVinney helped in this process by ensuring that the document conformed to good practices for xml encoding. For curating volume 1 of the *Electronic Literature Collection,* I owe a debt greater than words can express to my co-editors, who graciously agreed to allow me to join the editorial collective after the work was already well along and who did most of the heavy lifting for the project. Nick Montfort and Scott Rettberg, in particular, spent long hours fixing hyperlinks and programming to make sure all the works would run cross-platform, and Stephanie Strickland contributed invaluable help on proofreading, design, and editorial comments. John Gill served as editorial assistant to the project, with assistance from helen DeVinney, Cynthia Lawson Jaramillo, Steve McLaughlin, Marjorie Luesebrink, and Carol Wald. The CD-ROM cover design was produced jointly by Ryan Weafer and Roxane Zargham. The *ELC* sponsors include the Center for Programs in Contemporary Writing at the University of Pennsylvania; ELINOR: Electronic Literature in the Nordic Countries; MITH: Maryland Institute for

Technology in the Humanities at the University of Maryland; the Division of Arts and Humanities, Richard Stockton College of New Jersey; the School of Journalism and Mass Communication at the University of Minnesota; and the College of Letters and Science and the English Department at UCLA.

Thanks to the Electronic Literature Organization for permitting the first chapter to appear in print after it had first appeared on their website; to *New Literary History* for allowing chapter 2 to be reprinted from "Intermediation: The Pursuit of a Vision," *New Literary History* 38.1 (Winter 2007): 99–126; to *Performance Research* for permission to print, in revised form, chapter 4, from "Revealing and Transforming: How Literature Revalues Computational Practice," *Performance Research* 11.4 (December 2006): 5–16; and to *Collection Management* for permission to reprint chapter 5 from "The Future of Literature: Complex Surfaces of Electronic Texts and Print Books," *Collection Management* 31.1/2 (2006): 85–114 (copies of this article are available from The Haworth Document Delivery Service: 1-800-HAWORTH. Email address: docdelivery@haworthpress.com). I am also grateful to Millie Niss, William Poundstone, and John Cayley for permission to use illustrations from their works, as well as to the artists and writers who generously contributed their works to the *Electronic Literature Collection* under a license that allows them to be reproduced.

For support to complete the book, I am grateful to the National Humanities Center for a fellowship during fall of 2006; my time at the Center was one of the most delightful I can remember in recent times, thanks to the splendid librarians and technical staff, as well as the hospitality and intellectual stimulation provided by Director Geoffrey Harpham and the other Fellows during my tenure there. I am grateful to UCLA

for a sabbatical in 2007 and the support and unfailing good humor of English Department chair Thomas Wortham. As always, my family provided much-needed support. My greatest debt is to my husband Nicholas Gessler, collector extraordinaire and my constant collaborator in all matters technical, as indeed in life itself.

Electronic Literature

What Is It?

The Scriptorium was in turmoil. Brother Paul, the precentor in charge, had detected a murmur from the back row and, furious that the rule of silence was being compromised, strode down the aisle just in time to see Brother Jacob tuck something under his robe. When he demanded to see it, Brother Jacob shamefacedly produced a codex, but not one that the antiquarii of this monastery had copied—or of any monastery, for this Psalter was printed. Shocked as much by the sight of the mechanical type as by Brother Jacob's transgression, Brother Paul so far forgot himself that he too broke the silence, thundering that if books could be produced by fast, cheap, and mechanical means, their value as precious artifacts would be compromised. Moreover, if any Thomas, Richard, or Harold could find his way into print, would not writing itself be compromised and become commonplace scribbling? And how would the spread of cheap printed materials affect the culture of the Word, bringing scribbling into every hut and

hovel whose occupants had hitherto relied on priests to interpret writing for them? The questions hung in the air; none dared imagine what answers the passing of time would bring.

This fanciful scenario is meant to suggest that the place of writing is again in turmoil, roiled now not by the invention of print books but the emergence of electronic literature. Just as the history of print literature is deeply bound up with the evolution of book technology as it built on wave after wave of technical innovations, so the history of electronic literature is entwined with the evolution of digital computers as they shrank from the room-sized IBM 1401 machine on which I first learned to program (sporting all of 4K memory) to the networked machine on my desktop, thousands of times more powerful and able to access massive amounts of information from around the world. The questions that troubled the Scriptorium are remarkably similar to issues debated today within literary communities. Is electronic literature really literature at all? Will the dissemination mechanisms of the internet and the Web, by opening publication to everyone, result in a flood of worthless drivel? Is literary quality possible in digital media or is electronic literature demonstrably inferior to the print canon? What large-scale social and cultural changes are bound up with the spread of digital culture, and what do they portend for the future of writing?[1]

These questions cannot be answered without first considering the contexts that give them meaning and significance, and that implies a wide-ranging exploration of what electronic literature is, how it overlaps and diverges from print, what signifying strategies characterize it, and how these strategies are interpreted by users as they go in search of meaning. In brief, one cannot begin to answer the questions before thoroughly

exploring and understanding the specificities of digital media. To see electronic literature only through the lens of print is, in a significant sense, not to see it at all. This chapter aims to provide (some of) the context that will open the field of inquiry so that electronic literature can be understood as both partaking of literary tradition and introducing crucial transformations that redefine what literature is.

Electronic literature, generally considered to exclude print literature that has been digitized, is by contrast "digital born," a first-generation digital object created on a computer and (usually) meant to be read on a computer. The Electronic Literature Organization, whose mission is to "promote the writing, publishing, and reading of literature in electronic media," convened a committee headed by Noah Wardrip-Fruin, himself a creator and critic of electronic literature, to come up with a definition appropriate to this new field. The committee's choice was framed to include both work performed in digital media and work created on a computer but published in print (as, for example, was Brian Kim Stefans's computer-generated poem "Stops and Rebels"). The committee's formulation reads: "work with an important literary aspect that takes advantage of the capabilities and contexts provided by the stand-alone or networked computer."

As the committee points out, this definition raises questions about which capabilities and contexts of the computer are significant, directing attention not only toward the changing nature of computers but also to the new and different ways in which the literary community mobilizes these capabilities. The definition is also slightly tautological in that it assumes preexisting knowledge of what constitutes an "important literary aspect." Although tautology is usually regarded as a cardinal sin by definition writers, in this case the tautology seems appropriate, for electronic literature arrives on the scene after

five hundred years of print literature (and, of course, even longer manuscript and oral traditions). Readers come to digital work with expectations formed by print, including extensive and deep tacit knowledge of letter forms, print conventions, and print literary modes. Of necessity, electronic literature must build on these expectations even as it modifies and transforms them. At the same time, because electronic literature is normally created and performed within a context of networked and programmable media, it is also informed by the powerhouses of contemporary culture, particularly computer games, films, animations, digital arts, graphic design, and electronic visual culture. In this sense electronic literature is a "hopeful monster" (as geneticists call adaptive mutations) composed of parts taken from diverse traditions that may not always fit neatly together. Hybrid by nature, it comprises a "trading zone" (as Peter Galison calls it in a different context) in which different vocabularies, expertises, and expectations come together to see what might emerge from their intercourse.[2] This hybridity is vividly on display in the *Electronic Literature Collection*. Of the sixty works in the *ELC*, perhaps a third have no recognizable words, virtually all have important visual components, and many have sonic effects as well. By calling these works "literature," my co-editors and I hope to stimulate questions about the nature of literature in the digital era. Must an artistic work contain words (or sounds that draw on words, such as the protosemantic art of "sound poetry," as Steve McCaffrey calls it)? I would argue that although we may well wish to retain this criterion of verbal art for "literature," we need a broader category that encompasses the kind of creative work on display in the *ELC*. I propose "the literary" for this purpose, defining it as creative artworks that interrogate the histories, contexts, and productions of literature, including as well the verbal art of literature proper. The

significance of designating "the literary" as central to literary studies is beyond the scope of my discussion here. Nevertheless, even a casual acquaintance with major movements in the literary studies in the last half-century will immediately confirm that the discipline, in embracing cultural studies, postcolonial studies, popular culture, and many other fields, has been moving toward the broader category of "the literary" for some time. Now, at the dawn of the twenty-first century, we are poised to extend the interrogations of the literary into the digital domain. Hence this book's subtitle, "New Horizons for the Literary." The works in the *ELC,* and more generally the entire field of electronic literature, test the boundaries of the literary and challenges us to rethink our assumptions of what literature can do and be.

GENRES OF ELECTRONIC LITERATURE

In the contemporary era, both print and electronic texts are deeply interpenetrated by code. Digital technologies are now so thoroughly integrated with commercial printing processes that print is more properly considered a particular output form of electronic text than an entirely separate medium. Nevertheless, electronic text remains distinct from print in that it literally cannot be accessed until it is performed by properly executed code. The immediacy of code to the text's performance is fundamental to understanding electronic literature, especially to appreciating its specificity as a literary and technical production. Major genres in the canon of electronic literature emerge not only from different ways in which the user experiences them, but also from the structure and specificity of the underlying code. Not surprisingly, then, some genres have come to be known by the software used to create and perform them.

The varieties of electronic literature are richly diverse, spanning all the types associated with print literature and adding some genres unique to networked and programmable media. Readers with only a slight familiarity with the field, however, will probably identify it first with hypertext fiction characterized by linking structures, such as Michael Joyce's *afternoon: a story*,[3] Stuart Moulthrop's *Victory Garden*,[4] and Shelley Jackson's *Patchwork Girl*.[5] These works are written in Storyspace, the hypertext authoring program first created by Michael Joyce, Jay David Bolter, and John B. Smith and then licensed to Mark Bernstein of Eastgate Systems, who has improved, extended, and maintained it. So important was this software, especially to the early development of the field, that works created in it have come to be known as the "Storyspace school." Intended as stand-alone objects, Storyspace works are usually distributed as CDs (earlier as disks) for Macintosh or PC platforms and, more recently, in cross-platform versions. Along with Macintosh's Hypercard, it was the program of choice for many major writers of electronic literature in the late 1980s and 1990s. As the World Wide Web developed, new authoring programs and methods of dissemination became available. The limitations of Storyspace as a Web authoring program are significant (for example, it has a very limited palette of colors and cannot handle sound files that will play on the Web). Although Storyspace continues to be used to produce interesting new works, it has been eclipsed as the primary Web authoring tool for electronic literature.

With the movement to the Web, the nature of electronic literature changed as well. Whereas early works tended to be blocks of text (traditionally called "lexia")[6] with limited graphics, animation, colors, and sound, later works make much fuller use of the multimodal capabilities of the Web; while the hypertext link is considered the distinguishing feature of the

earlier works, later works use a wide variety of navigation schemes and interface metaphors that tend to deemphasize the link as such. In my keynote speech at the 2002 Electronic Literature Symposium at UCLA, these distinctions led me to call the early works "first-generation" and the later ones "second-generation," with the break coming around 1995.[7] To avoid the implication that first-generation works are somehow superseded by later aesthetics, it may be more appropriate to call the early works "classical," analogous to the periodization of early films.[8] Shelley Jackson's important and impressive *Patchwork Girl* can stand as an appropriate culminating work for the classical period. The later period might be called "contemporary" or "postmodern" (at least until it too appears to reach some kind of culmination and a new phase appears).

As the varieties of electronic literature expanded, hypertext fictions also mutated into a range of hybrid forms, including narratives that emerge from a collection of data repositories such as M. D. Coverley's *Califia* and her new work *Egypt: The Book of Going Forth by Day;*[9] the picaresque hypertext *The Unknown* by Dirk Stratton, Scott Rettberg, and William Gillespie, reminiscent in its aesthetic of excess to Kerouac's *On the Road;*[10] Michael Joyce's elegantly choreographed Storyspace work *Twelve Blue,* disseminated on the Web through the Eastgate Hypertext Reading Room;[11] Caitlin Fisher's *These Waves of Girls,* including sound, spoken text, animated text, graphics, and other functionalities in a networked linking structure;[12] Stuart Moulthrop's multimodal work *Reagan Library,* featuring QuickTime movies with random text generation;[13] *The Jew's Daughter* by Judd Morrissey in collaboration with Lori Talley, with its novel interface of a single screen of text in which some passages are replaced as the reader mouses over them;[14] Talan Memmott's brilliantly designed and programmed *Lexia to Perplexia;*[15] and Richard Holeton's parodic

Frequently Asked Questions about Hypertext, which in Nabo-kovian fashion evolves a narrative from supposed annotations to a poem,[16] along with a host of others. To describe these and similar works, David Ciccoricco introduces the useful term "network fiction," defining it as digital fiction that "makes use of hypertext technology in order to create emergent and re-combinatory narratives."[17]

Interactive fiction (IF) differs from the works noted above in having stronger game elements.[18] The demarcation between electronic literature and computer games is far from clear; many games have narrative components, while many works of electronic literature have game elements. (As a pair of mirror phrases in Moulthrop's *Reagan Library* puts it, "This is not a game" and "This is not not a game.") Nevertheless, there is a general difference in emphasis between the two forms. Para-phrasing Markku Eskelinen's elegant formulation, we may say that with games the user interprets in order to configure, whereas in works whose primary interest is narrative, the user configures in order to interpret.[19] Since interactive fiction cannot proceed without input from the user, Nick Monfort in *Twisty Little Passages: An Approach to Interactive Fiction,* the first book-length scholarly study of IF, prefers the term "inter-actor."[20] In his pioneering study, Montfort characterizes the essential elements of the form as consisting of a parser (the computer program that understands and replies to the inter-actor's inputs) and a simulated world within which the action takes place. The interactor controls a player character by is-suing commands. Instructions to the program, for example asking it to quit, are called "directives." The program issues replies (when the output refers to the player character) and re-ports (responses directed to the interactor, asking for example if she is sure she wants to quit).

Alternating game play with novelistic components, interactive fictions expand the repertoire of the literary through a variety of techniques, including visual displays, graphics, animations, and clever modifications of traditional literary devices. In Emily Short's *Savoir-Faire,* for example, solving many of the IF puzzles requires the user to make a leap of inference from one device to another that resembles it in function; for example, if a door and box are properly linked, opening the box also opens the door, which otherwise will not yield.[21] Such moves resemble the operation of literary metaphor, although here the commonality is routed not through verbal comparison of two objects but rather functional similarities combined with the player character's actions—a kind of embodied metaphor, if you will. In subtle ways, IF can also engage in self-referential commentary and critique. In Jon Ingold's *All Roads*, the player character is a teleporting assassin, William DeLosa, over whom the interactor discovers she has minimal control.[22] The allusion evoked by the title ("all roads lead to Rome") suggests that the imperial power here is the author's capacity to determine what the interactor will experience. The player character's vocation can thus be interpreted to imply that the metatextual object of assassination is the illusion that hypertext is synonymous with democracy and user empowerment.

Donna Leishman spins a variant of interactive fictions in her work, where the visual interface invites game-like play but without the reward structure built into most interactive fictions. Her striking visual style, exemplified by *Deviant: The Possession of Christian Shaw,* combines primitivism with a sophisticated visual sensibility, contemporary landscapes with a narrative originating in the seventeenth century.[23] Rather than striving to progress by solving various puzzles and mysteries,

the interactor discovers that the goal is not reaching the end (although there is a final screen providing historical context for the visual narrative), but rather the journey itself. The literariness (as distinct from the gaming aspect) is instantiated in the work's dynamics, which are structured to project the interactor inside the troubled interior world of Christian Shaw. With no clear demarcation between Christian's perceptions and exterior events, the work deconstructs the boundary between subjective perception and verifiable fact.

While works like *Deviant* use perspective to create the impression of a three-dimensional space, the image itself does not incorporate the possibility of mobile interactivity along the Z-axis. The exploration of the Z-axis as an additional dimension for text display, behavior, and manipulation has catalyzed innovative work by artists such as David Knoebel, Ted Warnell, Aya Karpinska, Charles Baldwin, Dan Waber, and John Cayley. In a special issue of *Iowa Review Web* guest-edited by Rita Raley,[24] these artists comment on their work and the transformative impact of the Z-axis. One need only recall Edward Abbott's *Flatland* to imagine how, as text leaps from the flat plane of the page to the interactive space of the screen, new possibilities emerge.[25]

One kind of strategy, evident in Ted Warnell's intricately programmed JavaScript work *TLT vs. LL,* is to move from the word as the unit of signification to the letter. The letters are taken from email correspondence with Thomas Lowe Taylor and Lewis Lacook (the sources for TLT and LL), with the "vs." indicating contestations translated in the work from the level of semantic content to dynamic interplay between visual forms. In "Artist's Statement: Ted Warnell," he comments that the breakthrough for him was thinking of the "vs." as "taking the form of 'rising' (coming to top/front) rather than 'pushing' (as if it were) from left/right."[26] Consequently, the emphasis

shifts to a dynamic surface in which rising and sinking motions give the effect of three dimensions as the layered letter forms shift, move, and reposition themselves relative to other letters, creating a mesmerizing, constantly mutating dance of competing and cooperating visual shapes.[27]

David Knoebel's exquisitely choreographed "Heart Pole," from his collection "Click Poetry," features a circular globe of words, with two rings spinning at 90 degrees from one another, "moment to moment" and "mind absorbing." A longer narrative sequence, imaged as a plane undulating in space, can be manipulated by clicking and dragging. The narrative, focalized through the memories of a third-person male persona, recalls the moment between waking and sleeping when the narrator's mother is singing him to sleep with a song composed of his day's activities. But like the slippery plane that shifts in and out of legibility as it twists and turns, this moment of intimacy is irrevocably lost to time, forming the "heart pole" that registers both its evocation and the on-goingness that condemns even the most deeply seated experiences to loss.[28]

The next move is from imaging three dimensions interactively on the screen to immersion in actual three-dimensional spaces. As computers have moved off the desktop and into the environment, other varieties of electronic literature have emerged. Whereas in the 1990s email novels were popular, the last decade has seen the rise of forms dependent on mobile technologies, from short fiction delivered serially over cell phones to location-specific narratives keyed to GPS technologies, often called "locative narratives." In Janet Cardiff's *The Missing Voice (Case Study B)* (1996), for example, the user listened to a CD played on a Walkman keyed to locations in London's inner city, tracing a route that takes about forty-five minutes to complete; *Her Long Black Hair* was specific to New York City's Central Park and included photographs as

well as audio narratives.[29] Blast Theory's *Uncle Roy All Around You* combined a game-like search for Uncle Roy, delivered over PDAs, with participants searching for a postcard hidden at a specific location.[30] Meanwhile, online observers could track participants and try to help or confuse them, thus mixing virtual reality with actual movements through urban spaces.

The complements to site-specific mobile works, which foreground the user's ability to integrate real-world locations with virtual narratives, are site-specific installations in which the locale is stationary, such as a CAVE virtual reality projection room or gallery site. In their specificity and lack of portability such works are reminiscent of digital art works, although in their emphasis on literary texts and narrative constructions they can easily be seen as a species of electronic literature. Like the boundary between computer games and electronic literature, the demarcation between digital art and electronic literature is shifty at best, often more a matter of the critical traditions from which the works are discussed than anything intrinsic to the works themselves.[31]

Pioneering the CAVE as a site for interactive literature is the creative writing program at Brown University spearheaded by Robert Coover, himself an internationally known writer of experimental literature. At the invitation of Coover, a number of writers have gone to Brown to create works for the CAVE, including John Cayley, Talan Memmott, Noah Wardrip-Fruin, and William Gillespie. Works produced there include Cayley's *Torus* (2005) in collaboration with Dmitri Lemmerman; Memmott's "E_cephalopedia//novellex" (2002); Wardrip-Fruin's *Screen* with Josh Carroll, Robert Coover, Shawn Greenlee, and Andrew McClain (2003);[32] and Gillespie's *Word Museum* with programming by Jason Rodriguez and David Dao.[33] Performed in a three-dimensional space in which the user wears virtual reality goggles and manipulates a wand, these works

enact literature not as a durably imprinted page but as a full-body experience.

Screen, with introduction narrated by Robert Coover, illustrates the potential of this work. As it begins, the user hears Coover read the words "In a world of illusions, we hold ourselves in place by memories" and sees text displayed on the three vertical CAVE walls in billboard fashion. The texts, one by a female narrator and one by a male, relate memories that slip away even as the narrators try to hold onto them. This narrative theme becomes enacted in a startlingly literal way when words suddenly begin peeling away from the walls and moving in the three-dimensional space. The user can try to bat them back into place with the data glove, but more words peel off faster than she put them back, despite her best efforts. Moreover, the batted words move along trajectories difficult to control, creating neologisms, nonsense words, and chaotic phrases that further make the text difficult to read. Eventually all the words lay jumbled on the floor, the text now impossible to recover for "normal" reading. In another sense, of course, the work has redefined what it means to read, so that reading becomes, as Rita Raley has pointed out, a kinesthetic, haptic, and proprioceptively vivid experience, involving not just the cerebral activity of decoding but bodily interactions with the words as perceived objects moving in space.[34]

Entering the narrative now does not mean leaving the surface behind, as when a reader plunges into an imaginative world and finds it so engrossing that she ceases to notice the page. Rather, the "page" is transformed into a complex topology that rapidly transforms from a stable surface into a "playable" space in which she is an active participant. "Playable media," a term coined by Noah Wardrip-Fruin to denote computer games and other interactive works such as *Screen,* accurately expresses the user's engagement with the game-like

aspects of the work.[35] In effect, *Screen* performs a historical trajectory arcing from a print-like reading surface that invites the reader to enter an imaginative world to complex topologies that constantly reenact, with every movement and change of spatial orientation, a computationally intense environment. In this environment, the barely perceptible lag times remind the user that nothing happens without the incredibly rapid calculations that are continuously generating the perceived environment, creating an interface in which a human user cooperates and competes with intelligent machines.

If memories hold us in place, as *Screen*'s introduction suggests, the engagement of human and machine cognizers shakes us out of our accustomed place of reading to an active encounter that hints at the place of the human in the contemporary world. The enchanced sensory range that such works as *Screen* entail is not without cost. CAVE equipment, costing upward of a million dollars and depending on an array of powerful networked computers and other equipment, is typically found only in Research 1 universities and other elite research sites. Because of the high initial investment and continuing programming and maintenance costs, it is usually funded by grants to scientists. Of the few institutions that have this high-tech resource, even fewer are willing to allocate precious time and computational resources to creative writers. Literature created for this kind of environment will therefore likely be experienced in its full implementation only by relatively few users (although some idea of the works can be gained from the QuickTime documentation that Cayley and others have created for their CAVE pieces), thus sacrificing the portability, low cost, robust durability, and mass distribution that made print literature a transformative social and cultural force.[36] Nevertheless, as conceptual art pushing the boundary of what

literature can be, this kind of coterie electronic literature has an impact beyond the technology's limitations. Moreover, the Brown programming team has recently developed a spatial hypertext authoring system that allows authors to create and edit their works using a representation of the CAVE on their laptops, with capabilities to link text, images, 3-D photographs and videos, and 3-models.[37] This development could be used not only to create but also to view CAVE works. Although it is too soon to know the impact of this software, it has the potential greatly to increase the audience and impact of CAVE productions.

Like the CAVE productions, interactive dramas are often site specific, performed for live audiences in gallery spaces in combination with present and/or remote actors. Many of these dramas proceed with a general script outlining the characters and the initiating action (sometimes the final outcome will also be specified), leaving the actors to improvise the intervening action and plot. In a variation on this type of performance, M. D. Coverley coordinated *M Is for Nottingham* as a trAce project in July 2002. Writers, including Coverley and Kate Pullinger, joined in collaborative writing at a website preceding the Incubation 2 Conference in Nottingham, riffing on the murder mystery genre to create a story revolving around the "death" of the book. During the conference the denouement was acted out by volunteers in costume, thus adding a component of live dramatic production. At SIGGRAPH 2006, *Unheimlich*, a collaborative telematic performance created by Paul Sermon, Steven Dixon, Mathias Fucs, and Andrea Zapp, was performed mixing audience volunteers (among them the media artist Bill Seaman) placed against a bluescreen background on which were projected images of actors improvising at a remote location.[38] Mixing the virtual and the real within

a loose dramatic framework, *Unheimlich* created a borderland that encouraged playful innovation and improvisational collaboration.

Interactive drama can also be performed online. Michael Mateas and Andrew Stern's *Façade* (2005) has a graphical interface and is programmed in ABL (A Behavior Language), which they devised to structure the action into "beats."[39] The drama situates the user as a dinner guest of a couple, Grace and Trip, celebrating their tenth wedding anniversary. Although the couple appears prosperous and happy, in *Who's Afraid of Virginia Woolf* fashion, cracks soon develop in the façade. The user can intervene in various ways, but all paths lead to an explosion at the end, a programming choice that maintains intact the Aristotelian plot structure of a beginning, middle, and end.

How to maintain such conventional narrative devices as rising tension, conflict, and denouement in interactive forms where the user determines sequence continues to pose formidable problems for writers of electronic literature, especially narrative fiction. Janet Murray's entertaining and insightful *Hamlet on the Holodeck* was one of the first critical studies to explore this issue in depth, surveying a wide variety of forms, including hypertext fiction, computer games, and interactive drama. With her usual acuity, she accurately diagnoses both sides of the question. "Giving the audience access to the raw materials of creation runs the risk of undermining the narrative experience," she writes, while still acknowledging that "calling attention to the process of creation can also enhance the narrative involvement by inviting readers/viewers to imagine themselves in the place of the creator."[40]

Marie-Laure Ryan, in *Avatars of Story*,[41] pioneers a transmedial approach to narrative that seeks to construct a comprehensive framework for narrative in all media, consisting

of simulative, emergent, and participatory models. She further constructs a taxonomy for narratives specifically in New Media that takes into account textual architecture and the actions and positions of the user, which she types as three binaries describing interactivity: internal/external, exploratory/ontological, and external/exploratory. Like Murray, she notes the tension between the top-down approach to narrative in which the narrator spins a story, and the bottom-up model of interactivity in which the user chooses how the story will be told.

The response to this tension in electronic literature has been a burst of innovation and experimentation, with solutions ranging from the guard fields of classic Storyspace works (in which certain conditions must be met before a user can access a given lexia) to the Aristotelian constraints of *Façade*. Even where multiple reading pathways exist, many interactive works still guide the user to a clear sense of conclusion and resolution, such as Deena Larsen's *Disappearing Rain*[42] and M. D. Coverley's *Califia*. Nevertheless, the constraints and possibilities of the medium have encouraged many writers to turn to nonnarrative forms or to experiment with forms in which narratives are combined with randomizing algorithms.

An important spokesperson for these approaches is Loss Pequeño Glazier, a poet and critic who has established the Electronic Poetry Center, which along with Kenneth Goldsmith's Ubuweb is one of the premier online sites for electronic poetry on the Web.[43] In his book *Digital Poetics: Hypertext, Visual-Kinetic Text and Writing in Programmable Media*, Glazier argues that electronic literature is best understood as a continuation of experimental print literature.[44] In his view, the medium lends itself to experimental practice, especially to forms that disrupt traditional notions of stable subjectivities and ego-centered discourses. Although he underestimates the

ways in which narrative forms can also be disruptive, Glazier nevertheless makes a strong case for electronic literature as an experimental practice grounded in the materiality of the medium. Moreover, he practices what he preaches. His *White-Faced Bromeliads on 20 Hectares*[45] uses JavaScript to investigate literary variants, with new text generated every ten seconds. The procedure disrupts narrative poetic lines with disjunctive juxtapositions that derail the line midway through, resulting in suggestive couplings and a sense of dynamic interplay between the prescripted lines and the operations of the algorithm. The combination of English and Spanish vocabularies and the gorgeous images from Latin American locations further suggest compelling connections between the spread of networked and programmable media and the transnational politics in which other languages contest and cooperate with English's hegemonic position in programming languages and, arguably, in digital art as well.

Generative art, whereby an algorithm is used either to generate texts according to a randomized scheme or to scramble and rearrange preexisting texts, is currently one of the most innovative and robust categories of electronic literature.[46] Philippe Bootz has powerfully theorized generative texts, along with other varieties of electronic literature, in his functional model that makes clear distinctions between the writer's field, the text's field, and the reader's field, pointing out several important implications inherent in the separation between these fields, including the fact that electronic literature introduces temporal and logical divisions between the writer and reader different from those enforced by print.[47] Bootz also usefully points out that in a European context hypertext has not been the dominant mode but rather textual generators and animated works, citing particularly the group of writers associated with A.L.A.M.O. (Atelier de Littérature Assistee par le

Mathematique et les Ordinateurs, or Workshop of Literature Assisted by Mathematics and Computers), which includes among others Jean-Pierre Balpe, and the group with which he is associated, L.A.I.R.E. (Lecture, Art, Innovation, Recherche, Écriture, or Reading, Art, Innovation, Research, Writing).[48] Bootz has pioneered many seminal works of generative and animated literature dating from the 1980s, including recently *La série des U* (*The Set of U*),[49] an elegant poem with text, pictures, and programming by Bootz and music by Marcel Frémiot. The work generates a different text-that-is-seen (texte-à-voir) each time it is played through subtle variations in the timing at which the textual elements appear and the relation between the verbal text and the sonic component, which is not directly synchronized with the words but nevertheless gives the serendipitous impression of coordination through programmed meta-rules.

American explorations of generative text include Noah Wardrip-Fruin's *Regime Change* and *News Reader,* created in collaboration with David Durand, Brion Moss, and Elaine Froehlich, works that Wardrip-Fruin calls "textual instruments" (a designation to which we will return). Both pieces begin with news stories (for *Regime Change,* President Bush's claim that Saddam Hussein had been killed, and for *News Reader,* the headlined stories in Yahoo.com), then employ the *n*-gram technique pioneered by Claude Shannon to find similar strings in the source and target documents, using them as bridges to splice together the two texts.[50] Naming such works "instruments" implies that one can learn to play them, gaining expertise as experience yields an intuitive understanding of how the algorithm works. Other randomizing algorithms are used by Jim Andrews in such works as *On Lionel Kearns,*[51] which splices extracts from the poems of Canadian writer Lionel Kearns to create scrambled texts, accompanied

by amusing and effective visualizations that function as interpretations of Kearns's work.

As Andrews, Kearns, and Wardrip-Fruin acknowledge, these works are indebted to William Burroughs's notion of the "cut-up" and "fold-in." They cite as theoretical precedent Burroughs's idea that randomization is a way to break the hold of the viral word and liberate resistances latent in language by freeing it from linear syntax and coherent narrative.[52] Other notable instances of randomizing works are Jim Andrews's *Stir Fry Texts,* in which collaborators used Andrews's "Stir Fry" algorithm to randomize their texts;[53] *When You Reach Kyoto,* a visual/verbal collaboration by Geniwate and Brian Kim Stefans;[54] Millie Niss and Martha Deed's *Oulipoems;*[55] and Patrick-Henri Burgaud's *Jean-Pierre Balpe ou les Lettres Dérangées,* a tribute to the earlier mentioned poet and software developer Jean-Pierre Balpe (also a pioneer in text generation algorithms) in which the work performs as a textual instrument that the user can manipulate.[56] If tenacious (and lucky), the user will find the "deranged" letters assuming coherency at the end, where "this is not the end" appears across Balpe's bibliography.

Just as the twentieth century saw an explosion of interest in the book as a medium, with an impressive canon of artists' books and other experimental practices exploring the potential of the book as an artistic and literary venue, so electronic literature has seen a growing body of work that interrogates networked and programmable media as the material basis for artistic innovation and creation. "Code work," a phrase associated with such writers as Alan Sondheim, MEZ (Mary Ann Breeze), and Talan Memmott and with critics such as Florian Cramer, Rita Raley, and Matthew Fuller, names a linguistic practice in which English (or some other natural language) is hybridized with programming expressions to create a creole

evocative for human readers, especially those familiar with the denotations of programming languages. "Code work" in its purest form is machine readable and executable, such as Perl poems that literally have two addressees, humans and intelligent machines. More typical are creoles using "broken code," code that cannot actually be executed but that uses programming punctuation and expressions to evoke connotations appropriate to the linguistic signifiers.[57] Replete with puns, neologisms, and other creative play, such work enacts a trading zone in which human-only language and machine-readable code are performed as interpenetrating linguistic realms, thus making visible on the screenic surface a condition intrinsic to all electronic textuality, namely the intermediating dynamics between human-only languages and machine-readable code.[58] By implication, such works also reference the complex hybridization now underway between human cognition and the very different and yet interlinked cognitions of intelligent machines, a condition that Talan Memmott has brilliantly evoked in *Lexia to Perplexia* with neologisms like "remotional" and "I-terminal."

The conjunction of language with code has stimulated experiments in the formation and collaboration of different kinds of languages. Diane Reed Slattery, Daniel J. O'Neil, and Bill Brubaker's *The Glide Project* enacts the visual language of Glide, which can be seen and performed as gestures in a dance but cannot be spoken because the semicircular shapes comprising it have no verbal equivalents, only clusters of denotations, functioning in this respect somewhat like ideographic languages.[59] Other experiments traversing the borderland between gestural and verbal languages have been performed by Sha Xin Wei and collaborators in *TGarden*,[60] where virtual reality technologies are used to record the movements of dancers as they attempt to create new gestural vocabularies, a topic

brilliantly explored by Carrie Noland in "Digital Gestures" analyzing digital works that evoke embodied gestures.[61] Such experiments in multiple and interrelated semiotic systems are both enabled by and reflective of the underlying fact that behaviors, actions, sounds, words, and images are all encoded as bits and ultimately as voltage differences. Another kind of interrogation of the conjunction between code and language has been explored by John Cayley through procedures that he calls "transliteral morphing," algorithms that transform source texts into target words letter by letter, a strategy that emphasizes the discreteness of alphabetic languages and its similarities to the discreteness of digital code[62] (see chapter 4 for an extended discussion). In *riverIsland,* Cayley uses transliteral morphing to juxtapose different translations of Chinese poems, comparing and contrasting the discreteness of alphabetic languages with the more analogue forms of Chinese morphographic language systems.[63]

The multimodality of digital art works challenges writers, users, and critics to bring together diverse expertise and interpretive traditions so that the aesthetic strategies and possibilities of electronic literature may be fully understood. Some writers, for example Thom Swiss, prefer to find graphic artists as collaborators. Others, such as Stephanie Strickland in her elegantly choreographed and playfully imagined hypertextual poem "The Ballad of Sand and Harry Soot," incorporate images by artists, including in this case the beautiful mechanized sand sculptures of Jean Pierre Hebert and Bruce Shapiro.[64] Still others who think of themselves as primarily graphic artists and programmers write texts to incorporate into their works; I would put Jason Nelson's playful and imaginative net art into this category, including his haunting *Dreamaphage,* with its bizarre narratives and childlike yet somehow ominous graphics.[65] Still others who come to digital media from back-

grounds as print writers, such as M. D. Coverley, are on steep upward learning curves in which their visual and graphic sensibilities are rapidly becoming as accomplished as their verbal expertise (compare, for example, the design qualities of *Califia* with the stunning graphic design of *Egypt: The Book of Coming Forth by Day*). From a critical point of view, works that appear in both print and electronic instantiations, such as Stephanie Strickland's innovative poetry book *V: Wave Son.Nets/Losing l'Una* and the Web work *V:Vniverse*, programmed in Director in collaboration with Cynthia Lawson, illustrate that when a work is reconceived to take advantage of the behavioral, visual, and/or sonic capabilities of the Web, the result is not just a Web "version" but an entirely different artistic production that should be evaluated in its own terms with a critical approach fully attentive to the specificity of the medium.[66] Moreover, in a few cases where the print and digital forms are conceptualized as one work distributed over two instantiations, as is the case with *V*, possibilities for emergent meanings multiply exponentially through the differences, overlaps, and convergences of the instantiations compared with one another. Other notable works that have appeared in different media instantiations include Lance Olsen's *10:01*, first published as a print hypertext and then transformed into a Web work in collaboration with Tim Guthrie,[67] and Geoff Ryman's *253* that made the opposite transition from Web hypertext to print book.[68]

As such works make vividly clear, the computational media intrinsic to electronic textuality have necessitated new kinds of critical practice, a shift from literacy to what Gregory L. Ulmer calls "electracy."[69] The tendency of readers immersed in print is to focus first on the screenic text, employing strategies that have evolved over centuries through complex interactions between writers, readers, publishers,

editors, booksellers, and other stakeholders in the print medium. For readers who do not themselves program in computational media, the temptation of reading the screen as a page is especially seductive. Although they are of course aware that the screen is not the same as print, the full implications of this difference for critical interpretation are far from obvious. Moreover, the shift from print to programmable media is further complicated by the fact that compositional practices themselves continue to evolve as the technology changes at a dizzying pace.

Among the critical voices exploring the new territories of networked and programmable media are many practitioner-critics whose astute observations have moved the field forward, including among others John Cayley, Loss Pequeño Glazier, Alan Sondheim, Brian Kim Stefans, and Stephanie Strickland.[70] Among those who work on the critical interpretation of electronic media, Florian Cramer, Rita Raley, Matthew Fuller, Ian Bogost, Mark B. N. Hansen (whose work is discussed in more detail in chapter 3), Adalaide Morris, and Matthew Kirschenbaum deserve special mention for their insistence on the specificity of networked and programmable media.[71] At the same time, these critics also build bridges linking digital art, literature, and games on the one hand, and traditional critical practice and philosophical writing on the other. In my view the optimal response requires both of these moves at once—recognizing the specificity of new media without abandoning the rich resources of traditional modes of understanding language, signification, and embodied interactions with texts.

Exemplifying this kind of critical practice is Matthew Kirschenbaum's *Mechanisms: New Media and Forensic Textuality.* Drawing an analogy with the scrutiny bibliographers and textual critics lavish on print texts, Kirschenbaum argues that

close examination of electronic objects is necessary fully to comprehend the implications of working with digital media. And look closely he does, all the way down to microscopic images of bit patterns on the disk substrate. He parses the materiality of digital media as consisting of two interrelated and interacting aspects: forensic materiality and formal materiality. Whereas forensic materiality is grounded in the physical properties of the hardware—how the computer writes and reads bit patterns, which in turn correlate to voltage differences— formal materiality consists of the "procedural friction or perceived difference . . . as the user shifts from one set of software logics to another" (ms. 27). Using the important distinction that Espen J. Aarseth drew in *Cybertext: Perspectives on Ergodic Literature*[72] between scriptons ("strings as they appear to readers") and textons ("strings as they exist in the text") (62), Kirschenbaum pioneers in *Mechanisms* a methodology that connects the deep print reading strategies already in effect with scriptons (letters on the page, in this instance) to the textons (here the code generating the screenic surface). He thus opens the way for a mode of criticism that recognizes the specificity of networked and programmable media without sacrificing the interpretive strategies evolved with and through print.

Stephanie Strickland, an award-winning print poet who has created significant work in digital media, has a keen sense both of literary tradition and of how criticism needs to change to accommodate digital media. In "Writing the Virtual: Eleven Dimensions of E-Poetry,"[73] she focuses on the ways in which E-poetry achieves dynamism, leading her to coin the neologism "poietics" (from "poetry" and "poïïsis," the Greek work for "making"). With succinct brilliance and a wide spectrum of examples, Strickland emphasizes thematic emergences, such as the emphasis on ruins; new processes of user psychology,

such as the "intense attachment" users experience at sites of interaction; and new configurations of physical parameters, such as the manifestation of time as "active, stratigraphic, and topologic," leading to the conclusion that time is "written multiply" (1). Recombinant flux using computational writing engines and generators is part of this dynamism, reflecting a desire, she argues, to create works that instantiate in their operations the incredibly swift operations of code and the deterministic and yet aleatory operations of digital networks.

The intermixture of code and language on which recombinant flux depends is situated within a more general set of practices in which human thinking and machine execution collaborate to produce literary works that reference both cognitive modes. Any work that uses algorithmic randomizers to generate text relies to a greater or lesser extent on the surprising and occasionally witty juxtapositions created by these techniques. It should be noted that algorithmic procedures are not unique to networked and programmable media. Before personal computers became as ubiquitous as dust mites, writers in print media were using a variety of techniques to achieve similar results, as Florian Cramer points out in *Words Made Flesh: Code, Culture, Imagination*. Jim Rosenberg's *Diagram* series poems, for example, in which the user can manipulate shapes representing grammatical relationships such as verbs and conjunctions, were implemented first on paper and only later in computer code.[74] Other works using algorithmic procedures in print media include Raymond Queneau's *Cent mille milliards de poèmes*, John Cage's mesostics, and Jackson Mac Low's *The Virginia Woolf Poems*.[75]

Brian Kim Stefans implicitly referenced this tradition when he published his computer poem "Stops and Rebels" in his print collection of essays, *Fashionable Noise: On Digital Poetics*, along with extensive annotations available only in

the print version.[76] In these annotations, which amount to a hyperlinked essay, he meditates on the conjunction of human and machine cognition. He anthropomorphizes the computer program that generated the poem by calling it the "Demon." The Demon, Stefans notes, is involved in a two-way collaboration: between the programmer who works with the limitations and possibilities of a computer language to create the program, and between the user and the computer when the computer poem is read and interpreted. Both collaborations invoke and enact the creative (mis)understandings and (mis)-prisings that emerge from the overlaps and disjunctions between humans as meaning-seeking animals and intelligent machines for which meaning is constructed in very different contexts than human-only language. This dimension of randomized electronic works distinguishes them from print works associated with algorithmic operations. A given work may, of course, ignore this specificity in its explicit textual content. Nevertheless, the conditions in which a work is created, produced, disseminated, and performed *always* mark it in distinctive ways that provide openings for critical interrogation and media-specific analysis, as Matthew Kirschenbaum decisively demonstrates in *Mechanisms*.

The collaboration between the creative imagination of the (human) writer and the constraints and possibilities of software is the topic of Ian Bogost's *Unit Operations: An Approach to Videogame Criticism,* in which he develops an extended analogy between the unit operations of object-oriented programming and a literary approach that explores the open, flexible, and reconfigurable systems that emerge from the relations between units.[77] In a sense, literary criticism has long regarded print works as enacting these kinds of systems, infinitely reconfigurable as critical attention shifts focus from one kind of textual parsing to another. By redescribing traditional

interpretations as "unit operations," Bogost builds a framework in which computer object-oriented programming can be seen as a related and interpenetrating domain with video games (his central focus), print literature, and electronic literature.

As Bogost's approach suggests, taking programming languages and practices into account can open productive approaches to electronic literature, as well as other digital and nondigital forms. The influence of software is especially obvious in the genre of the Flash poem, characterized by sequential screens that typically progress with minimal or no user intervention. (There are, however, exceptions to this practice, notably the Flash poem "Errand upon Which We Came,"[78] a collaboration between Stephanie Strickland and M. D. Coverley in which the authors include on principle possibilities for user intervention and choice.) Brian Kim Stefans's "The Dreamlife of Letters,"[79] although highly unusual in its stunning virtuosity, is in this sense more typical. Asked to respond to a theoretically dense piece by Rachel Blau DuPlessis, Stefans liberated the words from their original context by alphabetizing them and parsing them into thirty-six groups. He then choreographed the groups with different behaviors in a tour de force of animation and visualization. The eleven-minute Flash work playfully brings out, in Concrete fashion, the implications and connotations of the sexually laden language of the original, as well as new implications that emerge from the juxtapositions created by the alphabetized text. As the letters and words dance, stretch, collapse, fall, conjoin, separate, seduce, and swirl, it is as though the morphemes and phonemes of language have themselves acquired an eroticized graphic imagination, a collective unconscious capable of feeling and expressing desire—that is to say, of dreaming.

Robert Kendall's "Faith," although 180 degrees athwart from "The Dreamlife of Letters" in sensibility and theme, like Stefans's visual poem uses the computer's multimodal capabilities to create a work in which color, animation, music, and timed sequence collaborate with the verbal text to create signification.[80] The work proceeds in five stages (four of which are distinctly color coded in orange, red, burgundy, and black/ grey respectively), layering letters and words onto previously existing ones to create new meanings. For example, the orange "logic" from the first stage is interpolated in the second stage into "I edge/ logic/ out," with the new letters appearing in red; in the third stage, "edge" transforms into "hedge," with the new letter appearing in burgundy. As the words change position and become interpolated into new texts, they retain a hint of their previous significations through the colors that link them to their earlier appearances. The effect creates a palimpsest that visually performs the vacillations the lyric voice verbally articulates as it oscillates between logic and faith.

Young-Hae Chang Heavy Industries (YHCHI), a Seoul-based collaboration between Young-Hae Chang and Marc Voge, follows a different aesthetic strategy in creating Flash works where the emphasis falls mainly on the text, music, and timed sequence, with animation and color playing subsidiary roles. In *Dakota,* for example, black text on a white background proceeds in rhythmic syncopation to the jazz music of Art Blakey, evoking both a Kerouac-like road trip and Ezra Pound's first two *Cantos.*[81] Jessica Pressman classifies this work as "digital modernism," a phrase describing electronic works that emphasize their connection with modernist print texts.[82] In YHCHI's *Nippon* (discussed in more detail in chapter 3) a similar aesthetic strategy is used to narrate the story of a Japanese woman who entertains salarymen in an after-hours

bar, with Japanese ideograms in red and English in black appearing on the successive screens, choreographed to a Japanese folk song by R. Taki.[83] While alluding to print predecessors, this time-based work also performs its difference from a codex book in its rhythmic pace synchronized to the music tempo and operating outside the user's control.

Hypertext fiction, network fiction, interactive fiction, locative narratives, installation pieces, "codework," generative art, and the Flash poem are by no means an exhaustive inventory of the forms of electronic literature, but they are sufficient to illustrate the diversity of the field, the complex relations that emerge between print and electronic literature, and the wide spectrum of aesthetic strategies that digital literature employs. Having been a widely visible presence only for some two decades (although its predecessors stretch back at least to the computer poems of the early 1960s, and far beyond this in the print tradition), electronic literature has already produced many works of high literary merit that deserve and demand the close attention and rigorous scrutiny critics have long practiced with print literature. Such close critical attention requires new modes of analysis and new ways of teaching, interpreting, and playing. Most crucial, perhaps, is the necessity to "think digital," that is, to attend to the specificity of networked and programmable media while still drawing on the rich traditions of print literature and criticism.

ELECTRONIC LITERATURE IS NOT PRINT

Paying attention to the ways in which electronic literature both extends and disrupts print conventions is a neat trick, and the criticism is littered with those who have fallen prey to Scylla or Charybdis, ballyhooing its novelty or failing to see

the genuine differences that distinguish it from print. After a generation of spirited debate it is now possible to see the landscape more clearly, in part because we are able to build on the path-breaking work of those who came before. Early hypertext theorists, notably George Landow and Jay David Bolter,[84] stressed the importance of the hyperlink as electronic literature's distinguishing feature, extrapolating from the reader's ability to choose which link to follow to make extravagant claims about hypertext as a liberatory mode that would dramatically transform reading and writing and, by implication, settings where these activities are important, such as the literature classroom. Given the major works of electronic literature that then loomed large, particularly Michael Joyce's *afternoon: a story* and Stuart Moulthrop's *Victory Garden,* this emphasis was understandable, for these works consist mainly of screens of text with very limited graphics, no animation, and no sound.

One problem with identifying the hyperlink as electronic literature's distinguishing characteristic was that print texts had long also employed analogous technology in such apparati as footnotes, endnotes, cross-reference, and so on, undermining the claim that the technology was completely novel. Perhaps a more serious problem, however, was the association of the hyperlink with the empowerment of the reader/user. As a number of critics have pointed out, notably Espen J. Aarseth, the reader/user can only follow the links that the author has already scripted.[85] Moreover, in a work like *afternoon: a story,* looping structures are employed from which there is no escape once the reader has fallen into them, short of closing the program and beginning again. Compared to the flexibility offered by the codex, which allows the reader complete freedom to skip around, go backward as well as forward, and open the book wherever she pleases, the looping struc-

tures of electronic hypertexts and the resulting repetition forced on the reader/user make these works by comparison more rather than less coercive. As Aarseth astutely observed, interactivity in this early criticism "is a purely ideological term, projecting an unfocused fantasy rather than a concept of any analytical substance" (51).

A corollary to the emphasis on multiple reading paths was the connection Landow and Bolter forged between deconstruction and electronic literature. In the heady days when deconstruction was seen as a bold strike against foundational premises, hypertext was positioned as the commonsense implementation of the inherent instabilities in signification exposed by deconstructive analysis. Hypertext, Bolter wrote in his seminal book *Writing Space,* takes "the sting out of deconstruction."[86] In conflating hypertext with the difficult and productive aporias of deconstructive analysis, these theorists failed to do justice either to the nuanced operations of works performed in electronic media or to the complexities of deconstructive philosophy. Nevertheless, both theorists have made important contributions, and their books remain landmarks in the field. Moreover, both have significantly revised their earlier work to take into account the rapidly changing technology and additional insights it catalyzed. In the second edition of *Writing Space,* subtitled *Computers, Hypertext, and the Remediation of Print,* Bolter incorporates insights from the important work he co-authored with Richard Grusin, *Remediation: Understanding New Media,* which posits and extensively illustrates the recursive dynamic between immediacy and hypermediation in New Media.[87] Landow similarly has twice revised his original text, considerably expanding his insights and adding new material to take account of the Web in *Hypertext 2.0: The Convergence of Contemporary Critical*

Theory and Technology and of globalization in *Hypertext 3.0: Critical Theory and New Media in an Era of Globalization.*[88]

The shortcomings of importing theoretical assumptions developed in the context of print into analyses of electronic media were vividly brought to light by Espen J. Aarseth's important book *Cybertext: Explorations of Ergodic Literature.* Rather than circumscribe electronic literature within print assumptions, Aarseth swept the board clean by positing a new category of "ergodic literature," texts in which "nontrivial effort is required to allow the reader to traverse the text" (1). Making a different analytical cut through textual groupings that included computer games, print literature, and electronic hypertexts, among others, Aarseth established a grid comprised of eight different operators, many of which have purchase mostly with electronic texts rather than print. The grid yields a total of 576 different positions on which a variety of different kinds of texts can be located.[89] Although the method has limitations, notably that it is blind to content and relatively indifferent to the specificity of media, it has the tremendous virtue of demonstrating that electronic texts cannot simply be shoved into the same tent with print without taking into account their different modes of operation. These innovations have justifiably made *Cybertext* a foundational work for the study of computer games and a seminal text for thinking about electronic literature.[90] Markku Eskelinen's work, particularly "Six Problems in Search of a Solution: The Challenge of Cybertext Theory and Ludology to Literary Theory," further challenges traditional narratology as an adequate model for understanding ergodic textuality, making clear the need to develop frameworks that can adequately take into account the expanded opportunities for textual innovations in digital media. Proposing variations on Gérard Genette's narratologi-

cal categories, Eskelinen demonstrates, through a wide variety of ingenious suggestions for narrative possibilities that differ in temporal availability, intertextuality, linking structures, and so on, how Aarseth's ergodic typology can be used to expand narratology so it would be more useful for ergodic works in general, including digital works.[91]

Similar ground clearing was undertaken by Lev Manovich in his influential *The Language of New Media*.[92] Although his emphasis is primarily on cinema rather than electronic literature, his "five principles of new media" have helped to define the distinctiveness of new media forms in contrast to print and other electronic media such as broadband television.[93] Four of the five follow in straightforward fashion, respectively, from the binary basis for digital computers (numerical representation), object-oriented programming (modularity and variability), and networked architectures with sensors and actuators (automation). The deepest and most provocative for electronic literature is the fifth principle of "transcoding," by which Manovich means the importation of ideas, artifacts, and presuppositions from the "cultural layer" to the "computer layer" (46). Although it is too simplistic to posit these "layers" as distinct phenomena (because they are in constant interaction and recursive feedback with one another), the idea of transcoding nevertheless makes the crucial point that computation has become a powerful means by which preconscious assumptions move from such traditional cultural transmission vehicles as political rhetoric, religious and other rituals, gestures and postures, literary narratives, historical accounts, and other purveyors of ideology into the material operations of computational devices. This is such an important insight that, although space does not allow me to develop it fully here, I will return to it later to indicate briefly some of the ways in which it is being explored.[94]

With these ground-clearing arguments, new opportunities became available to rethink the specificities of print and electronic literature and to explore their commonalities without collapsing one into the other. Loss Pequeño Glazier's *Digital Poetics,* cited earlier, argues that the materiality of practice is crucial both to experimental print literature and to innovative electronic work. As he and others have argued, notably Matthew Kirschenbaum, John Cayley, and Matthew Fuller, code must be considered as much a part of the "text" of electronic literature as the screenic surface. Web pages, for example, rely on HTML, XML, or similar markup languages to be properly formatted. Alexander Galloway in *Protocol* puts the case succinctly: "*Code is the only language that is executable*" (emphasis in original).[95] Unlike a print book, electronic text literally cannot be accessed without running the code. Critics and scholars of digital art and literature should therefore properly consider the source code to be part of the work, a position underscored by authors who embed in the code information or interpretive comments crucial to understanding the work.

Jerome McGann, whose work on the Rossetti Archive[96] and contributions to the Institute of Advanced Technology in the Humanities (IATH) at the University of Virginia have made him a leading figure in the field, turns this perspective on its head in *Radiant Textuality: Literature after the World Wide Web* by arguing that print texts also use markup language, for example, paragraphing, italics, indentation, line breaks, and so forth.[97] Although this point somewhat muddies the waters in that it conflates operations performed by the reader with those performed by the computer, it nevertheless establishes common ground between scholars interested in bibliographic and textual criticism of print works and those oriented to close examination of digital texts. Also contributing to building

bridges between digital protocols and close-reading practices is *The Ivanhoe Game,* a joint project of Johanna Drucker and Jerome McGann, now being developed at Speculative Computing Laboratory at the University of Virginia.[98] Part literary criticism, part creative play, and part computer game, *The Ivanhoe Game* invites participants to use textual evidence from a given literary text to imagine creative interpolations and extrapolations, facilitated through a computer interface.[99] Noah Wardrip-Fruin and David Durand follow similar lines of inquiry in *Cardplay,* a program that uses virtual playing cards to create the script of a play. Similar projects are Mark Bernstein's *Card Shark* and *Thespis,* systems to create hypertext narrative using AI techniques.[100] As with *Regime Change* and *News Reader* discussed earlier, Wardrip-Fruin and Durand call these programs "textual instruments," likening them both to computer games and musical instruments.

Complementing studies focusing on the materiality of digital media are analyses that consider the embodied cultural, social, and ideological contexts in which computation takes place. Although a full account of this body of work is beyond the scope of this discussion, a few seminal studies should be noted. Mark B. N. Hansen, focusing more on digital arts than electronic literature, makes powerful arguments for the role of the embodied perceiver as not only a necessary site for the reception of digital art work but as a crucial aspect foregrounded by works that literally do not make sense without taking embodiment into account.[101] Working the opposite side of the street, so to speak, is Friedrich A. Kittler's emphasis on the genealogy of technology as a formative force in its own right.[102] Kittler's controversial opening line in the preface to *Gramophone, Film, Typewriter,* "Media determine our situation," although not unproblematic, suggests the larger contours within which electronic literature can be seen as a

cultural force helping to shape subjectivity in an era when net-worked and programmable media are catalyzing cultural, po-litical, and economic changes with unprecedented speed[103] (the work of these two theorists is discussed in detail in chapter 3). Writing on New Media poetics, Adalaide Morris aptly dis-cusses this aspect of digital literature by commenting that it articulates for us what we already in some sense know.[104] To this I would add it creates practices that help us know more about the implications of our contemporary situation. Much as the novel both gave voice to and helped to create the liberal humanist subject in the seventeenth and eighteenth centuries, so contemporary electronic literature is both reflecting and en-acting a new kind of subjectivity characterized by distributed cognition, networked agency that includes human and non-human actors, and fluid boundaries dispersed over actual and virtual locations (a topic explored further in chapter 4).

Located within the humanities by tradition and academic practice, electronic literature also has close affinities with the digital arts, computer games, and other forms associated with networked and programmable media. It is also deeply en-twined with the powerful commercial interests of software companies, computer manufacturers, and other purveyors of apparatus associated with networked and programmable media. How and in what ways it should engage with these commercial interests is discussed in Alan Liu's magisterial work *The Laws of Cool: Knowledge Work and the Culture of Information*.[105] Liu urges a coalition between the "cool"—designers, graphic artists, programmers, and other work-ers within the knowledge industry—and the traditional hu-manities, suggesting that both camps possess assets essential to cope with the complexities of the commercial interests that currently determine many aspects of how people live their everyday lives in developed societies. Whereas the traditional

humanities specialize in articulating and preserving a deep knowledge of the past and engage in a broad spectrum of cultural analyses, the "cool" bring to the table expert knowledge about networked and programmable media and intuitive understandings of contemporary digital practices. Electronic literature, requiring diverse orientations and rewarding both contemporary and traditional perspectives, is one of the sites that can catalyze these kinds of coalitions. Realizing this broader possibility requires that we understand electronic literature not only as an artistic practice (though it is that, of course), but also as a site for negotiations between diverse constituencies and different kinds of expertise.

Among these constituencies are theorists and researchers interested in the larger effects of network culture. Of the very large number of studies that have appeared in recent years, I will mention two to illustrate the kinds of scholarship that should rightly fall within the domain of electronic literature. First is Alexander Galloway and Eugene Thacker's *The Exploit,* a work that builds on Gilles Deleuze's notion of the control society[106] and Michael Hardt and Antonio Negri's *Empire* and *Multitude*[107] to argue that the materiality, rhetorical force, and structure of the network provide the basis for new kinds of political power and oppression while also opening possibilities for new modes of theoretical analysis and political resistance.[108] Complementing their study is Rita Raley's *Tactical Media,* a brilliant analysis of a systemic shift from strategy to tactics in contemporary political resistance as enacted by a diverse group of artistic computer games, online art works, and art installations. Adrian Mackenzie's *Cutting Code: Software as Sociality* studies software as collaborative social practice and cultural process.[109] Analyzing a range of technical practices from Unix operating systems to extreme programming, *Cutting Code* explores how social forms, subjectivities, mate-

rialities, and power relations entwine in the creation, marketing, and use of software.

Mackenzie's work serves as a salutary reminder that just as one cannot understand the evolution of print literature without taking into account such phenomena as the court decisions establishing legal precedent for copyright and the booksellers and publishers who helped promulgate the ideology of the creative genius authoring the great work of literature (for their own purposes, of course), so electronic literature is evolving within complex social and economic networks that include the development of commercial software, the competing philosophy of open source freeware and shareware, the economics and geopolitical terrain of the internet and World Wide Web, and a host of other factors that directly influence how electronic literature is created and stored, sold or given away, preserved or allowed to decline into obsolescence.

PRESERVATION, ARCHIVING, AND DISSEMINATION

Over the centuries, print literature has developed mechanisms for its preservation and archiving, including libraries and librarians, conservators, and preservationists. Unfortunately, no such techniques exist for electronic literature. The situation is exacerbated by the fluid nature of digital media; whereas books printed on good quality paper can endure for centuries, electronic literature routinely becomes unplayable (and hence unreadable) after a decade or even less. The problem exists for both software and hardware. Commercial programs can become obsolete or migrate to new versions incompatible with older ones, and new operating systems (or altogether new machines) can appear on which older works will not play. With a foreshortened canon limited to a few years and without the

opportunity to build the kinds of traditions associated with print literature, electronic literature risks being doomed to the realm of ephemera, severely hampered in its development and the influence it can wield.

The Electronic Literature Organization has taken a proactive approach to this crucial problem with the Preservation, Archiving and Dissemination Initiative (PAD). Part of that initiative is realized in the *Electronic Literature Collection,* volume 1, co-edited by Nick Montfort, Scott Rettberg, Stephanie Strickland, and me, featuring sixty works of recent electronic literature and other scholarly resources. Collecting innovative, high-quality work is an important step forward in opening electronic literature up to a wider audience and moving it into the classroom. (I am frequently asked by colleagues how they can find "the good stuff" among the immense flood of works available on the Web; now there is an easy—albeit still very partial—answer to that question.) It is anticipated that the *ELC* will continue on a biennial basis, with each subsequent volume compiled by an editorial collective that will take responsibility for soliciting important works and making them available in accessible cross-platform formats.

Another part of the PAD initiative is this chapter, which appears in essay form at the ELO website. By attempting to give a recognizable shape to this fast-moving and diverse community of artists, writers, designers, programmers, and critics and to the works they create and interpret, I hope this essay will also interest specialists who may be familiar with one or more areas of electronic literature but not necessarily with the field as a whole. The essay is part of a triad of critical works commissioned by the Electronic Literature Organization as part of the PAD initiative, joining two white papers published at the ELO site, "Acid-Free Bits" by Nick Montfort and Noah Wardrip-Fruin,[110] and "Born-Again Bits" by Alan Liu, David

Durand, Nick Montfort, Merrilee Proffitt, Liam R. E. Quin, Jean-Hughes Rety, and Noah Wardrip-Fruin.[111] While this essay focuses on surveying the field (and thus on dissemination), the two white papers are centrally concerned with preserving and archiving electronic literature.

"Acid-Free Bits" offers advice to authors to help them "find ways to create long-lasting elit, ways that fit their practice and goals" (3). The recommendations include preferring open systems to closed systems, choosing community-directed systems over corporate driven systems, adhering to good programming practices by supplying comments and consolidating code, and preferring plain-text to binary formats and cross-platform options to single-system options. Since electronic literature does not have the economic clout to convince commercial developers to ensure its continuing viability on their platforms, it is simply good sense to prefer open systems to closed. Likewise, plain-text formats will remain human-readable while binary formats will not, and cross-platform options increase the availability of works to interested audiences. These commonsense recommendations make available to writers and authors issues they can consider at the beginning of projects, before substantial time and resources are invested in options that may prove damaging to long-term preservation and costly to change, once the work has been implemented.

More encompassing, and even more visionary, is the proposal in "Born-Again Bits" for the "X-Literature Initiative." The basic premise is that XML (Extensible Markup Language) will continue to be the most robust and widespread form of Web markup language into the foreseeable future. Working from this assumption, the proposal envisions a set of practices and tools that will enable older electronic literature to be migrated to XML for preservation, facilitate XML compliant authoring, ensure the inclusion of appropriate metadata to allow

works properly to be identified and archived, develop tools for the easy reading, annotating, and teaching of electronic literature, and provide authors with applications for creating electronic literature in X-Lit formats. The scope here is breathtaking, and if even a portion of the proposal can be successfully implemented, the contribution to the preservation, dissemination, and archiving of electronic literature will be immense.

The X-Literature Initiative makes startlingly clear that the formation we know as "literature" is a complex web of activities that includes much more than conventional images of writing and reading. Also involved are technologies, cultural and economic mechanisms, habits and predispositions, networks of producers and consumers, professional societies and their funding possibilities, canons and anthologies designed to promote and facilitate teaching and learning activities, and a host of other factors. All of these undergo significant transformation with the movement into digital media. Exploring and understanding the full implications of what the transition from page to screen entails must necessarily be a community effort, a momentous task that calls for enlightened thinking, visionary planning, and deep critical consideration. It is in these wide and capacious senses that electronic literature challenges us to rethink what literature, and the literary, can do and be.

CHAPTER TWO

Intermediation

From Page to Screen

Literature in the twenty-first century is computational. As noted in chapter 1, almost all print books are digital files before they become books; this is the form in which they are composed, edited, composited, and sent to the computerized machines that produce them as books. They should, then, properly be considered as electronic texts for which print is the output form. Although the print tradition of course influences how these texts are conceived and written, digitality also leaves its mark, notably in the increased visuality of such best-selling novels as Mark Danielewski's brilliant hypertext novel *House of Leaves*, Jonathan Safran Foer's *Extremely Loud and Incredibly Close*, and Salvador Plascencia's *The People of Paper*,[1] texts whose dynamics are explored in chapter 5. The computational nature of twenty-first century literature is most evident, however, in electronic literature. More than being marked by digitality, electronic literature is actively formed by it. For those of us interested in the present state of literature and where it might be going, electronic literature raises complex, diverse, and compelling issues. In what senses is electronic literature in dynamic interplay with computational media, and what are the effects

of these interactions? Do these effects differ systematically from print as a medium, and if so, in what ways? How are the user's embodied interactions brought into play when the textual performance is enacted by an intelligent machine? Addressing these and similar questions requires a theoretical framework responsive both to the print tradition from which electronic literature necessarily draws and the medial specificity of networked and programmable machines. Computation is not peripheral or incidental to electronic literature but central to its performance, play, and interpretation. Consequently, I begin by considering the cognitive capacities of computation for participating in the kind of recursive feedback loops characteristic of literary writing, reading, and interpretation.

DYNAMIC HETERARCHIES AND FLUID ANALOGIES

Many scholars in the humanities think of the digital computer as an inflexible brute force machine, useful for calculating but limited by its mechanical nature to the simplest kind of operations. This is both true and false—true in that everything computable must be reduced to binary code to be executed, but false in the belief that this inevitably limits the computer to simple mechanical tasks with no possibility for creativity, originality, or anything remotely like cognition. From the field that includes artificial intelligence, artificial life, neural connectionism, simulation science, and related computational research, I focus here on two central conceptual clusters to develop the idea of intermediation: dynamic heterarchies and fluid analogies as embodied in multiagent computer programs, and the interpretive processes that give meaning to information.

The simple computational devices called "cellular automata," as Stephen Wolfram's research demonstrates, can cre-

ate complex patterns that emerge from local interactions between individual cells (or agents).[2] The problem then becomes how to bootstrap such results into increasingly complex patterns of second-, third-, and n-level emergences. One proposal is "intermediation," a term I have adopted from Nicholas Gessler, whereby a first-level emergent pattern is captured in another medium and re-represented with the primitives of the new medium, which leads to an emergent result captured in turn by yet another medium, and so forth.[3] The result is what researchers in artificial life call a "dynamic hierarchy," a multi-tiered system in which feedback and feedforward loops tie the system together through continuing interactions circulating throughout the hierarchy. Because these interactions go up as well as down, down as well as up, such a system might more appropriately be called a "dynamic heterarchy." Distinguished by their degree of complexity, different levels continuously inform and mutually determine each other. Think, for example, of a fetus growing inside a mother's body. The mother's body is forming the fetus, but the fetus is also re-forming the mother's body; both are bound together in a dynamic heterarchy, the culmination of which is the emergent complexity of an infant.

The potential of this idea to explain multilevel complexity is the subject of Harold Morowitz's *The Emergence of Everything: How the World Became Complex.*[4] Its glitzy title notwithstanding, Morowitz's book is essentially a revisioning of well-established domains of scientific knowledge such as cosmology, the origins of life, and molecular biology into a unified scenario in which, at every level from the beginning of the universe through complex human social systems, complexity emerges through dynamic heterarchies interacting with one another. For example, atoms consist of dynamical systems in which electrons interact with the nucleus comprised of

protons and neutrons (in the simplest account) to form more or less stable units. When atoms combine to form molecules, the nature of the dynamics change, and the patterns created by the interplay of atomic forces is transformed into a different system in which the emergent results of the first system are re-represented in the different medium of molecular interactions. These are captured and re-represented in turn when molecules combine to form macromolecules such as proteins. At this point the interplay between digital and analogue processes enters in decisively important ways. DNA sequences can be understood as primarily digital systems of base pairs, represented by the discrete letters of the DNA code, ATCG. But when the sequences are folded into proteins—the process responsible for determining functionality—the analogue processes of topology become crucial as they continuously interact with the genetic sequences.

As this example suggests, digital and analogue processes together perform in more complex ways than the digital alone, for each has strengths complementary to the other. Digital processes, because they are discrete, have much finer control over error than analogue processes. By definition, analogue processes vary continuously along a spectrum; rectifying small errors is difficult because all real points along a number line can theoretically be occupied. This is the main reason why analogue computing, which flourished until the 1950s, lost out to digital computing. Nevertheless, analogue processes have strengths of their own. They excel in transferring information from one medium to another through morphological resemblance, and the complexity of continuous variation allows them to encode information in more diverse ways than digital encoding. In dynamical heterarchies, analogue and digital processes can be expected to perform synergistically with one another, as they typically do in biological processes.

Now let us make a speculative leap and consider the human and the digital computer as partners in a dynamic heterarchy bound together by intermediating dynamics. Do these components satisfy the requirements for a dynamic heterarchy? They are obviously at different levels of complexity, the human being immeasurably more complex than the computer. Just as obviously, they exist as different media, with the human a carbon-based entity with complex electrochemical and neuronal feedback loops, whereas the computer's dynamics are based on relatively simple electrosilicon circuits. Differences in complexity notwithstanding, the human and computer are increasingly bound together in complex physical, psychological, economic, and social formations.

Increasingly, the environments people create for themselves include a diverse array of intelligent machines, especially in developed countries such as the United States. As computers proliferate, they are endowed with increasingly powerful networking capabilities; they are also moving out of the box into the environment through ubiquitous computing, embedded sensors and actuators, mobile technologies, smart nanodevices embedded in a wide variety of surfactants and surfaces, real-time sensors and data flows, and a host of other developments. As a result, people in developed societies are surrounded by smart technologies of all kinds, from the online virtual world Second Life to cars that talk to intelligent toasters that decide when the bread is brown. In light of these developments, it seems reasonable to assume that citizens in technologically developed societies, and young people in particular, are literally being reengineered through their interactions with computational devices, a possibility explored in chapters 3 and 4.

Anthropologists have long recognized that humans have been biologically, psychologically, and socially shaped by their technologies at least since Paleolithic times.[5] The new wrinkle

is the power of computers to perform cognitively sophisticated acts. Compared, say, to a hammer or stone ax, a computer has much more flexibility, interactivity, and cognitive power. In addition, computers are able to handle both natural language and programming code, capabilities that allow them to function in complex human–computer networks. Humans are routinely considered to be distinguished from other species by their intelligence and particularly by their ability to use language, making it possible for them to develop complex social formations. Computers are crucial components of those structures, from international banking protocols to air traffic control to twelve-year-olds IMing their friends. In developed societies, it is not merely speaking metaphorically to say that (some) humans and computers are bound together in dynamic heterarchies characterized by intermediating dynamics. Humans engineer computers and computers reengineer humans in systems bound together by recursive feedback and feedforward loops, with emergent complexities catalyzed by leaps between different media substrates and levels of complexity.

What evidence is there that computers can function as cognizers, that is, as agents capable of intentionality, the "aboutness" that makes a subject (or an agent) capable of referring to something outside of itself? In view of John Searle's Chinese room analogy, we may also add the requirement that in some way the computer must *understand* what it is about in order to be considered a cognizer in the strong sense.[6] Here I turn to the research of Douglas Hofstadter, who in collaboration with several generations of graduate students has devoted himself to investigating this issue.

In *Fluid Concepts and Creative Analogies: Computer Models of the Fundamental Mechanisms of Thought*, Hofstadter details this research.[7] His mantra, "Cognition is recognition," nicely summarizes his conclusion that cognition is

built on the ability to recognize patterns and extrapolate from them to analogies (pattern *A* is like pattern *B*). Once analogies can be formed, the process can theoretically be extended to analogies between analogies (between analogies . . .), a progression capable of leapfrogging between levels in recursive cycles of increasing complexity. The first necessarily modest step is to create a computer program capable of recognizing a pattern. Hofstadter's test case was inspired by the "Jumble" puzzle that appears in many newspapers, in which the reader is challenged to unscramble a sequence of letters to form a recognizable word. The idea is to construct the program (dubbed "Jumbo") using a wide variety of "codelets," small programs that function as independent agents performing specific tasks. The result from the interactions of all the agents is the successful construction of a word.

The codelets function by randomly putting together pairs of letters or larger strings in a process that includes parameters indicating how strong are the letters' affinities for each other and how "sticky" that string is, that is, how much those particular letters want other letters to join them. Another feature of the program is the "coderack" (an allusion to the coat rack in a check room), a sequencer that determines which codelet runs next. As a codelet moves from random assemblage into strings where the bonds between letters are strong, its urgency rating increases so that it will be run more frequently. Hence, the closer it comes to assembling a recognizable word, the greater the likelihood it will be allocated processor time by the coderack to finish the task. Although the programs necessarily run sequentially, this mode of sequencing simulates multiagent parallel processing, because all programs are given some opportunity to run, albeit in an evolutionary environment where fitness is defined in terms of creating recognizable words. This programming structure creates a milieu in which the program

can "understand" the words it assembles—that is, understand not semantically but philologically and linguistically in terms of grapheme and syllable formation.

Another program (Copycat) seeks to complete an analogy by performing a transformation like a given transformation of a sequence of letters (or numbers)—for example, abc => abd is "like" wxy => ? The answer would be immediately obvious to a human (wxy => wxz), but the point is to use local interactions between diverse agents to arrive at an analogy that reveals the deep structure of the situation. In the example above, the deep structure is the linear sequence of the alphabet. A more challenging analogy is this comparison: abc => abd is "like" xyz => yz? Faced with the challenge, the program evolved through local interactions three emergent results. The first, xyz => xy, implies that the alphabet is a line segment with nothing beyond its terminus. The second, xyz => xyzz, suggests a deep structure in which the line segment may be extended by repeating elements. The most elegant solution, xyz => xya, implies that the alphabet is circular, with the end cycling back to the beginning.

Despite the apparent simplicity of the challenges, the payoff is that the programs accomplish their tasks not by applying a rigid set of rules, but rather through fluid exchanges between many codelets that progress from random forays in the possibility space to increasingly "informed" guesses about possible answers. Because the dynamics are emergent and interactive, the programs create the computational equivalent of "understanding" the problem, unlike programs that merely encourage the illusion of comprehension while understanding nothing (which Hofstadter calls the "Eliza effect," after Joseph Weizenbaum's well-known program that mimics Rogerian psychoanalysis).[8] Hofstadter's inspiration for his research came from introspection about his own techniques for solving

similar problems. Following subtle clues and momentary glimpses into his perceptions as they surfaced into consciousness, he became convinced that his cognition emerged not from rigid rules but flexible analogies that could branch in several different directions; hence his name for the method he instantiated in the programs, "fluid concepts" and "creative analogies." As we will see, this work is particularly appropriate for thinking about intermediation between humans and computers as a framework for understanding electronic literature. The programs that perform electronic literature are generally quite different from those created by Hofstadter and his collaborators, but Hofstadter's programs nevertheless nicely capture their spirit. Because literature is not limited to factual recreation but rather works through metaphor, evocation, and analogy, it specializes in the qualities that programs like Jumbo and Copycat are designed to perform.

In the context of electronic literature, intermediation has two distinct ways in which it might be understood: as a literal description of the dynamics of human–computer interaction or as a metaphor for such interactions. Hofstadter's programs add the possibility of recursive loops between these binaries, loops that entangle the literal with the metaphoric, so that the binaries operate as a spectrum of possibilities rather than as polar opposites with an excluded middle. As subcognitive systems, Hofstadter's programs provide the matrix from which higher cognitions can emerge. For example, while they have no capacity for semantic recognition, the humans interpreting their results might see interesting patterns in, say, the set of recognizable words generated from a given anagram. The more complex cognitive system, the human who gains insights from the program's results, might complete the loop by tweaking the program. In this case, the programs function as components in an adaptive system bound together with humans

through intermediating dynamics, the results of which are emergent realizations. The programs can also operate as metaphors for other computational systems less intelligent that similarly spark insights in the humans who use them. Framed like this, the literal/metaphoric binary becomes a spectrum along which a variety of programs can be placed, depending on their cognitive capacities and the ways in which the patterns they generate and/or recognize are structurally coupled with humans.

The idea of considering meaning making as a spectrum of possibilities with recursive loops entangling different positions along the spectrum has been catalyzed by Edward Fredkin's recent proposal that *"the meaning of information is given by the process that interprets it"* (my emphasis),[9] for example, an MP3 player that interprets a digital file to produce audible sound. The elegance of the concept is that it applies equally well to human and nonhuman cognizers. Although Fredkin himself did not develop the idea beyond this bare-bones formulation, the concept can be generalized by envisioning the processes of interpretation as taking place within dynamic heterarchies that cycle between human and nonhuman cognizers. To continue the MP3 example, we may suppose that the sound reaches the ear of a human who hears and appreciates it as a meaningful composition, perhaps Beethoven's Fifth Symphony. Underlying the conscious attribution of meaning are many interrelated processes of interpretation, from the modulations produced by sound waves acting on the ear drum, to the excitation of neuronal groups in the brain, to narrations of consciousness as the symphony proceeds. At every level, the interpretations of one process feed into and prepare for the interpretations of the next.

From this relatively simple proposition, a host of important implications emerge. "Aboutness" is now transformed

Intermediation

from an absolute condition to a cascading series of recognitions, from the subcognitive processes of the MP3 player to sophisticated musical appreciation. In each case, however rudimentary the level at which the interpretations emerge, the processes refer to something beyond themselves in arriving at their interpretations. For the MP3 player, "aboutness" has to do with the relation it constructs between the digital file and the production of sound waves. For the music sophisticate, "aboutness" may include a detailed knowledge of Beethoven's work, the context in which it was written and performed, historical changes in orchestral instrumentation, and so on.

Without knowing Fredkin's formulation, Daniel Dennett arrives at a similar vision in *Kinds of Minds,* where he proposes that it makes sense to talk of a cell (or even DNA) having a mind because these subsystems provide the ground from which the more complex operations of high-level cognition such as consciousness emerge.[10] Again working along parallel lines to Fredkin, Dennett in *Darwin's Dangerous Idea: Evolution and the Meanings of Life* takes on rival philosophers' objections that the kind of "aboutness" that machines or subcognitive processes can achieve is derivative of original (that is, human) conscious intentionality and so not "real" intentionality at all.[11] In a series of delightful thought experiments, Dennett refutes these objections by demonstrating that in a certain sense human intentionality too is an artifact that must ultimately have emerged from the subcognitive processes responsible for the evolution of humans as a species. He concludes, "[Y]our selfish genes can be seen as the original *source* of your intentionality—and hence of every meaning you can ever contemplate or conjure up—even though you can then transcend your genes, using your experience, and in particular the culture you imbibe, to build an almost entirely independent (or 'transcendent') locus of meaning on the base your genes

have provided" (426). Dennett explicitly makes evolution part of his argument and, by association, the non- and subcognitive processes that preceded conscious thought: "I, as a person, consider myself to be a source of meaning, an arbiter of what matters and why, [notwithstanding] the fact that at the same time I am a member of the species *Homo sapiens*, a product of several billion years of nonmiraculous R and D, enjoying no feature that didn't spring from the same set of processes one way or another" (426). Fredkin's formulation enhances the generality of Dennett's conclusions so that the same kind of reasoning can be applied to nonhuman cognizers, an implication Dennett embraces in his thought experiments that move between mechanical and human cognition.

Fredkin's concept also can potentially heal the breach between meaning and information that was inscribed into information theory when Claude Shannon defined information as a probability function.[12] To justify his formulation, Shannon stressed that his definition of information had nothing to do with meaning in the ordinary sense, an idea reinforced by Warren Weaver in his influential introduction to Shannon's theory.[13] The divorce between information and meaning was necessary, in Shannon's view, because he saw no way to reliably quantify information as long as it remained context dependent, because its quantification would change every time it was introduced into a new context, a situation calculated to drive electrical engineers mad. Nevertheless, the probability functions in Shannon's formulations necessarily implied processes that were context dependent in a certain sense—specifically, the context of assessing them in relation to all possible messages that could be sent by those message elements. The difficulty was that there seemed to be no way to connect this relatively humble sense of context to the multilayered, multifaceted contexts ordinarily associated with high-level

meanings (for example, interpretations of Beethoven's Fifth). Fredkin's formulation overcomes this difficulty by defining meaning through the processes that interpret information, all the way from binary code to high-level thinking.

This idea also makes it possible to see how Donald MacKay's version of information theory, which connected the meaning of information to changes it brought about in culturally and historically specific embodied receivers, can be reconciled both to Shannon's version of information theory and to the subcognitive processes of intelligent machines.[14] MacKay focused on the context of reception, thus foregrounding the role of embodiment in strong contrast to Shannon's abstraction. Because MacKay's theory envisions an immeasurably richer context for reception, it can seem incompatible with Shannon's version of information, a conclusion emphasized by Mark B. N. Hansen in his discussion of MacKay's and Shannon's theories.[15] The difference diminishes, however, when both theories are seen to rely on processes that interpret information in cascading fashion, a conjunction implicit in MacKay's insistence that the meaning of a message "can be fully represented only in terms of the full basic-symbol complex defined by all the elementary responses evoked. These may include visceral responses and hormonal secretions and what have you" (*Information, Mechanism, Meaning,* 42). Putting Shannon's mechanistic model together with MacKay's embodied model makes sense when we see higher-order meanings emerging from recursive lower level subcognitive processes, as MacKay emphasizes when he highlights "visceral responses and hormonal secretions and what have you." Like humans, intelligent machines also have multiple layers of processes, from ones and zeros to sophisticated acts of reasoning and inference.

Bernadette Wegenstein, in a different context, points to this kind of convergence when she argues that "the medium that

signifies the body, its *representation*, no longer is any different from the 'raw material' of the body itself. Without mediation the body is nothing. However, mediation already is what the body always was, in its various historical and cultural strata."[16] Mediation in this sense includes the body's perceptual processes, the subcognitive processes that build on and interpret these processes, and the fully conscious processes that interpret them in turn. In the digital age, these internal processes are intimately and complexly connected with intelligent machines, which have their own internal cascading processes of interpreting information and hence of giving it meaning. Through intermediating dynamics, a richer picture emerges of multiple points of connection at many different levels between and among these two different kinds of cognizers.

In electronic literature, this dynamic is evoked when the text performs actions that bind together author and program, player and computer, into a complex system characterized by intermediating dynamics. The computer's performance builds high-level responses out of low-level processes that interpret binary code. These performances elicit emergent complexity in the player, whose cognitions likewise build up from low-level processes interpreting sensory and perceptual input to high-level thoughts that possess much more powerful and flexible cognitive powers than the computer does, but that nevertheless are bound together with the computer's subcognitive processes through intermediating dynamics. The cycle operates as well in the writing phase of electronic literature. When a programmer/writer creates an executable file, the process re-engineers the writer's perceptual and cognitive system as she works with the medium's possibilities. Alternating between writing modules and testing them to ensure they run correctly, the programmer experiences creation as an active dynamic in which the computer plays a central role. The result is a meta-

analogy: as human cognition is to the creation and consumption of the work, so computer cognition is to its execution and performance. The meta-analogy makes clear that the experience of electronic literature can be understood in terms of intermediating dynamics linking human understanding with computer (sub)cognition through the cascading processes of interpretation that give meaning to information.

Crucial to the formation of this analogy is the sense that the human is interacting not exclusively with a rigid rule set (although for most of the programs currently used to create electronic literature, such rule sets exist in abundance), but rather with a fluid mix of different possibilities. For the player, the sense might come from a program designed to encourage this orientation by having parameters vary continuously to produce unexpected results. For the programmer, the fluidity might arise from unexpected effects that are possible when different functionalities within the software are activated simultaneously. However the effects are achieved, the importance of fluidity to the analogy-forming process is evident in the richly diverse senses in which flow has become central to narrative thematics, design functionalities, and literary dynamics for contemporary electronic literature.

At this point it may be instructive to compare the processes described above with what happens when a person writes and/or reads a book. The book is like a computer program in that it is a technology designed to change the perceptual and cognitive states of a reader. The difference comes in the degree to which the two technologies can be perceived as cognitive agents. A book functions as a receptacle for the cognitions of the writer that are stored until activated by a reader, at which point a complex transmission process takes place between writer and reader, mediated by the specificities of the book as a material medium. Authors have occasionally attributed agen-

tial powers to the book (in Borges's fantastical "Book of Sand," for example, the letters shift into new positions every time the book is closed);[17] in actual books, of course, the letters never shift once ink has been durably impressed on paper. But in many electronic texts, words and images do shift, for example through randomizing algorithms or programs that tap into real-time data flows to create an infinite number of possible recombinations.[18] "Recombinant flux," as the aesthetic of such works is called, gives a much stronger impression of agency than does a book. Displays of the computer's agency are common in electronic literature, including animated Flash poems that play by themselves with little or no intervention by the user, generative art such as Loss Pequeño Glazier's poems that disrupt the narrative poetic line every few seconds, and interactive fictions such as Emily Short's *Galatea,* a sophisticated program that produces different responses from the Galatea character depending on the precise dynamics of the player character's actions.[19] Because the computer's real agency as well as the illusion of its agency are much stronger than with the book, the computer can function as a partner in creating intermediating dynamics in ways that a book cannot.

When literature leaps from one medium to another—from orality to writing, from manuscript codex to printed book, from mechanically generated print to electronic textuality—it does not leave behind the accumulated knowledge embedded in genres, poetic conventions, narrative structures, figurative tropes, and so forth. Rather, this knowledge is carried forward into the new medium typically by trying to replicate the earlier medium's effects within the new medium's specificities. Thus written manuscripts were first conceived as a visual continuity of connected marks reminiscent of the continuous analogue flow of speech; only gradually were such innovations as spacing between words and indentations for paragraphs intro-

duced. A similar pattern of initial replication and subsequent transformation can be seen with electronic literature. At first it strongly resembled print and only gradually began to develop characteristics specific to the digital medium, emphasizing effects that could not be achieved in print. Nevertheless, the accumulated knowledge of previous literary experiments has not been lost but continues to inform performances in the new medium. For two thousand years or more, literature has explored the nature of consciousness, perception, and emergent complexity, and it would be surprising indeed if it did not have significant insights to contribute to ongoing explorations of dynamic heterarchies.

I propose to put the idea of intermediation in conversation with contemporary works of electronic literature to reveal, in a systematic and disciplined way, how they achieve their effects and how these effects imply the existence of entangled dynamic heterarchies binding together humans and intelligent machines. In *My Mother Was a Computer: Digital Subjects and Literary Texts*, I explored intermediation by taking three different analytical cuts, focusing on the dynamics between print and electronic textuality, code and language, and analogue and digital processes.[20] Because such wide-ranging analyses are beyond the scope of this chapter, I limit my examples here to the interplay between print and electronic textuality, with the understanding that the other dynamics, although not foregrounded in this discussion, also participate in these processes.

FROM PAGE TO SCREEN: MICHAEL JOYCE'S *AFTERNOON: A STORY* AND *TWELVE BLUE*

When electronic literature was in its infancy, the most obvious way to think about screens was to imagine them as pages of a

book one turned by clicking, something that was visually explicit in the short-lived Voyager experiments with electronic books. Nothing comes of nothing, as King Lear observes, and electronic literature was not born *ex nihilo*. Especially in the first generation of electronic literature the influence of print was everywhere apparent, much in the way the first automobiles were conceived as horseless carriages. In retrospect, early claims for electronic hypertext's novelty seem not only inflated but misguided, for the features that then seemed so new and different—primarily the hyperlink and "interactivity"—existed in a context in which functionality, navigation, and design were still largely determined by print models. As the field began to develop and mature, however, writers, artists, designers, sound artists, and others experimented to find out what the medium was good for and how best to exploit it.

That evolution is richly evident in the contrast between Michael Joyce's seminal first-generation hypertext *afternoon: a story*[21] and his later Web work *Twelve Blue*.[22] Both are authored using Storyspace (Eastgate System's proprietary hypertext authoring program), but the ways in which the medium is conceptualized are startlingly different. In the few years separating these two works we can see a steep learning curve in process, a curve that reflects one writer's growing realization of the technology's resources as a literary medium. *afternoon* has received many excellent interpretations, so its effects can be briefly summarized.[23] It works through a branching structure in which the reader is offered alternative plot developments depending on which sequences of lexias she chooses to follow. In different plot lines Peter, the protagonist, discovers either that his son died that day or did not die. The ambiguity is not so much resolved as illuminated when the reader comes upon "white afternoon," a crucial lexia surrounded by a "guard field," a program conditional that prevents a reader

begin

I try to recall winter. < As if it were yesterday? > she says, but I do not signify one way or another.

By five the sun sets and the afternoon melt freezes again across the blacktop into crystal octopi and palms of ice-- rivers and continents beset by fear, and we walk out to the car, the snow moaning beneath our boots and the oaks exploding in series along the fenceline on the horizon, the shrapnel settling like relics, the echoing thundering off far ice. This was the essence of wood, these fragments say. And this darkness is air.

< Poetry > she says, without emotion, one way or another.

Do you want to hear about it?

Figure 1. Screen shot, *afternoon*

from accessing it until certain other lexias have been opened. In "white afternoon" the reader discovers that Peter may have been the driver of the car that collided with the vehicle in which his son and ex-wife were riding, with the possible result that he himself caused the fatal injury to his son. This discovery explains the approach-avoidance pattern Peter displays in attempting to find out where his son is; he does not want to face what in some sense he already knows. As Jane Yellowlees Douglas explains in her fine reading of the work, once the reader reaches this lexia she is apt to feel that she has in some sense "completed" the work, even if all the lexias have not been discovered and read. The work is thus driven by a mystery that, once solved, gives the reader the satisfaction

normally attained through a conventional Aristotelian plot structure of rising complication, climax, and denouement.

The technique of conflicting plot lines is of course not original with Michael Joyce. Some two decades earlier, Robert Coover experimented with similar techniques in short stories such as "The Elevator" and "The Babysitter," print fictions that, like *afternoon,* are broken into brief segments relating mutually contradictory details.[24] These stories are often identified as precursors to electronic hypertexts, for like *afternoon* they employ branching structures that create irreconcilable ambiguities centering on violent events. In some ways Coover's stories are more daring than *afternoon,* for they contain no kernel that invites the reader to reconcile the contradictions through a psychological interpretation. Comparing the two works reveals how printcentric *afternoon* is, notwithstanding its implementation in an electronic medium. It uses screens of text with minimal graphics, no animation, no sound, no color, and no outside links (which were only possible in the wake of the World Wide Web). Navigation proceeds by using the Storyspace navigational tool showing what links are available from each lexia, or by clicking on "words that yield" within each lexia. The linking patterns create short narrative sequences, also identifiable through the navigation tool that allows the reader to follow a given narrative sequence through the similarity of the lexias' titles. The writer's control over these sequences is palpable, for several of them do not allow any exit (short of closing the program) until the reader has clicked through the entire sequence, creating an oppressive sense of being required to jump through the same series of hoops numerous times. Although the reader can choose what lexias to follow, this interaction is so circumscribed that most readers will not have the sense of being able to play the work—

hence my repeated use here of the term "reader" rather than "player."[25]

In *Twelve Blue*, by contrast, playing is one of the central metaphors. Significantly, it is not conceived as a work driven by the reader's desire to solve a central mystery. There is no mystery here, or more precisely, there are mysteries but not ones that can be solved in any conventional sense, for they open onto unanswerable questions about life and death ("Why do we think the story is a mystery at heart?" the lexia entitled "riddle" asks, following that with "Why do we think the heart is a mystery?").[26] Other central images, playing on the etymology of "text" as "weaving," are threads that come together to form patterns and then unravel to come together in different ways to create new patterns. "Twelve Blue isn't anything," Joyce writes in his introduction. "Think of lilacs when they're gone." Compared with *afternoon, Twelve Blue* is a much more processual work. Its central inspiration is not the page but rather the flow of surfing the Web. The work is designed to encourage the player to experience it as a continuous stream of images, characters, and events that seep or surge into one another, like tides flowing in and out of an estuarial river. In this sense, although it has no external links, *Twelve Blue* is Web conceived as well as Web born.

Two seminal intertextual works illuminate the difference between *afternoon* and *Twelve Blue. Twelve Blue*'s epigraph, taken from William H. Gass's *On Being Blue: A Philosophical Inquiry,*[27] signals that the strategy will be to follow trails of associations, as Gass says, "the way lint collects. The mind does that" (7). Every screen contains at least one instance of the word "blue," in a range that parallels Gass's own capacious repertoire. The second, less explicit, intertext is Vannevar Bush's seminal essay "As We May Think,"[28] in which he

argues that the mind thinks not in linear sequences but in associational links, a cognitive mode he sought to instantiate in his mechanical Memex, often regarded as a precursor to electronic hypertext. In *Twelve Blue,* Joyce takes Bush up on his speculation by creating a work that, much more than *afternoon,* instantiates associational thinking and evokes it for the player, who must in a certain sense *yield* to this cognitive mode to understand the work (to say nothing of enjoying it). The player who comes to *Twelve Blue* with expectations formed by print will inevitably find it frustrating and enigmatic, perhaps so much so that she will give up before fully experiencing the work. It is no accident that compared to *afternoon, Twelve Blue* has received far fewer good interpretations and, if I may say so, less comprehension even among people otherwise familiar with electronic literature. Like sensual lovemaking, the richness of *Twelve Blue* takes time to develop and cannot be rushed.

Let us begin, then, with a leisurely embrace that wants to learn everything it can about this textual body, with an intention to savor rather than attack or master it.[29] The surface that first presents itself already invites us to play, for it consists of twelve colored threads in different hues, predominantly clustered at the blue end of the spectrum, against a deep blue background. The threads, which are interactive and change orientation according to how they are played, are divided into eight "bars," suggesting the measures of a musical score. By playing this score we are also weaving the threads into patterns, a metaphor not so much mixed as synesthetic, for sight is in-mixed with sound, texture with vision. As we open the screens by clicking on the threads or choosing to play one of the bars, the mix we have chosen is imaged on screen left, representing the orientation the threads have in that bar. The URL, shown at screen bottom, indicates the bar and thread re-

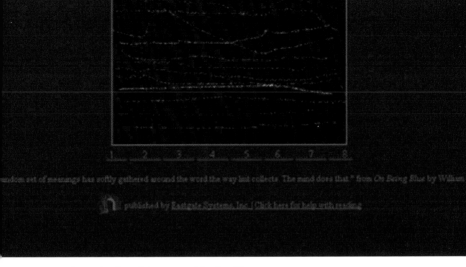

random set of meanings has softly gathered around the word the way lint collects. The mind does that." from *On Being Blue* by William

published by Eastgate Systems, Inc. | Click here for help with reading

Figure 2. Opening screen, *Twelve Blue*

ch river flows two ways for at least an instant, whether a gasp at the source, the spring half lapsing before going on, or a watery wavering at the certain edge which joins her to river or the sea. Nonetheless the long sigh of the estuary is something different, the Hudson easing swollen and rumbent upward halfway to Albany, plumping in her banks like the black flesh of an oyster, pregnant with pearl sheen even when no stone forms.

hen you make a slide, for an instant as you capture the smear before staining it you can see life itself in macrocosm in the microbe swirl. A dinner couldn't need science. She could look along this shore of the body's river and see lifeforms: virus, pearl, cancer, fetus, yeast spore.

e violet stain it like no color in nature. Alizah. Kak. Queen.

stead she gazes on the samples with a neutral eye, labours and detached as a river in December. In the microscope there is no difference between e birth of an infant savior or the death of a crone at year's end. Life is a river that flows both ways, it doesn't do to get caught up in the threads the ter weaves. So the men taught who tutored her in these alchemies. Even so she sees dreams in algae, lotus blossoms in saline solution, a sister in e oyster.

Figure 3. Screen shot, *Twelve Blue*

spectively of that sequence (for example, 4_10). Repeated exploration could theoretically locate each sequence within a two-dimensional grid indicating its position in time (the bar number) and space (the thread number).

Entering the flow of the screen narratives, one cannot help noticing how difficult it is to identify the characters. Pronouns abound while proper nouns appear sparsely, teasing the player with ambiguities and arousing the desire to probe further into the work, to anchor the actions to terra firma. Gradually, as the player enters the flow and lets it enter her, she comes to recognize patterns and sees them emerge into recognizable shapes. Think of staring at a random dot image; if one strains one only delays the emergence of the pattern, but if one relaxes and lets it take over, the subconscious puts together the information and suddenly the patterns leap out.

So now with *Twelve Blue*. Javier, the cardiovascular surgeon, was married to Aurelie, but they were "unmarried" ("Blue mountain," 2_5) when she chose to "run off" ("Run off," 3_8) with her daughter Beth's swim coach, a woman named Lisa, who "didn't do mother" ("Fierce eyes and a mother's fears," 7_8). Nevertheless, Aurelie cannot help associating Beth and Lisa, these apparent antinomies flowing together in her thoughts. Divorced from Aurelie, Javier has fallen in love with Lisle, a Canadian virologist who also has a teen-aged daughter, Samantha. Lisle and Samantha live by Wappinger Creek. When a deaf boy drowns in the creek while his girlfriend, who cannot sign, sits helplessly by on a creekside log, Samantha is the one to find his body as it floats down to her and Lisle's house.

This is the picture that emerges, but as with a random-dot image, the picture itself is unremarkable. The interest is rather on the picture's emergence, the mysterious subconscious and unconscious processes that, out of a chaos of seemingly

random information, mysteriously assemble a coherent whole. Central to these processes is the flow of images, like streams coming together, joining, separating. Images caress one another by fleetingly touching, sometimes through the juxtapositions created by links, sometimes by sparking a momentary conflagration in a player's receptive mind. An example or two will illustrate the process (although, since the flows are continuous, one or two has a way of modulating into eight or twelve).

One of Lisle's memories from her childhood is of Delores Peters, whose father on impulse bought a carnival ride in which blue cars, like "stubby little shoes" whirl around ("white moths," 4_10). He sets it up in his farmyard and his wife invites her daughter's girlfriends over to play on it. The mother tries to make the occasion festive by baking a cake and bringing out a jug of lemonade, which she sets in a tub of ice. As day fades into evening, the ice melts and white moths settle on the dark liquid, some to struggle and escape, others to die ("white moths," 8_10). The farmyard whirly flows into Lisle's memory of the carnival ride on which she whizzes with her carny boyfriend, after which they have furious sex ("Alpine," 5_9); the blue cars flow into the blue leather Mary Janes that she wore as a child, which she remembers carrying her to the parochial school where she was embarrassed to tell the Sister she had her period ("Long time after one," 2_10). Menstrual blood links this memory to her daughter's poetic image of the damp creekside soil smelling like blood, which she narrates to Lisle in a story that has a boy named "Henry Stone" coming to her ("waters of resurrection," 6_6). This pattern flows into the deaf boy's girlfriend, who refuses to join him in the water on the day he drowns because she is having her period. Samantha sees the moon whitely reflected on the dark creek water and imagines it is like a photograph ("Li Po," 6_12); she is

startled when the deaf boy's body surfaces in the middle of this image, in a pattern that recalls the white moths struggling on the dark water. Another lexia entitled "white moths" has Lisle explicitly making the connection to the boy's death, thinking "the world was a drum of dark water where we sometimes caught our wings like moths" ("white moths," 7_10).

Like Hofstadter's codelets that have varying degrees of affinities for different letters, the images are constructed to "stick" preferentially to other image sequences to form larger patterns such as the one discussed above. Metapatterns emerge through the process of forming analogies between analogies. For example, the associations comprising the Lisle/Samantha group are linked with another group centering on Eleanore and Ed Stanko, connected to Lisle/Samantha through the over-lapping character of Javier. Long ago Javier met a woman named Elli in the Blue Ridge Mountains of Virginia and had an affair with her; the woman is (perhaps) Eleanore, who now lives in a seedy hotel-turned-apartment-building owned by Ed Stanko, an unremittingly mean and hard man. Eleanore has but a shaky grasp on reality (not to put too fine a point on it, she is nutso) and, having long ago lost a baby girl who may (perhaps) be Javier's illegitimate child, somehow blames Ed Stanko for her loss. Luring him into her apartment with the offer of a quickie, she knifes him in the gut while he is in the bathtub, which she afterwards cleans, along with herself, in a strange ritual involving flowers and skins of blood oranges.

The moon-reflection-as-photograph image from the Lisle/Samantha group connects with the photograph of Javier's great-grandmother Mary Reilly that he discovers in the lobby of Ed Stanko's ex-hotel, the only image of her known to exist. Through pure meanness Ed Stanko denies even a copy of the image to Javier, who therefore undertakes a pilgrimage with his daughter Beth back to the hotel so she can see it. When

they arrive, Eleanore (who on Javier's previous stop at the hotel had hitched a ride with him to Roanoke, perhaps to buy the blood oranges she uses in her cleansing ritual) tells him that Ed Stanko is "indisposed," a pattern that flows into the body of the deaf boy, who like Stanko dies in water. The silence in which the deaf boy had lived in turn flows into Eleanore's silence when she is told (presumably by the police) that she has the right to remain silent.

Such play as this has no necessary end, especially when the player accepts the flow as fulfilling desire rather than insisting on the sharper, more focused, but also briefer satisfaction of a climax, no sooner reached than replaced by the legendary sadness of the denouement. Here the pleasure is more diffuse but also longer lasting, ending only when the player closes the work, knowing that if she were to linger, still more flows could be discovered, more desires evoked and teasingly satisfied. As Anthony Enns points out in his reading of *Twelve Blue*, this work challenges Frank Kermode's criterion for "the sense of an ending" that helps us make sense of the world by establishing a correlation between the finitude of human life and the progression through a beginning, middle, and end characteristic of many print narratives.[30] Here there is no inevitable progress toward the death of the plot. Does that mean *Twelve Blue* fails in the archetypal narrative purpose of establishing a correlation between its sequentiality and human mortality? I would argue rather that *Twelve Blue* makes a different kind of sense, one in which life and death exist on a continuum with flowing and indeterminate boundaries.

In a lexia representing in free indirect discourse the thoughts of Ed Stanko, the narrator links him with the deaf boy, a character already dead by drowning while the other is soon to meet his death in a bathtub. "No consciousness in the grub or maggot, none in the fallen bird, the grain of wood, the

drowned boy. And yet for all of your life you have wondered, redeeming that word: a wonder Do we live beyond our breath?" ("Wonders never cease," 5_11). The deaf boy becomes a metaphor for the divine in a linked pair of lexias connecting the "minor character" of his girlfriend (whose name we never learn, she being minor in our story, though undoubtedly major in her own) with another young woman marked for life by the drowning of her mother: "Consider the mind of god a drowning boy" ("naiad," 2_11). Deconstructing the boundary between the mindlessness of inanimate objects, the once-mindfulness of the newly dead, and the infinite mind of God, the analogy-between-analogies that emerges from these flows suggests there are no sharp distinctions among the noncognitive, the subcognitive, and the fully cognitive.

In one of the few perceptive interpretations of *Twelve Blue*, Gregory Ulmer relates it to the shift from a novel-based aesthetic to a poetics akin to the lyric poem.[31] He also relates it to a change from literacy to "electracy," arguing that its logic has more in common with the ways in which image and text come together on the Web than to the linearity of alphabetic language bound in a print book. The graphic qualities of the work indeed play a larger role in *Twelve Blue* than in *afternoon*, from the sensuous deep blue background to the interactive threads with their changing spatial orientations. Undoubtedly Ulmer is correct; the publication of *Twelve Blue*, Joyce's first work available on the Web, took place at a time when the Web was explosively evolving from curiosity to daily necessity. The leap from *afternoon* to *Twelve Blue* demonstrates the ways in which the experience of the Web, joining with the subcognitive ground of intelligent machines, provides the inspiration for the intermediating dynamics through which this literary work creates emergent complexity.

Intermediation

MARIA MENCIA: TRANSFORMING THE RELATION
BETWEEN SOUND AND MARK

In Maria Mencia's work, the emphasis shifts from the in-mixing of human and machine cognition to reconfigurations possible with digital technologies of the traditional association of the sound with the mark. It was, of course, this association that inaugurated literacy and, in the modern period, became deeply identified with print technology. In "Methodology," Mencia comments that she is particularly interested in the "exploration of visuality, orality and the semantic/'non semantic' meaning of language."[32] On the strength of her graduate work in English philology, she is well positioned to explore what happens when the phone and phoneme are detached from their customary locations within morphemes and begin to circulate through digital media into other configurations, other ways of mobilizing conjunctions of marks and sounds. Digitality assists in the process by providing functionalities that unsettle the established conventions of print and enable new conjunctions. With traditional print literature, long habituation causes visuality (perception of the mark) to flow automatically into subvocalization (inaudible sound production), producing the recognition of words (cognitive decoding) that in turn is converted by the "mind's eye" into the reader's impression that the words on the page give way to a scene she can watch as the characters speak, act, and interact.

Worthy Mouths demonstrates how Mencia's reconfigurations trouble this process.[33] The video shows a mouth articulating words, but no sound emerges; rather, text phrases flash at a pace too rapid to allow them to be read completely, although not so fast that portions cannot be deciphered (one such phrase, for example, is "lips pushed outwards closed"). By the time the phrase is decoded, the mouth is already form-

ing other words, no sooner pursued than they too are dislocated from the mouth's movements. The effect is both to mobilize the viewer's desire to connect mark with sound and discombobulate it, forcing a disconnect that unhinges our usual assumptions about the connection between sound and mark. In *Audible Writing Experiments*,[34] video projections covered the gallery's four walls, so that the spectator was surrounded by writing and immersed in a soundscape in which a voice articulated English phonemes. The writing quickly became illegible as it proceeded down the space, transforming into wavy lines that forsook their graphemic vocation and instead began to resemble the threads of a woven fabric. Mencia notes that the illegible writing was "quite textural," a phrase that recalls the etymology of "text" as "knitting" or "weaving." Although the connection between text and vocalization remained intact, the visual perception of the mark registered its gradual divorce from phonetic equivalent into purely visual form.

In Mencia's *Things come and go . . .*,[35] digital projection showed an animated calligramme composed of pieces of paper inscribed with letters moving through the sky, initially legible as a poem about the ongoingness of things as they come into being, change, and go, a process humans resist as they attempt to hold onto them. As the calligramme shifted and reformed into new shapes, the initially coherent phrases of the poem were broken and reconfigured while a computerized voice articulated the changing configurations. In her documentation of the work, Mencia comments that "the spectator can either love or hate" this voice, or accept it as it moves "from one state to another."[36] We may wonder if her comment about hating the voice reflects feedback from spectators who found the work frustrating because they yearned for the durably inscribed marks of print that have the decency not to mutate while one is reading them.

Intermediation

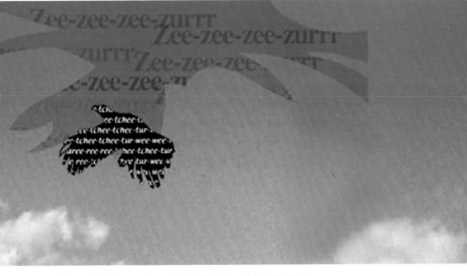

Figure 4. Screen shot, *Birds Singing Other Birds' Songs*

In *Birds Singing Other Birds' Songs*,[37] a work shown as a video installation and now available as a Flash version on the Web, birds' sounds were transcribed into morphemes representing human perception of their songs and represented as the corresponding graphemes. These graphemes were then animated to form the bodies of birds flying with human voices, tweaked by the computer, articulating the sounds denoted by the marks. In the complex processes of translation that the work instantiates, the human is in-mixed with nonhuman life forms to create hybrid entities that represent the conjunction of human and nonhuman ways of knowing.[38] The work can also be understood as a reenactment of the history of literacy through different media as it moves from sounds present in the environment to written marks (orality/writing), written marks to the iconographic shapes of the animated avian bodies (writing/digital images), accompanied by the re-representation of

human speech as computerized voice production (digital multimodality).

The ways in which Mencia's works go in search of meaning create analogies between human and nonhuman cognizers on the one hand, and on the other, analogies between different media transformations. The analogy-between-analogies suggests that media transformations are like the dynamic interchanges between different kinds of cognizers, thus revealing a deep structure of intermediation that encompasses the history of media forms as well as the emergent complexities of interactions between humans, animals, and networked and programmable machines. Although Mencia's works can be classified as electronic literature, they are fundamentally about literacy rather than any given literary form, illustrating the interrogations that the literary can undertake of the histories, contexts, and productions of literature. Reenacting media transformations and the conditions that make literacy possible, Mencia's works are appropriate complements to the comparison between the print-inflected aesthetic of *afternoon* and the "electracy" of *Twelve Blue*.

RUPTURING THE PAGE: *THE JEW'S DAUGHTER*

Judd Morrissey's *The Jew's Daughter,* like the works discussed above, both references the print page and profoundly alters its dynamics.[39] In an interview with Matthew Mirapaul, Morrissey stated that because *The Jew's Daughter* "takes the paradigm of the page, you can see that it's not a page."[40] The entire work exists as a single screen of text. Reinforcing the page metaphor is a small box at the upper right corner, which when clicked indicates the current screen's number and provides as well a box in which the player can type to indicate what

Will she disappear? That day has passed like any other. I said to
you, "Be careful. Today is a strange day" and that was the end of
it. I had written impassioned letters that expressed the urgency of
my situation. I wrote to you that that it would not be forgivable,
that it would be a violation of our exchange, in fact, a criminal
negligence were I to fail to come through. To hand to you the
consecrated sum of your gifts, the secret you imparted persistently
and without knowledge, these expressions of your will that lured,
and, in a cumulative fashion, became a message. In any case, the
way things worked. Incorrigible. Stops and starts, overburdened
nerves, cowardice (Is this what they said?), inadequacy, and, as a
last resort, an inexplicable refusal. You asked could I build you
from a pile of anonymous limbs and parts. I rarely slept and
repeatedly during the night, when the moon was in my window, I
had a vision of dirt and rocks being poured over my chest by the
silver spade of a shovel. And then I would wake up with
everything. It was all there like icons contained in a sphere and
beginning to fuse together. When I tried to look at it, my eyes
burned until I could almost see it in the room like a spectral yellow
fire.

A street, a house, a room.

close

Figure 5. Screen shot, *The Jew's Daughter*

screenic text (as indicated by "page" number) should come up
next. Within the screen text, a few letters (from part of a word
to a sentence or two) appear in blue, seeming to reference the
clickable links pervasive on the Web. The blue letters are
not links in the conventional sense, however, but rather screen
locations of mouseovers. When the player mouses over the
blue letters, some part of the text, moving faster than the eye
can catch, is replaced. Reading thus necessarily proceeds as

rereading and remembering, for to locate the new portion of the page the reader must recall the screen's previous instantiation while scanning to identify the new portion, the injection of which creates a new context for the remaining text.

For example, the beginning screen narrative is focalized through the young male writer and student whose voice is the predominant, though not the only, narrator for the text:

> I wrote to you that it would not be forgivable, that it would be a violation of our exchange, in fact, a criminal negligence were I to fail to come through. To hand to you the consecrated sum of your gifts, the secret you imparted persistently and without knowledge, these expressions of your will that lured, and, in a cumulative fashion, became a message. In any case, the way things worked. Stops and starts, overburdened nerves, cowardice (Is this what they said?), inadequacy, and as a last resort, an inexplicable refusal. You asked could I build you from a pile of anonymous limbs and parts. I rarely slept and repeatedly during the night, when the moon was in my window, I had a vision of dirt and rocks being poured over my chest by the silver spade of a shovel. And then I would wake up with everything. It was all there like icons contained in a sphere and beginning to fuse together. When I tried to look at it, my eyes burned until I could almost see it in the room like a spectral yellow fire.
>
> A street, a house, a room. (*The Jew's Daughter,* 1)

Mousing over "criminal," the word in blue, changes the text to this:

> To hand to you the consecrated sum of your gifts, the secret you imparted persistently. June through clouds

like sculpted snow demons. My fortune had said, you are about to cross the great waters. But how, now, to begin? After stops and starts, overburdened nerves, cowardice, inadequacy, inexplicable refusal, after everything, she is still here, dreaming just outside the door, her affirmed flesh beached in bed as the windows begin to turn blue. And what can now be said about this sleeping remainder? Her face is a pale round moon. She had a vision of dirt and rocks being poured over my chest by the silver shape of a shovel. (*The Jew's Daughter,* 2)

While in the first screen the "I" who has a "vision of dirt and rocks" is the male writer, in the new context the pronoun shifts to "she," his lover and girlfriend who is sometimes called Eva. The shifting antecedents are embedded within intertextual allusions that recall Shelley Jackson's *Patchwork Girl,* in which the female creature from Mary Shelley's *Frankenstein* is reassembled to become the principal narrator. Also evoked is the original *Frankenstein,* with its portrayal of graveyard robbing to obtain body parts. The play here between the male and female characters sets up an ambiguity similar to that instantiated in *Patchwork Girl,* where the female creature displaces the male scientist as the focalizer. Resonating through the passage is the "spectral yellow moon," an image that recalls the "dull yellow eye" of the male creature that Victor sees open in *Frankenstein* (chap. 5), a detail Jackson repeats in *Patchwork Girl.* In the second screen, however, the "pale round moon" of her sleeping face becomes a second source of light competing with the "spectral yellow fire" representing the emergent realization the male writer can almost, but not quite, achieve. This gesture toward some looming synthesis, evoked only to be postponed, is the work's

central dynamic, instantiated both in its thematics and functionalities. As each screen modulates into the next, the pattern of overlapping repetition and innovation propels the text forward through a series of disjunctions and connections, as if it were perpetually in process, driving us toward a synthesis inevitably delayed as the text transforms once again.

In the interview with Matthew Mirapual, Morrissey commented that in conceptualizing *The Jew's Daughter,* "I wanted a fluidity that I haven't seen in hypertext." The fluidity is indeed there, but so are ruptures and discontinuities created by disjunctive syntax and wrenched contexts. The effect is significantly different from the "stream of consciousness" associated with modernist texts, including the work alluded to by Morrissey's title, James Joyce's *Ulysses.*[41] In episode 17 ("Ithaca") of *Ulysses,* the anti-Semitic ballad "The Jew's Daughter" is inscribed during the course of a conversation Bloom and Stephen have in the kitchen after Bloom has invited Stephen home. Unlike the shifting pronouns and sliding antecedents of Morrissey's work, episode 17 takes the form, unique in *Ulysses,* of an ultrarational catechism in which an interlocutor asks questions and another voice answers using the "objective" language of the "view from nowhere."[42] To visualize the scene, readers are forced to translate from the style's pretentious objectivism back into the language of everyday perceptions. Whereas *The Jew's Daughter* has an excess of "stickiness" that facilitates ambiguities and multiple syntactic combinations, the *Ulysses* episode performs the opposite extreme, articulating facts with a pseudoprecision associated with the scientistic goal of eliminating ambiguity altogether.

The "stickiness" of phrases that can ambiguously attach to different sentences and phrases also enacts a difference between modernist stream of consciousness and the kind of awareness represented in *The Jew's Daughter.* As Molly Bloom's final

passage illustrates, stream of consciousness narration usually proceeds as a continuous flow of ideas, images, and language. In *The Jew's Daughter,* by contrast, narration is both belated and premature, early and late. Consider the following sequence. "Words are always only words, but these waiting words pause, are cautious, self-aware; know that what is said determines what is has been and will be, what has already not yet happened, what losses are taken and who gets what" (7). This morphs to "Words are always only real-time creation, realized under the pressure of days, just as this once should have been realized under the pressure of days. Incipit. Three knocks" (8), which morphs to "The fog-breath of the carriage horse on Michigan Avenue would rise impenetrably to obscure the city. Real-time creation, realized under the pressure of days, just as it once should have been realized under the pressure of days. Incipit. Three knocks" (9). "Real-time creation" makes sense in the context of the fog-breath rising, but in the earlier context of *words* as "real-time creation" makes less sense, especially when one thinks of words as inscriptions that linger. Similarly, the comparison "just as *this* once should have been realized under the pressure of days" can be taken to refer to the present text's composition, but when transposed into the next screen's context, results in a puzzling repetition as the relative pronoun mutates to the third-person singular pronoun: "Real-time creation, realized under the pressure of days, just as it once should have been realized under the pressure of days." As the phrase "what has already not yet happened" suggests, temporality has become fractally complex, no longer a uniform progression but a complex formation in which different strata overlap, diverge, and move with different tempos. This temporal complexity is reflected at the narrative level by the disjunctions, sometimes slight and other times more radical, that signal breaks in the text where a passage has inserted

itself before its proper context or lingered after its conjoining phrases have mutated into something else. Taken as a representation of consciousness, the kind of awareness performed here is not a continuous coherent stream but rather multilayered shifting strata dynamically in motion relative to one another.

This kind of interaction is very similar to the "Multiple Drafts Model" that Daniel C. Dennett, in *Consciousness Explained,* argues best explains the nature of consciousness.[43] Dennett proposes that consciousness is not the manifestation of a single coherent self synthesizing different inputs (characterized as the "Cartesian Theater," the stage on which representations are played out and viewed by a central self); rather, interacting brain processes, operating with varying temporal dynamics and different neural/perceptional inputs, *are* consciousness. In Dennett's model, time is represented by and instantiated in distributed brain processes and neural locations; as a result, perceived time is emergent rather than given, constantly modulating according to which processes and locations are dominant at a given instant. To explain the subjective impression of possessing a central self, Dennett argues that the self is not synonymous with consciousness as such. Rather, the *illusion* of self is created through an internal monologue that does not so much issue from a central self as give the impression a central self exists. This narrative, the emergent result from different processes interacting, sutures together discontinuities in time, location, differential inputs, and diverse perceptions to create a single stream of storytelling that tries to make sense and create coherence.

Seen in this perspective, *The Jew's Daughter* recapitulates the temporal and spatial discontinuities constitutive of consciousness through the (inter)mediation of computer software and hardware. The computer, programmed by the writer and

designer, reveals to the human player the mechanisms whereby her interior monologue is (mis)taken as the production of a coherent self. The visual interface presenting itself as a print page can then be understood as a simulacrum in multiple senses. Possessing a fluidity and mutability that ink durably impressed on paper can never achieve, it simulates the illusion of a coherent stream of consciousness narrative (and by implication, a coherent self producing the narrative) while also making visible on the screenic surface the temporal discontinuities, spatial dislocations, and narrative ruptures that subvert the premises underlying traditional ideas about consciousness, thereby pointing toward another model of consciousness altogether. Consciousness in this view is disjunctive, emergent, dynamic, and temporally stratified, created through local interactions between diverse agents/processes that together create the illusion of a continuous coherent self.

That the computer is intimately involved in the performance of this simulation is not coincidental, for as we have seen, similar cascading subcognitive processes take place within it, a mechanism that remains innocent of the experience of consciousness. Without knowing anything about *The Jew's Daughter,* Dennett sets up the comparison between human and machine cognition by likening the subcognitive agents from which consciousness emerges, and the even simpler processes that underlie them, to mechanical programs that could theoretically be duplicated in a computer.[44] This move enables us to give an account of *The Jew's Daughter* in terms that combine the computer's operation with the human player's cognitions. In the intermediating cycle as it occurs in *The Jew's Daughter,* mechanical processes perform a simulacrum of a narrative traditionally understood as the production of consciousness, thereby stimulating in the player subcognitive processes that dynamically produce consciousness as

the emergent result, which in turn results in the player's mouseovers that, processed by the computer, perform the ruptures and discontinuities gesturing toward the emergent nature of the narrative and the consciousness with which it is associated, both within the diegesis and within the player herself.

The Error Engine, a collaborative work co-authored by Judd Morrissey, Lori Talley, and computer scientist Lutz Hamel, carries the implications of *The Jew's Daughter* to another level by functioning as an adaptive narrative engine that initiates a coevolutionary dynamic between writer, machine, and player. In "Automatic Narrative Evolution: A White Paper," Hamel, Morrissey, and Talley explain how the program works.[45] Each narrative node—that is, each textual passage—is assigned a list of keywords that may or may not appear explicitly but in any event reflect the node's thematics. In response to the player's selection of a given word in the screen text, the engine searches for the node whose keyword list most closely matches that choice and presents it as the next screen of text. The algorithm differs from a traditional link coded in html as <href> in that the link is not hard wired but rather chosen from a pool of possible candidates. In the next instantiation of the program, not yet implemented, the authors envision an algorithm whose selection criteria can itself evolve in relation to the player's choices. Such a program would deserve to be called a "genetic algorithm," a complex adaptive system in which the user's choices and the algorithm responding to those choices coevolve together. Whether the present implementation is truly evolutionary may be debated, but clearly the authors envision evolutionary computing as the appropriate context in which to understand their work.[46] In this sense intermediating dynamics, whereby recursive feedback loops operate through the differently embodied entities of the computer and human, become an explicit part of the work's

Intermediation

design, performance, and interpretation. Adaptive coevolution implies that real biological changes take place in the player's neuronal structure that result in emergent complexity, expressed as a growing understanding of the work's dynamics, thematics, and functional capabilities; these in turn change and evolve in interaction with the player's choices.

At this point readers who grew up with print and remain immersed in print aesthetics may object that this is merely a fancy way to say what literary criticism has said for a very long time—that literature functions as a technology designed to change the cognitions of readers. Certainly print literature changes a reader's perceptions, but the loop is not closed because the words on the page do not literally change in response to the user's perceptions. The new component possible with networked and programmable media is the cycle's completion, so that the feedback loops run in both directions—from the computer to the player and from the player to the computer. To fully take this reflexivity into account requires understanding the computer's cascading interpretive processes and procedures, its possibilities, limitations, and functionalities as a subcognitive agent, as well as its operations within networked and programmable media considered as distributed cognitive systems. The danger in applying critical models developed for print is that the new possibilities opened for literary creation and interpretation will simply not be seen. Whatever limitations intermediation as a theory may have, its virtue as a critical framework is that it introduces computation into the picture at a fundamental level, making it not an optional add-on but a foundational premise from which to launch further interrogation.[47]

The implications of intermediation for contemporary literature are not limited to works of electronic literature but extend to contemporary print literature and indeed to literary

criticism as a whole. They include the in-mixing of human and machine cognition; the reimagining of the literary work as an instrument to be played, where the textual dynamics guide the player to increased interpretive and functional skills; deconstruction of the relation between sound and mark and its rearticulation within environments in which language and code are in active interplay; the rupture of narrative and the consequent reimagining and representation of consciousness not as a continuous stream but as the emergent result of local interactions between cascading neural processes and subcognitive agents, both biological and mechanical; the deconstruction of temporality and its reconstruction as an emergent phenomena arising from multiagent interactions; and the performance of an adaptive coevolution cycling between humans and intelligent machines envisioned as cognizers embodied in different media at different levels of complexity.

The urgent challenge digital textuality presents for criticism is to reenvision and rearticulate legacy concepts in terms appropriate to the dynamics of networked and programmable media.[48] No less than print literature, literary criticism is affected because digital media are increasingly essential to it, limited not just to word processing but also to how critics now access legacy works through digital archives, electronic editions, hypermedia reinstantiations, and so forth. Critical production is affected as online journals such as *Vectors* offer publishing venues for the development and dissemination of multimedia criticism—that is, criticism that is not just about multimedia works but that uses the capabilities and functionalities of multimedia as essential components of interpretation and analysis.[49] The validation and review procedures of print criticism are also under revision, for example in the project sponsored by the Institute for the Future of the Book to reimagine how publication protocols should change for digital

media.[50] These developments imply that critics, no less than writers, are increasingly involved with computation-intensive environments. Given as a truism that the technology one uses affects not only *how* work is produced but *what* is produced, the critical self-reflection that linked, for example, grammatological theory with changed modes of writing and thinking should result in further transformations that link computational theory with new ways of critical thinking, writing, and creating.

Literature, conceptualized not just as print books but as the entire complex system of literary production—including writers, editors, publishers, critics, designers, programmers, booksellers, readers, players, teachers, copyright laws and other legal formations, websites and other electronic dissemination mechanisms, and the technologies that enable and instantiate all of the above—is permeated at every level by computation. The bellelettristic tradition that has on occasion envisioned computers as the soulless other to the humanistic expressivity of literature could not be more mistaken. Contemporary literature, and even more so the literary that extends and enfolds it, *is* computational.

Contexts for Electronic Literature

The Body and the Machine

The context of networked and programmable media from which electronic literature springs is part of a rapidly developing mediascape transforming how citizens of developed countries do business, conduct their social lives, communicate with each other, and perhaps most significantly, how they construct themselves as contemporary subjects. Extending the argument of chapter 2 about intermediation, this chapter asks how the embodied subject and the computational machine can be thought together. Linking subjectivity with computational media is a highly contested project in which the struggle for dominance plays a central role: should the body be subjected to the machine, or the machine to the body? The stakes are nothing less than whether the embodied human becomes the center for humanistic inquiry within which digital media can be understood, or whether media provide the context and ground for configuring and disciplining the body.

For literary studies, the latter position translates into a paradigm in which the print tradition of literature, evolved when the writing system was distinctively different than today's digital convergence, is relegated to an epistemic epoch with which contemporary culture has decisively broken. We are the

side of technical media, while the bulk of the literary tradition is on the other side of a continental divide where storage, transmission, and dissemination were undifferentiated functions secured by the ancient "monopoly of writing."[1] Literature in this model can register the effects of media but is helpless to interrogate, understand, or interpret it, for in this view media provide the presuppositions that make literary articulations possible.

By contrast, choosing the side of the body reduces technical innovations to their phenomenal effects without adequate consideration of the ways in which media develop along trajectories determined by the specificities of prior technologies, the development of new materials, and innovations based on these materials. I argue that both the body and machine orientations work through strategic erasures. A fuller understanding of our contemporary situation requires the articulation of a third position focusing on the dynamics entwining body and machine together. Taken as a context for electronic literature, this perspective allows continuities to be thought between the print tradition and digital texts. It also positions electronic literature as part of a contemporary mediascape with significant implications for embodied practice and subjectivity. Most importantly, it empowers electronic literature so that it not only reflects but *reflects upon* the media from which it springs. This reflexive feedback loop, whereby electronic literature registers media effects and also interrogates the media producing these effects, is central to electronic literature's potential to transform literary practices.

THE EPOCH OF TECHNICAL MEDIA

No theorist has done more to advance the idea of technical media as an autonomous force determining subjectivity than

Friedrich A. Kittler, whose brilliant if idiosyncratic analyses in such works as *Discourse Networks 1800/1900*; *Gramophone, Film, Typewriter*; and *Literature, Media, Information Systems* have set forth a wide-ranging framework within which media transformations can be understood.[2] Influenced by Foucault rhetorically as well as methodologically, Kittler departs from him in focusing not on discourse networks understood as written documents, but rather on the modes of technology essential to their production, storage, and transmission. Prior to 1900, the hegemonic mode of inscription was writing, either through printed books or hand inscription. As long as "the book was responsible for all serial data flows," Kittler writes in "Gramophone, Film, Typewriter," "words trembled with sensuality and memory. All the passion of reading consisted of hallucinating a meaning between letters and lines: the visible or audible world of romantic poetry" (*LMIS*, 40).

Among the arts, literature is privileged because it registers media's effects both psychologically and heuristically. But media strike the drumbeat; literature marches to the tune. Literature acts on the body but only within the horizon of the medium's technical capabilities. Especially important in this regard, Kittler argues, was the development of the phonetic method of reading, introduced in Germany by Heinrich Stephanie around 1800. The phonetic method transformed the mark into sound, erasing the materiality of the grapheme and substituting instead a subvocalized voice. The voice, moreover, was one the reader had already heard, a variant of the sounds emanating from the mother's mouth in the almost-but-not-quite-forgotten mists of childhood. This orality, associated with an eroticized relation to the mother, was transferred to Mother Nature, for whom only the (male) poet could speak.

After 1900, media differentiated data streams into distinct technologies: acoustic (phonograph), visual or optical (film),

writing or textual. Kittler writes in *Gramophone, Film, Type-writer*:

> Once the technological differentiation of optics, acoustics, and writing exploded Gutenberg's writing monopoly around 1880, the fabrication of so-called Man became possible. His essence escapes into apparatuses. Machines take over functions of the central nervous system, and no longer, as in times past, merely those of muscles. . . . The physiology of eyes, ears, and brains have to become objects of scientific research. For mechanized writing to be optimized, one can no longer dream of writing as the expression of individuals or the trace of bodies. The very forms, differences, and frequencies of its letters have to be reduced to formulas. So-called Man is split up into physiology and information technology. (intro., *GFT,* 16)

With the formation of a new kind of subject, the voice of Mother/Nature ceases to spring forth from the page in a kind of hallucination. The typewriter, and mechanical inscription in general, "does not obey any voice and therefore forbids the leap to the signified," Kittler writes in *Discourse Networks 1800/1900.* "Understanding and interpretation are helpless before an unconscious writing that, rather than presenting the subject with something to be deciphered, makes the subject what it is" (*DN,* 196). This proposition marks a clear division between Kittler and Marshall McLuhan. Drawing on McLuhan's ideas, especially the notion that the content of media is other media, Kittler goes his own way in proposing that "it remains an impossibility to understand media, in spite of the title of McLuhan's book *Understanding Media,* because—quite

conversely—the communications technologies of the day exercise remote control over all understanding and evoke its illusion" (intro., *LMIS*, 30).

In his excellent foreword to *Discourse Networks 1800/1900*, David E. Wellbery calls this the "presupposition of exteriority" (*DN*, xii). It is the forcing move that encapsulates literature, the body, and indeed social life in general within the circumference of the media episteme. Wellbery suggests that Anglo-American criticism has never fully come to grips with poststructuralism, arguing that Kittler's work shows what a truly poststructuralist criticism would be. Why has Anglo-American criticism refused to bite the bullet? In Wellbery's view, it is because we are too fond of "business as usual," that is to say, the hermeneutic enterprise of interpretation and understanding, which we persist in performing even though Kittler's work has presumably shown that whatever conclusions can be drawn from it are already predetermined by prevailing media conditions. I argue there is another explanation for this failure of Anglo-American criticism to convert itself wholesale into Kittlerian media analysis—namely, that the crucial move of making social formations interior to media conditions is deeply flawed. Wellbery chooses his terminology well when he calls the forcing move a "presupposition," which by definition comes before analysis and is taken as a priori for the argumentation that follows. Although Kittler's presupposition is fruitful as a theoretical provocation, leading to the innovative analyses that make his work exciting, it cannot triumph as a theoretical imperative because it depends on a partial and incomplete account of how media technologies interact with social and cultural dynamics.

One indication of this partiality is the inability of Kittlerian media theory to explain how media change comes

about (as has often been noted, this is also a weakness of Foucault's theory of epistemes). In a perceptive article, Geoffrey Winthrop-Young[3] argues that in Kittler's analyses, war performs as the driving force for media transformation; this explains why war so often occupies center stage in Kittler's work, as in his witty aphorism that the entertainment industry constitutes "an abuse of army equipment" (*GFT,* 111). Consider the following passage from Kittler's "Typewriter" in *Gramophone, Film, Typewriter:*

> In order to supersede world history (made from classified intelligence reports and literary processing protocols), the media system proceeded in three phases. Phase 1, beginning with the American Civil War, developed storage technologies for acoustics, optics, and script: film, gramophone, and the man-machine system, typewriter. Phase 2, beginning with the First World War, developed for each storage content appropriate electric transmission technologies: radio, television, and their secret counterparts. Phase 3, since the Second World War, has transferred the schematic of a typewriter to a technology of predictability per se; Turing's mathematical definition of computability in 1936 gave future computers their name. (*GFT,* 243)

Locating the impetus for media transformation in war only postpones the problem, however, for the question immediately arises: what drives war? As Winthrop-Young notes, to this challenge Kittlerian analyses cannot respond with any of the usual suspects that generations of historians have identified as driving forces—economic contestation, fight for territory,

individual pathology, conflicting ideologies, and so on—because all of these are supposedly also circumscribed by media conditions. Although Winthrop-Young offers several ingenious alternatives, clearly the real problem is that media alone cannot possibly account for all the complex factors that go into creating national military conflicts. What is true for war is true for any dynamic evolution of complex social systems; media transformations alone are not sufficient.

To demonstrate the point, I turn in the next section to a case study in which media conditions are shown in active interplay with cultural dynamics, with neither predominant and both involved in recursive feedback loops with one another. To be fair to the Kittlerian viewpoint, I have chosen a site where media conditions are unusually strong in determining the interactions that take place within it—namely, the elite world of global finance. The media conditions that prevail here are characteristic of the contemporary period, in that the differentiation between data streams marking early twentieth century media transformations have undergone integration (or de-differentiation, an ungainly word that nevertheless usefully reminds us the present integration must be seen in the context of the earlier differentiation that prepared the ground for the later developments.) Contemporary de-differentiation crucially depends on digital media's ability to represent all kinds of data—text, images, sound, video—with the binary symbolization of "one" and "zero." With the advent of the internet, standardization of protocols has also allowed the rapid and virtually seamless integration of data flows from computers all over the world. These developments set the stage for the emergence of international finance as it is presently practiced. Let us turn now to consider the challenges this site poses to Kittlerian media theory.

MEDIA CONDITIONS FOR GLOBAL FINANCE:
WHY MEDIA THEORY IS NOT SUFFICIENT

Among important recent work on global finance are the ethnographic studies of international currency traders by Karin Knorr Cetina and Urs Bruegger.[4] Exchange traders typically work for large international banks with offices in the central financial capitals, including London, Zurich, New York, Tokyo, and Singapore. As marketmakers, they deal with first-tier institutional buyers and sellers involving large amounts of currency exchanges, amounting to $1.5 trillion annually. The traders act as facilitators to ensure liquidity, for example in international mergers that call, say, for dollars to be exchanged for euros. They receive a base salary from the bank but also get bonuses based on the amount of money they make for the bank; in addition, they trade on their own behalf as well. They have no role in production at all. Their income, and the profit they generate for the bank, come solely from price differentials among currency equivalents and from the different rates at which currencies can be bought and sold. Trades involving several million dollars are routinely executed in 2–4 seconds using protocols that recognize that a delay of even a few seconds can make the difference between profit and loss. In brief, this is money at its most virtual, moving around the globe in nearly instantaneous electronic exchanges and reflecting rate fluctuations sensitively dependent on a wide variety of fast-changing economic, social, and political factors.

As the technology has moved from teletypes and telephones to screens displaying real-time data from all over the world, geographical diversity is integrated with temporal simultaneity. As a result, Knorr Cetina and Bruegger propose the theoretical concept of global microsociality ("Global Microstructures," 909). For sociologists, this comes close to

being an oxymoron. Microsocial dynamics customarily apply to local situations such as the dynamics of a given office and are treated with nonstatistical models such as rational actor theory, while macrosocial situations involving hundreds or thousands of agents are typically treated aggregatively, for example with statistically weighted surveys. Global microsociality represents a new kind of phenomenon possible only with advanced communication technologies allowing for nearly instantaneous exchanges between geographically distant locations; compared to the telephone and teletype, the quantitative differences are so great as to amount to qualitative change. While the bank's business and offices are global in scope, the traders are tightly connected to each other and their clients through relationships that develop over time and involve reciprocity and trust, qualities not adequately accounted for by graph and network theory. Inflected by the dynamics of global economies, the traders nevertheless operate within microsocial dynamics—hence the necessity for global microsociality.

The conditions under which the traders work include numerous screens they watch intensely throughout the day, the inner circle displaying economic data and current rates, with the outer circle keyed into feeds such as CNN that deliver breaking news about economic, social, and political events. Recapitulating within their sensoria the media differentiation into separate data flows, the traders develop a form of parallel processing through a division of sensory inputs, using phones to take orders from brokers through the audio channel and the screens to take in visual data and conduct trades electronically. The environment, however, is dominated by the screens.

Although the spatial locations of events reflected on the screens are important, the effect that dominates is watching time unfold. In Knorr Cetina and Bruegger's analogy, the screens create a temporal horizon that unfurls like a carpet

unrolling, except that the carpet's design is not determined in advance but is continuously woven and rewoven from temporally driven events as these come into view, converge and/or diverge, and fade into the past ("Inhabiting Technology," 398). As new events appear over the ever-transforming horizon, the traders use their knowledge of past configurations, present statistics, and anticipated tendencies to weave a fabric of temporality, which like the fabled magic carpet is perceived at once as a space one can occupy and as an event as ephemeral and ever-changing as the air currents on which the magic carpet rides.

What does it mean to say that temporality becomes a place to inhabit? As distinct from spatiality, temporality in everyday life is usually envisioned as a unidirectional flow progressing through a single dimension. H. G. Wells to the contrary, one cannot turn around in time and go the opposite direction; time is a one-way street where the traffic rules are rigorously enforced by the same physics police that lay down the laws of nature. In contrast, spatiality allows motion backward and forward, up and down. The ability to move in space allows the construction of an interior and exterior, a home and an outside, a place to stand and other places to journey toward.

Temporality partakes of these characteristics because the screens function as temporalized "places" traders occupy; time in these circumstances becomes the spatialized parameter in which communities are built and carry out their business. As Knorr Cetina and Brueggers explain, some exchanges such as options cannot normally be concluded in a single day. At the end of their working hours, traders pass their books to their counterparts in the next time zone, so that the books follow the sun around the globe, creating "communities of time" wherein time differentials are crucial to the binding effect ("Global Microstructures," 928). From a practical view-

point, the time the books journey toward lies in the past of the time zone they leave and the future of the time zone they enter. Time thus ceases to be constructed as a universal "now" conceived as a point source moving unambiguously forward along a line at a uniform pace. Driven by globalized business pressures, time leaves the line and smears into a plane.

Moreover, because the "communities of time" are bound together precisely by the temporal disparities of the different zones in which they operate, local time correlates with spatiality and becomes a relative quantity specified by geographical coordinates. Universal time, by contrast, is identified with standardized Greenwich Mean Time, always displayed on the screens and referenced in trading communications to avoid confusion. Greenwich time thus operates as the conventional one-way time that always moves in one direction, whereas local time becomes incorporated into a spatialized fabric that can be traversed in different directions as circumstances dictate.

In this spatialized temporality, the traders occupy an ambiguous position. On the one hand, they are participants in the place of temporality they create by watching the screens, helping in significant ways to shape the market and related events as they continuously unfold and affect one another (Clark, Thrift, and Tickell have written about the interrelations of the market and media, whereby the market not only becomes a media event but a medium in itself, interacting with all the other media events and media).[5] In this sense the traders' actions are mirrored inside the screens, constantly visible to themselves and others. On the other hand, they are also observers outside the screens, watching the action as it unfolds. Screens in various locations all show more or less the same data, so that the traders, by watching the screens, are in effect not only watching their own actions but also the actions of

others reacting to their actions as well as their responses to these actions, and so on, in a continuing weave of action, response, counter-response, and so forth, all proceeding at frenetic velocities and near-light-speed transmissions. The net result of these interactions is perceived by the traders as "the market." When asked what the market is, one respondent said it is "'who's selling, who's buying, where, which center, what central banks are doing . . . what the press is saying . . . what the Malaysian prime minister is saying. It's everything—everything all the time'" ("Object of Attachment," 146). Note that although location enters into the trader's sense of the market, it is the temporal dimension—everything *all the time*—that constitutes the place of habitation the market creates and the traders occupy.

This sense of the market as "everything" is reinforced by the traders' experience in being so intimately and tightly connected with the screens that they can sense the "mind" of the market. One trader remarked that the market is "a lifeform that has being in its own right . . . it has form and meaning," adding that he sees it "as a greater being" ("Object of Attachment," 150). This intuition is highly sensitive to temporal fluctuations and, when lost, can be regained only through months of immersion in current conditions. Attributing a "mind" to the market of course implies it is an entity possessing consciousness, desires, and intentions; more precisely, it is a megaentity whose existence is inherently emergent. Containing the traders' actions with everything else, it comes into existence as the dynamic realization of innumerable local interactions. As an emergent phenomenon, the market in Knorr Cetina and Bruegger's formulation is "an unfolding structure that is non-identical with itself" ("Object of Attachment," 142), amplifying to a global scale the continuous flux amid patterned continuities characteristic of living beings.

This is the context in which the screens become objects of intense attachment for the traders. The trading environment, combining continual risk taking with real financial consequences, often proves irresistibly seductive as well as emotionally draining. For many traders the experience becomes all consuming, occupying their dreams as well as most of their waking hours. Their involvement extends beyond cerebral to affective and bodily engagements; traders recognize that managing their emotions is a crucial job skill, without which a novice will not last ("Inhabiting Technology," 400). Moreover, they enter the trading world by taking a "position"—that is, buying or selling currencies—so that their entry into the place of temporality is synonymous with exposure and risk, which they often describe as physical and sexual vulnerabilities, vividly imaged as violent penetrations of the body's interior spaces ("Inhabiting Technology," 400). Despite the stress, the attachment to the screens is so intense it becomes addictive. When traders leave the game, some purchase handheld Reuters' screens so they can continue to experience the market-making atmosphere, even if tenuously from the periphery.

So far the case study has functioned as an object lesson demonstrating Kittler's dictum, "Media determine our situation." At this point, however, let us turn to consider how cultural dynamics interact with the media conditions to codetermine their specificities. Knorr Cetina and Brueggers mention parenthetically that almost all of the traders are male ("Global Microstructures," 919). This gender predominance, far from accidental, is deeply imbricated into the ways in which the media dynamics play out. One learns to become a trader, Knorr Cetina and Brueggers explain, not by going to school or reading books but by watching other traders through an apprenticeship system ("Object of Attachment," 152).

Moreover, the traders themselves are controlled and surveilled by the chief trader, who constantly monitors their activities. This tightly disciplined and hierarchical mode of interaction means that cultural norms are enforced more strictly than in most civilian settings and are unusually sensitive to the tone set by the chief trader and the "star" trader who sits by his side, that is, the trader whose sales outrank everyone else's. One chief trader, remarking on this aspect of the culture, observed that if a star trader "behaves like a pig you can be sure that within two months everyone behaves like a pig" ("Object of Attachment," 152).

In this setting, gendered cultural practices proliferate more uniformly and extensively than normally would be the case. The metaphors through which the traders describe their activities are not just masculinized but hypermasculinized, taking to extreme the stereotypically masculine qualities of aggression, confrontation with an enemy, and the drive to succeed at any cost. The goal is not to maintain one's position or to survive but to win, often expressed in highly physical terms ("Inhabiting Technology," 397). Traders see themselves as engaged in combat, if not outright war, with rival banks and other traders. War and the heightening of masculine qualities associated with it provide a model, a mode of being in the world, that allows the traders to cope with the high stress, meteoric pace, and necessity for instantaneous decisionmaking. Moreover, the warfare metaphor provides an appropriate correlative to the ways in which the media situation acts on the bodies of the traders, including the demand for high levels of alertness for extended periods of time, frequent adrenaline surges, and intense attention to multiple factors undergoing rapid change. Warfare here does not function to bring about media transformations, as it often does in Kittler's analyses; rather, warfare is encapsulated within the horizon codeter-

mined by media conditions and cultural formations. It is appropriated in part because it expresses—indeed, explains and justifies—the intensified desires and fears aroused by the traders' situation. Like making war, trading is a young man's game; the oldest trader the researchers report was thirty-three years old ("Global Microstructures," 919).

One can imagine other ways of being and other metaphors that might have coevolved with the media conditions of contemporary global finance that would give it a very different tone. For example, rather than war the dominant metaphor might have been cooperation between partners (such metaphors do appear in the traders' communications with their regular trading partners but remain a minor thread within the overall culture). As another example, why not explain these conditions through the cultural model of, say, tending a two-year-old, which also involves high levels of alertness, frequent adrenaline surges, and intense attention to fast-changing factors? One need only advance such a proposal to see how voraciously gender stereotypes reproduce themselves within this hierarchically controlled culture. The nuances of nurturing, selflessness, and caring for someone much smaller and weaker than oneself invoke an emotional calculus entirely at odds with the capitalist premises within which trading operates. The media conditions alone, then, are underdetermining with respect to the culture that actually emerges. Other factors, particularly cultural models linked with masculine dominance, are necessary to explain how the media function to "determine our situation."

For the most part trading is a zero-sum game. The only way one trader can win in anticipating which way a currency will move is if another trader bets the movement will be in the opposite direction, making the mirror moves that, in the overall context of market conditions, ensure continuing liquidity.

When tendencies appear that run counter to the capitalist emphasis on profit, they are not encoded as feminine but rather as the necessity for traders, pushed to the wall, to assume the role of the stand-up guy. The ethics of trading demand that large international banks ensure liquidity above all, even if it means on occasion taking a position that the traders know will not work to their advantage. In the long run, of course, all banks depend on market stability and therefore on continuing liquidity, so reputable banks contribute to the common good by taking on this ethical obligation. Here again, cultural models are necessary for a fuller explanation of trading culture. Media provide the simultaneity that spatializes time, creates global microsociality, catalyzes attachment to screens, and gives rise to emergent objects "that are not identical with themselves," but the emotional tone, dominant metaphors, hypermasculinized dynamics, and capitalist economics codetermine how trading practices actually operate.

EMBODIMENT AND THE COEVOLUTION OF TECHNOLOGY

If media alone are not enough to determine our situation, neither is embodiment.

No one has more forcefully argued for the importance of embodiment in relation to new media art than Mark B. N. Hansen, who in *New Philosophy for New Media* draws on a wide range of philosophers, neurophysiologists, and digital artists to argue that embodiment—especially affective, haptic, kinesthetic, and proprioceptive capacities—are crucial to converting the informational data patterns of digital images into meaningful images.[6] Updating Bergson's idea in *Matter and Memory* that the body selects from the environment images on which to focus, Hansen contests Deleuze's reading of Bergson

in *Cinema 1* in order to reinstall affectivity at the center of the body-brain achievement of making sense of digital images. In the process he performs insightful readings of a wide range of digital art works to show how affectivity interacts with them to convert information into meaning.

This is a major intervention that serves as an important counterweight to Kittler's perspective. Hansen posits that "only meaning can enframe information" (82), and in his view it is humans, not machines, who provide, transmit, and interpret meanings (a position that strongly contrasts with the argument of chapter 2 that machines also interpret information in locally specific contexts and thus create contingent and context-dependent meanings). He points out that although machines might continue to function if all humans were spontaneously to disappear, "this function would be entirely without meaning" (80). Responding directly to Kittler, he argues that "so-called Man must not be relegated to the junk pile, to the pathetic status of a dependent variable with an uncertain prognosis" (84). The dark appeal of Kittler's argument, as he flirts with subordinating humans to media epochs, is here met with a strong positive affirmation of the necessity for human enframing, the flexibility and power of embodied capacities, and the importance of these capabilities for understanding and interpreting new media art.

Since Hansen's argument draws in part on sources I use in my book *How We Became Posthuman,* extending to new media art my argument about the importance of embodiment and amplifying it with an impressive range of citations and arguments, I (perhaps more than most) have reason to be sympathetic to this perspective. Yet despite my overall sympathy, I cannot help noticing places where the argument, in its zeal to establish that embodiment trumps every possible machine capacity, circumscribes the very potential of the body to be

transformed by its interaction with digital technologies for which Hansen otherwise argues. The tensions between the body's transformative potential and the threat that the machine will appropriate embodied functions (with the looming specter that machines will thereby make the body obsolete) are most acute around issues of vision, for unlike deep body functions such as kinesthesia and proprioception, vision can be duplicated and performed by machines in ways vastly faster and more acute than humans can manage. From my point of view, the perceived "threat" here is not a threat at all; the point is not that machines can see better, faster, and farther than can humans, but rather that human vision, whether enhanced by machines or not, remains for most people an essential faculty whereby we place ourselves in the world and interact creatively with it. Embodiment will not become obsolete because it is essential to human being, but it can and does transform in relation to environmental selective pressures, particularly through interactions with technology.

The problem that Hansen perceives with sight is articulated most problematically in his chapter on virtual reality (VR), "The Automation of Sight and the Bodily Basis of Vision" (92–124). Here he makes clear that he regards the "ocularcentrism" of VR a problem because vision is too readily susceptible to co-optation by machines. Following Paul Virilio's critique of machinic vision, he even argues emphatically for a "right to blindness," suggesting that what is at stake is a "right to see in a fundamentally different way" (105). He continues, "For if we now regularly experience a 'pathology of immediate perception' in which the credibility of visual images has been destroyed, isn't the reason simply that image processing has been dissociated from the body?" (105). The exemplar of this "industrialization" (105) of vision in Hansen's argument is the virtual cockpit developed by the American military,

in which the pilot controls key instruments by directing his gaze in concert with articulated commands.

Vision, then, cannot in Hansen's account be allowed to be the dominant perceptual sense, or even on a par with privileged faculties that (not coincidentally) are much more difficult to automate, particularly what he calls "affectivity," the capacity of the sensorimotor body to "experience itself as 'more than itself' and thus to deploy its sensorimotor power to create the unpredictable, the experimental, the new" (7). To substantiate that the sensorimotor body has this capacity, he draws on the writing of Raymond Ruyer, a French theorist who during the 1950s proposed to combat the mechanist tendency of post–World War II cybernetics by positing bodily faculties that, he argued, are nonempirical and nonobservable. Chief among these is a "transpatial domain of human themes and values" (80). Given the research within the last three decades with brain imaging technologies and their abilities to reveal neurological functionalities, it seems odd to hinge large parts of the argument on outdated postwar claims that by definition cannot be substantiated. If we were to call the "transpatial domain" by the more traditional name "soul," its problematic nature would quickly become evident. In question are not only the multiple implications that Hansen draws from Ruyer's work, but also the standard of evidence that implicitly puts this work on a par with that of Claude Shannon or, in a different context, Francisco Varela, researchers whose influence on subsequent thinkers has been profound. When Tim Lenoir in his splendid foreword to *New Philosophy for New Media* refers to Ruyer as "overlooked" (xxi), one may perhaps wonder if he has been overlooked for good reason.

In the context of VR, Hansen's commitments to the sensorimotor body over vision leads him to make claims that are incorrect, for example that "the [digital] image becomes a

merely contingent configuration of numerical values that can be subjected to 'molecular' modification" (9). This assertion ignores the role that software plays in assembling, coloring, and giving perceptual integrity to digital images. In PET (positron emission tomography) scans, for example, the software takes a list of numerical values obtained through sensing differential uptakes of glucose spiked with radio nucleotides and assembles them into iconographic images that humans can perceive as the brain "thinking" (the images are colored to reflect the different metabolic rates at which the brain takes up glucose as different regions are activated). The point of using such imaging technology is to present humans with something other than a "merely contingent configuration of numerical values," which could not be grasped by humans in the quick holistic way possible with PET scans and related technologies such as functional magnetic resonance images (fMRI), precisely because numerical tables lack the strong visual cues and interpretive richness that images provide. Moreover, the creative potential that Hansen ascribes to the sensorimotor body can also be present in vision. If vision has in some applications been "industrialized," it has not necessarily been co-opted in all situations; moreover, it retains the capacity to participate in creative transformations of embodied capacities.

Although it is undoubtedly true, as Hansen argues citing Brian Massumi (109), that proprioception, kinesthetic, and haptic capacities are involved with vision, this does not mean that they replace vision or even that they become dominant over vision in a VR interface. Indeed, it is precisely because vision plays such an important role in VR that VR sickness arises. In VR the accustomed input from the sensorimotor body is often disconnected from vision; for example, in a VR installation that visually shows a car whizzing along a road, the usual inputs from a driver's kinesthetic, proprioceptive,

Contexts for Electronic Literature

and haptic faculties are missing, resulting in a brain-body contradiction that physically manifests as nausea and dizziness. Were vision not a dominant sense, this would not happen. Thus when Hansen writes "What I want to argue here is that perception in the VR interface—as the exemplary instance of the filtering of information from a universe of information—can *only* take place in the [sensorimotor] body" (163, emphasis in original), his relegation of vision to a minor player must be understood as ideologically motivated, not as an accurate description of what happens in VR.

Indeed, one can almost chart when the argument is likely to become most heavily ideological by correlating it with invocations of Ruyer. Consider the following passage:

> [D]ataspaces can be intuited, as it were, only through what post-Bergsonist philosopher Raymond Ruyer calls an "absolute survey"—a nondimensional grasping of a perceptual field as an integral whole or "absolute surface." As it is deployed in certain aesthetic experimentations with the VR interface, the capacity for absolute survey furnishes the mechanism for a nongeometric and nonextended "giving" of space that is nothing other than a production of space in the body, or better, a bodily spacing. Accordingly, in Ruyer's account . . . , rather than being there where the object (image) is, perception—or better, sensation—always takes place in the body, as *a spacing of the embodied organism.* (163–64, emphasis in original)

Although some VR installations involve senses other than vision, in most cases vision remains primary. Insofar as the sensorimotor capacities are involved, they are activated because of their correlations with neuronal group interactions in

the brain, as Gerald M. Edelman has shown in his meticulous research on neuronal group selection and interactions between different neuronal groups.[7] Falling back on such mystified terms as "transpatial domain" and "absolute survey" fails to do justice to the extensive research now available on how synesthesia actually works. Relying on Ruyer leads Hansen to the tautological conclusion that because Ruyer's reasoning cited above erases vision from the picture, "it is this under-standing of perception as bodily space that allows the ocular-centrism of VR to be overcome" (164). Overcome, one might add, through a priori claims for which no evidence is adduced or possibly could be adduced, since they pertain to an al-legedly "nonobservable" domain.

Throughout these arguments, there is an unavoidable ten-sion between Hansen's insight that technology and the body coevolve together and his ideological commitment to the pri-ority of embodiment over technology. Obviously, if the body and technology are involved in a coevolutionary spiral, neither logically has precedence over the other; debating priority is about as useful as discussions about the chicken and the egg, for once coevolution begins, both partners are bound in co-temporal recursive cycles with one another. Latent in *New Philosophy for New Media*, this tension becomes explicit in *Bodies in Code*.[8]

In *Bodies in Code*, Hansen seeks to extend the ambiti-ous program he sets out in *New Philosophy for New Media*, working here to reconceptualize phenomenology so that it can more adequately support the importance of embodiment in digital media. For this purpose, he adopts the metaphor of "mixed reality," using it to connote the conditioning of expe-rience "by a technical dimension" that results from the "co-functioning of embodiment with technics" (*BIC*, 9). Conven-tionally, of course, mixed reality refers to the mixing of virtual

images and other digital data with real-life environments. As Hansen uses the term, however, reality becomes "mixed" when the perceptual input for humans comes not from their unaided bodies operating alone in the environment, but rather from their embodied interactions with technologies. "Let us say that mixed reality appears from the moment that tools first delocalized and distributed human sensation, notably touch and vision," he writes (*BIC*, 9). At the same time, he also wants to see mixed reality as a "concrete moment in the history of human technogenesis in which the constituting or ontological dimension of embodiment is incontrovertibly exposed" (*BIC*, 9).

In this account, then, the coevolution of the body and technology is given a teleological trajectory, a mission as it were: its purpose is to show the "constituting or ontological dimension of embodiment." Largely erased are material specificities and capacities of technical objects as artifacts. It is as though the feedback loop between technical object and embodied human enactor has been cut off halfway through: potentiality flows from the object into the deep inner senses of the embodied human, but its flow back into the object has been short-circuited, leading to an impoverished account of the object's agential capacities to act outside the human's mobilization of its stimuli. Consider as a counter-narrative a potter shaping a wedged block of clay. When the work is good, the potter and clay enact a kind of dance to which both contribute, as the clay's chemical composition, water content, grittiness, and many other factors interact dynamically with the potter's intent. In what Andrew Pickering calls the mangle of practice, the resistances of technical objects play crucial roles in modifying and directing a researcher's efforts. With an intelligent machine, the circuit between technical object and human is much more intense and varied as the machine's increased

agential powers are deployed along a broad spectrum of possibilities, both within and outside of human perception.

Although Hansen pays homage to the idea of human-technological coevolution in employing the term "technogenesis," its implicit negation often creeps into the rhetorical formulations of his argument. For example, elaborating on the paradigm of "mixed reality," he emphatically explains that the body's "coupling with the domain of social images occurs *from within the operational perspective* of the organism and thus comprises a component of its primordial embodied agency" (*BIC,* 13, emphasis in original). Although it is difficult to know exactly what weight "primordial" is meant to carry, it insinuates that the body comes first and technology operates only within the horizon of "embodied agency" rather than as an autonomous force. For another example, in discussing technology's potential to "expand the body's motile, tactile, and visual interface with the environment," Hansen argues that "digital technologies lend support to a phenomenological account of embodiment and expose the technical element that has always inhabited and mediated our embodied coupling with the world," which sounds as though technology and the body are copartners in this endeavor. Immediately following, however, he refers to this as the "subordination of technics to embodied enaction," a phrase that again encapsulates technology within the body's horizon (*BIC,* 26).

This encapsulation is problematic for several reasons. It ignores the increasing use of technical devices that do not end in human interfaces but are coupled with other technical devices that register input, interpret results, and take action without human intervention, from fire sprinklers that automatically go on when heated to automated weaponry that responds to threats without human initiation. Much of the current research in nanotechnology is based on self-assembly

Contexts for Electronic Literature

principles in which it is not the interface with the embodied observer that matters, but rather the material's ability to build larger components using the physics and chemistry of the constituent parts.[9] In addition, as we saw with *New Philosophy for New Media,* Hansen's approach of privileging the body over technology means that he pays scant attention to the actual construction of the technology; when technical details enter the discussion, they typically are mentioned only insofar as they interface with the body.

Such an account is helpless to explain how technology evolves within the horizon of its own limitations and possibilities. Radio (originally called "wireless telegraphy"), for example, converted wired telegraphy, in which messages were sent to specified recipients, into broadband transmission with its own distinctive consequences. Among these was the need for strong encryption, for if anyone could receive the signal new methods were needed to preserve secrecy, especially in military applications. Hence radio led directly to the expansion and refinement of encryption techniques, culminating in the German military's deployment of the Enigma encryption machine during World War II. Since humans cannot transmit, receive, or perceive radio waves directly, this kind of technological lineage, as Kittler rightly argues, depends primarily on changes in media technology and only secondarily on embodied capacities.

As if assuming a mirror position to Kittlerian media theory, which cannot explain why media change except by referring to war, Hansen cannot explain why media develop except by referring to embodied capacities. Consider the implications of this passage: "[T]echnologies are always already embodied . . . they are in their own way 'essentially' embodied, if by this we mean that they mediate—that they express—the primordial fission, the gap, within the being of the sensible"

(*BIC*, 59). That is, the ability of humans to develop and appropriate technologies springs, in Hansen's account, from the "primordial fission, the gap," which implies technology is always already supplemental to and implied by embodiment.[10] This for him is what it means to say technology is embodied. One might, however, come up with a much more commonsense definition: technologies are embodied because they have their own material specificities as central to understanding how they work as human physiology, psychology, and cognition are to understanding how (human) bodies work.

Finally, the encapsulation of technology is limiting because it makes a truly coevolutionary approach difficult if not impossible. By positing the body as establishing the horizon of possibilities within which technological development proceeds, Hansen relegates technology to a secondary role and circumscribes its creative potential to what "the body" can already do. As Hansen elsewhere acknowledges, "the body" is not a historical absolute, especially when viewed in evolutionary time scales. The evolution of *Homo sapiens* has codeveloped with technologies; indeed, it is no exaggeration to say modern humans literally would not have come into existence without technology. Physical changes in human biology such as the opposable thumb and upright posture, which involved complex coordinated changes in musculature, skeletal structure, and cognitive functioning, have been attributed by anthropologists to the catalyzing effects of the development, use, and transport of tools. Given this evolutionary context, it makes little sense to argue that these capacities were "potentially" in early humanoids and that tools merely brought out what was already there. Had early tools developed along different technological lineages, early hominid evolution also might have developed along quite different biological lines. Given the importance of technologies to human evolution, we

could (perversely) turn Hansen's argument inside out and argue that human embodiment is encapsulated within the horizon established by technological development and evolution, which would expand Kittler's media theory to grandiose proportions by including all technologies as determinants of human embodiment, from stone axes to computers. Instead of subordinating the body to technology or technology to the body, however, surely the better course is to focus on their interactions and coevolutionary dynamics.

Central to these dynamics, especially in the context of media theory and electronic literature, are neural plasticity and language ability. The evolution of language has been linked to tool use by Stanley H. Ambrose, an anthropologist at the University of Illinois. Ambrose has proposed a connection between the evolution of language in the Paleolithic period and the practice of fashioning compound tools (tools with more than one part that have to be assembled in sequential order, such as a stone ax with a handle, bindings, and a stone insert).[11] For 2.5 to 3 million years, early humans used simple tools without much change in brain structure. Then, about three hundred thousand years ago, compound tools were invented and things really starting hopping (relative to Paleolithic time scales). Evidence indicates that compound tools were contemporaneous with the accelerated development of Broca's area in the frontal cortex, a part of the brain involved in language use. Ambrose speculates that the sequential and hierarchical ordering required in the fashioning of compound tools coevolved with language because language, like compound tools, requires the sequential ordering of reproducible and discrete units. In this scenario, the trait often identified with the essence of the human—our ability to use complex languages—was bound up at the dawn of *Homo sapiens* with the emergence of a relatively sophisticated technology (that

is, compound versus simple tools), initiating a coevolutionary spiral in which language and compound tools developed together to bring about a new phase in human cognitive development.

In view of this connection between human biology and tool use, what can we say about how contemporary media may be affecting brain functioning? It is well known that the brain's plasticity is an inherent biological trait; humans are born with their nervous systems ready to be reconfigured in response to their environments. While the number of neurons in the brain remains more or less constant throughout one's lifetime, the number of synapses—the connections neurons form to communicate with other neurons—is greatest at birth. The newborn infant undergoes a pruning process called "synaptogenesis," whereby the neural connections that are used strengthen and grow, while those that are not decay and disappear.[12] The evolutionary advantage of this pruning process is clear, for it bestows remarkable flexibility, giving humans the power to adapt to widely differing environments. Although synaptogenesis is greatest in infancy, plasticity continues throughout childhood and adolescence, with some degree continuing even into adulthood. In contemporary developed societies, this plasticity implies that the brain's synaptic connections are coevolving with environments in which media consumption is a dominant factor. (According to a report commissioned by the Kaiser Family Foundation, American young people spend an average of 6.5 hours per day with media).[13] Children growing up in media-rich environments literally have brains wired differently than humans who did not come to maturity in such conditions.[14]

Neural plasticity is often cited in evolutionary contexts in connection with the so-called Baldwin Effect, proposed by James Mark Baldwin in 1896 as a modification to Darwinian

Contexts for Electronic Literature

evolution.[15] Baldwin argued that natural selection, as articulated by Darwin, is framed mostly in negative terms; individuals who do not live to reproduce have their traits eliminated from the population (retrospectively, after the modern synthesis combined natural selection with Mendelian genetics in the early twentieth century, this would be understood as having one's genes eliminated from the gene pool). Natural selection does not, however, adequately explain the positive selective pressures that learning can exert on individuals, nor does it account for changes to the environment that learning may bring about. To explain this, Baldwin argued for what he called "organic selection." In the same way that the brain overproduces neuronal connections that are then pruned in relation to environmental input, so Baldwin thought that "organic selection" proceeded through an overproduction of exploratory behaviors, which are then pruned through experience to those most conducive to the organism's survival. This results in a collaboration between phylogenetic selection (that is, selection that occurs through genetic transmission) and ontogenic mechanisms of adaptation (which occur in individuals through learning).

Evolution is not solely physical in this view but psychophysical; it is not genetic transmission alone that determines outcomes but rather the fitness of the entire individual, which includes the benefits bestowed by learning. In turn, learning and cerebral plasticity work synergistically together to accelerate evolution and give it a certain directionality by catalyzing environments in which learning and cerebral plasticity become even more advantageous. In this way, what begins as ontogenetic adaptation through learning feeds back into selective pressures to affect physical biology. Terrence Deacon in *The Symbolic Species: The Co-Evolution of Language and the Brain* uses the Baldwin Effect to argue that such psychophysical

feedback cycles resulted in the coevolution of human cerebral plasticity and the emergence of language capacities, each catalyzing and helping to accelerate the other.[16]

Now let us consider the role of technology in this complex dynamic. Ambrose's scenario linking compound tools with the emergence of language illustrates how technology enters into the psychophysical feedback cycle by changing the ways in which learning occurs and the kinds of learning that are most adaptive. In contemporary environments increasingly dominated by media technologies, embodiment is in active interplay with the ways in which media are shaping humans psychophysically through the combination of neural plasticity and ontogenic adaptation. The computer, our new compound tool, uses the hierarchical ordering of discrete reproducible units (ones and zeros) to create new kinds of temporal and spatial experiences. If data differentiation at the beginning of the twentieth century broke the ancient monopoly of writing, the computer at the beginning of the twenty-first century breaks the monopoly of vision associated with reading. Interactive text, reminiscent in some ways of the digital art discussed by Hansen, stimulates sensorimotor functions not mobilized in conventional print reading, including fine movements involved in controlling the mouse, keyboard, and/or joystick, haptic feedback through the hands and fingers, and complex eye–hand coordination in real-time dynamic environments.[17] Moreover, this multisensory stimulation occurs simultaneously with reading, a configuration unknown in the Age of Print. Brain imaging studies show that everyday tool use entails complex feedback loops between cognitive and sensorimotor systems.[18] For humans who habitually interact with computers, especially at young ages, such experiences can potentially affect the neurological structure of the brain. Although a full analysis of how media are catalyzing contempo-

rary ontogenic adaptations is beyond my scope here, let me sketch some possibilities.

Steven Johnson, in *Everything Bad Is Good For You: How Popular Culture Is Actually Making Us Smarter,* cites the studies of James R. Flynn indicating that IQs rose significantly from 1932–78, the so-called Flynn Effect that Johnson correlates with increased media consumption.[19] Anecdotal evidence as well as brain imaging studies indicate that "Generation M" (as the Kaiser Family Foundation dubbed the 8- to 18-year-old cohort) is undergoing a significant cognitive shift, characterized by a craving for continuously varying stimuli, a low threshold for boredom, the ability to process multiple information streams simultaneously, and a quick intuitive grasp of algorithmic procedures that underlie and generate surface complexity. This cognitive mode, which I have elsewhere called "hyper attention," is distinctively different from that traditionally associated with the humanities, which by contrast can be called "deep attention."[20] Deep attention is characterized by a willingness to spend long hours with a single artifact (for instance, a seven-hundred-page Victorian novel), intense concentration that tends to shut out external stimuli, a preference for a single data stream rather than multiple inputs, and the subvocalization that typically activates and enlivens the reading of print literature.

Contemporary cultures in developed countries are currently in a period of active transition in which the cognitive mode of deep attention is still being fostered by formal education, especially humanities courses, and by parents who want their children to read books rather than surf the World Wide Web and play video games. Nevertheless, there is a clear generational shift in which preference for hyper attention is more prevalent the younger the age group, at least down to ages four or five, typically the developmental stage when the neural

system has developed sufficiently to handle multiple incoming data streams.[21] The effects of hyper attention are already being reflected in literary works, for example in John Cayley's *Translation* and *Imposition*, discussed in chapter 5, where text is accompanied by glyphs visually indicating the algorithm's operation.[22] With multiple data streams, constantly changing stimuli, and evocation of an intuitive grasp of algorithmic operation, these works appeal simultaneously to deep attention and hyper attention as part of the process transforming what it means to read.

The uneven demographics of deep attention and hyper attention have created an environment in which various media compete and cooperate not only in terms of design, style, and thematic content, but also in terms of reader preferences and styles of engagement. At issue are matters fundamental to our understanding of what "literature" means: what it means to write, to read, to interpret, to understand, to feel literary effects in the body, and to embody literature in a specific medium. The interiorized subjectivity associated with print has not disappeared (Kittler's claim to the contrary notwithstanding), but it is being hybridized by a complex dynamic in which a subvocalized human voice, the characteristic mode through which print creates and performs its distinctive mode of subjectivity, is no longer the primary goal of screen displays.[23] (Indeed, Robert Coover at one point decried electronic textuality precisely because it lacked the authorial "voice" of print texts.)[24] As media change, so do bodies and brains; new media conditions foster new kinds of ontogenic adaptations and with them, new possibilities for literary engagements. This is the context in which we should evaluate and analyze the possibilities opened by electronic literature. Insisting on an internalized subvocalized "voice" as the standard for literary quality can only lead to the predetermined conclusion that electronic liter-

ature is inferior to print literature, for the criterion already dictates the outcome. By contrast, attending to the multisensory modalities through which electronic literature operates not only illuminates its dynamics but also elucidates how contemporary print novels operating in new media conditions are also undergoing transformations as they too participate in the recursive feedback loops connecting bodies and machines, natural language and code, human and artificial intelligence.

Thus Kittler has it right in insisting on the catalyzing effects of media on the body, on subjectivity, and on the structures of knowledge associated with them; Hansen has it right in insisting on the importance of embodiment and the ways in which embodied processes enable meaning to emerge. A critical interrogation of Kittler's position revealed that media and cultural formations interact. At work in this dynamic are the specific effects of global microsociality, attachment to screens, spatialized temporality, emergent objects "that are not identical with themselves," and the pressures media exert on bodies, expressed through metaphors of warfare and bodily penetrations. An analysis of Hansen's position showed how incorporating technology and embodiment together in psychophysical feedback loops gives a richer, fuller account of the potential of technology to accelerate and direct evolution through the Baldwin Effect, illustrated in the contemporary period by the shift toward hyper attention. The cascading processes of interpretation that give meaning to information are not confined solely to human interlocutors, as Hansen argues, but take place within intelligent machines as well. It is precisely when these multilayered, multiply sited processes within humans and machines interact through intermediating dynamics that the rich effects of electronic literature are created, performed, and experienced. Let us turn now to two works of electronic literature, Talan Memmott's *Lexia to Perplexia*[25]

and Young-Hae Chang Heavy Industries' (YHCHI) *Nippon*,[26] to explore how the complex dynamics between the body and the machine entwine together to codetermine our situation.

THE BODY AND MACHINE IN ELECTRONIC LITERATURE

Attachment to screens, imaged iconigraphically by facing double funnels, is prominently on display in Talan Memmott's *Lexia to Perplexia*, suggesting that the subjects facing screens are somehow merging with them, so that subjectivity is ambiguously distributed across the screen boundary. Other iconographic designs such as eyes looking out suggest that the technology is not a neutral purveyor of human intentions and desires but also has its own "mind," subject as well as object of visual attachment. The notorious "nervousness" of this work, whereby a tiny twitch of the cursor can cause events to happen that the user did not intend and cannot completely control, conveys through its opaque functionality intuitions about dispersed subjectivities and screens with agential powers similar to those we saw with international currency traders. Neologisms like "communification" point toward the merging of global capital with information technologies, while the narrative voices that have been funneled through the apparatus seem to speak from a great distance, as if overcome by their own virtuality. These techniques invite the user to think critically about the effects displayed in the work, an invitation realized most dramatically in reflections that double back on themselves to become recursive loops.

This doubling effect is carried out in part through the sophisticated play between Echo and Narcissus that dominates the work's first section and appears intermittently throughout. Icons of eyes and the letters E. C. H. O. splash across the

Contexts for Electronic Literature

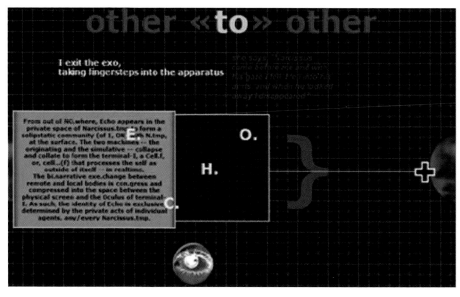

Figure 6. Screen shot, *Lexia to Perplexia*

screen, suggesting through their complex meanings that these hyper characteristics are deployed in reflexive contexts demanding deep attention. Consider the following passage from the opening screen:

> The inconstancy of location is transparent to the I-terminal as its focus is at the screen rather than the origin of the image. It is the illusory object at the screen that is of interest to the human enactor of the process— the ideo satisfractile nature of the FACE, an inverted face like the inside of a mask, from the inside out to the screen is this same <HEAD>[FACE]<BODY>, <BODY> FACE</BODY> rendered now as sup\posed other.
> Cyborganization and Its Dys/Content(s)
> Sign.mud.Fraud

In Ovid's version of the myth, Narcissus, looking into the reflective pool, falls in love with his image and pines for a supposed other who is in reality himself; Echo, loving Narcissus, fades away to a voice doomed to repeat what others say. In Memmott's rewriting of the myth in the context of information technologies, the "I-terminal," a neologism signifying the merging of human and machine, looks at the screen and desires to interact with the image, caught like Narcissus in a reflexive loop that cycles across the screen boundary between self/other. Recalling the international currency traders who think they can intuit the "mind" of the market they help to create, the origin is ambiguously located in the user whose image the screen reflects and an emergent subjectivity deep inside the machine itself. This emergent subjectivity takes the anthropomorphic shape of the FACE, whose nature, the "ideo satisfractile" neologism suggests, entangles ideology, narcissistic satisfaction, and fractal self-similarity. Moreover, the FACE is imaged as if inverted "like the inside of a mask," suggesting that the reality of the situation is simultaneously revealed and masked from the "I-terminal" gazing at the screen. The process of revelation is irreducibly complex, for the shape of the FACE can only be discerned by reflexively reconstructing from the mask's interior what the presumptive face looks like, an indirect procedure analogous to the onlooker who must infer her identity from its reflection on the screen.

The feedback cycle suggested here between self and other, body and machine, serves as a metaphor for the coconstruction of embodiment and media technologies. In addition, the work also entangles the user in this loop, for example through the ambiguity of the eyes imaged on screen, which can be seen either as eyes looking out at the user or the user's eyes reflected on the screen surface. In the endless cycle created by these possibilities, the user becomes implicated within the recursive cas-

cading processes of interpretation, at once reflected in the work and reflecting upon it, that give meaning to information.

Similar entanglements are enacted by the verbal text. The passage cited above continues with "broken" code, that is, code that is a creolization of English with computer code, evocative of natural language connotations but not actually executable. The syntax of the html markup is not correct, for the expression <HEAD>[FACE]<BODY> lacks the closing </HEAD> that would signal the end of the heading before the body starts; the expression also lacks the closing tag for the body. Inserted instead is the FACE, suggesting a Cartesian oscillation in which the face is ambiguously located either with the head or body. The next expression, <BODY>FACE </BODY>, continues the play by indicating that the FACE is part of the body. The closing phrase, "rendered now as the sup\posed other," once again indicates ambiguity in the locus of selfhood, indeterminably dispersed between a "posed" other and its virtual "supposed" twin. The signature, 'Sign.mud Fraud," simultaneously evokes Freud's famous analysis of narcissism and debunks it, suggesting that Freudian psychology must be rethought in the semiotic context of networked and programmable media. In particular, the play between human language and code points to the role of the intelligent machine in contemporary constructions of subjectivity, gesturing toward what Scott Bukatman has called "terminal identity,"[27] or in Memmott's lexicon, the "I-terminal."

While *Lexia to Perplexia* could be played as if it were an idiosyncratic computer game that the user "wins" by reaching the final screen, the point is not to zip through the screens (admittedly not an easy task!). Engaging the hyper-attentive characteristics of multiple information streams and rapid transformations (images, words, graphics, lightning-quick morphing of screens, mouseovers, and so on), the work reflects upon

its own hyper-attentive aesthetics in the final section, where the prefix "hyper" replicates itself with every imaginable stem. At the same time, the work obviously requires deep-attention skills to grasp the complex interactions between verbal play, layered screen design, twitchy navigation, and JavaScript coding. In my experience teaching this work, I find that an effective strategy is to form two-person teams between experienced gamers and textual critics such as English graduate students who have read considerable critical theory. In discussions that emerge between team members, the partners typically express distaste for some of the work's strategies and admiration for others. The flash point comes when they discover their critical evaluations are mirror images of one another, leading to further discussions about how different interpretive traditions and media experiences precondition the work's reception. In terms of the complex dynamics between body and machine, we might say that the gamer and textual critic have had their neural plasticities shaped in different but overlapping ways. Works such as *Lexia to Perplexia* can function as testing grounds to engage and explore these differences and similarities.

While *Lexia to Perplexia* is primarily concerned with the transformative effect of information technologies on contemporary subjectivity, Young-Hae Chang Heavy Industries engages the global microsociality and spatialization of temporality characteristic of information-intensive settings such as international currency trading discussed above. The work is a Seoul-based collaboration between Marc Voge, a French artist, and Young-Hae Chang, a Korean artist. Programmed in Flash, their works use timed animation to display sequential blocks of text, with the movement from one screen of text to the next synchronized with an accompanying sound track, typically jazz. With settings that include Japan, Korea, and the

African continent, the narratives display an international flavor, often heightened by hip language and a noir flavor. With a restrained color palette and few animations, the work's emphasis falls on sound and text—but text with a difference.

The flashing sequential blocks of text convert the reading experience from eye motion that progresses down the page in horizontal sweeps from left to right (for English text) to looking at the same area on screen where the text constantly replaces itself. The impression is not that the eye moves but rather that the text moves while the eye remains (more or less) stationary. Agency is thus distributed differently than with the print page where the reader controls the pace of reading and rate at which pages turn. Programmed as a Flash animation impervious to user intervention (the user's only choice is to let the piece run or to stop it and start over from the beginning), the work proceeds at speeds rarely coinciding with a comfortable reading rate, either lingering longer than the reading requires or flashing by so quickly one must strain to catch all the words. The effect is to introduce a disruptive temporality into the spatiality of the (presumptive) page, converting it into a hybrid form in which spatiality and temporality compete for dominance in the place of reading.

As Jessica Pressman has observed, the idea of text that moves while the reader's eye remains stationary was conceived by Bill Brown in the 1920s. Brown devised a machine that he called the "Readie," which was intended to display text much as it appears in YHCHI's compositions.[28] Taking his cue from cinema as a time-based medium, Brown imagined that reading could be brought up to speed, so to speak, by displaying it as a linear stream of words flashing by, much as a highway unfolds at night through the windshield while one is driving fast. The metaphor of text as an unfolding road was literalized by the Research in Experimental Documents (RED) group at

Xerox PARC (without knowing about Brown's Readies). Their reading machine, the "Speeder Reader" displayed in 2001 at SIGGRAPH and other venues under the title "XFR: Experiments in the Future of Reading," was a device that flashed text while the user controlled the speed by way of a pedal.[29] Thus the notion of speed, mobility, and modernity has been consistently linked with the linear display of flashing text for nearly a century, a conjunction that prompts Jessica Pressman to categorize the productions of YHCHI as "digital modernism." In their works, of course, the speed is controlled through a computer algorithm; this implies that the aesthetic departs from the mechanical version insofar as it involves the rapid processing of code by an intelligent machine, the interaction of language with the execution of code, and the global reach of networked and programmable media as the piece is accessed and played using data stored at the Young-Hae Chang Heavy Industries website. All of these factors contribute to an interrogation of global microsociality and temporality as a place to inhabit.

In *Nippon*, global microsociality is emphasized by an intimate address that appears on a screen split between Japanese ideograms above and English words beneath. The two languages are not literal translations of one another but rather use colloquial speech replete with idiomatic expressions, as if the narrators were equally at home in both languages. Employing tropes from noir films, the work locates them in the Japanese cultural tradition of the after-hours bar where men gather after the office closes to be entertained by attractive young women most assuredly not their wives. With the diegesis set in local time, the work nevertheless moves toward the spatialization of temporality through the screen display that coordinates the textual space with the temporality of a musical sound track. Moving in time with the music, the text is ani-

仕事に行く
には早すぎる。
EXCHANGED?

Figure 7. Screen shot, *Nippon*

mated in subtle and obvious ways—obviously when one screen of text gives way to the next, subtly in time-based effects such as text bouncing slightly to a drum crack, shaking with bold musical phrasing, and appearing in larger fonts with emphatic punctuation in coordination with increased volume or tempo. The subvocalization that activates the connection between sound and mark in literary reading here is complicated by the text's movement and its interpenetration by sound, becoming a more complex and multimodal production in which embodied response, machine pacing, and transnational semiotics, along with the associated spatialization of temporality, all contribute to construct the relation between text, body, and machine.

The temporalization of textual spatiality is reinforced by allusions to other time-based media, particularly film. The self-conscious narrative begins as if the narrator, posing as a film director, is delivering instructions to a young woman catering to the married men. In what is apparently one side of a

dialogue, the voice cajoles the young woman to use her ciga-
rette as a seduction prop, coaches her on the proper moves,
and argues with her about whether she should stretch to show
off her long neck (better not, the narrator admits, because it
would reveal the line where her makeup stops). Then the nar-
ration moves into free indirect discourse, reflecting the young
woman's thoughts about her superiority to the men's wives. By
indiscernible degrees, the focalization migrates to free indirect
discourse narrating the thoughts of one of the young men in
the party as he speculates, among other topics, on how much
it would cost to get one of the young women to sleep with
him. The fluctuating gender politics, world-weary tone, chang-
ing narrative foci, satirical take on the situation, and difficulty
of absorbing the text as it flashes quickly by—all contribute to
the work's complexity.

Although the work appeals to hyper attention through
its speed and context, deep attention is required fully to com-
prehend the work's narrative strategies and the synergistic
interplay of text, music, color, motion, and animation, to say
nothing of how the similarities and differences between the al-
phabetic and ideogrammatic scripts moving at different tempos
relate to one another, as well as the nuances, connotations,
and implications of the two different languages. If the space of
the text has been temporalized, it has also been reinforced as a
semiotic system demanding deep attention. The resulting ten-
sion mandates that the user intent on comprehending the work
will necessarily be forced to play it many times, unable to
escape hyper attention by stopping the text-in-motion or deep
attention by lapsing into interactive game play.

In the larger context in which *Lexia to Perplexia* and
Nippon are embedded, the body and machine interact in fluid
and dynamic ways that are codetermining. Electronic litera-
ture can be seen both as participating in these dynamics and as

exploring their implications for contemporary subjectivity and cultural formations. If agency is distributed between conditions established by the media and embodied responses of humans who interact with the media, this does not mean agential empowerment is absent. Indeed, in this framework, the points of intervention expand to include those who fashion the hardware and build the software, those who use the software to create works of electronic literature, and those who interact with electronic literature as users/players. Media technologies do not come into existence by themselves any more than bodies do. Both are the result of complex feedback loops between our evolutionary heritages, the cerebral plasticity that reconfigures bodies and helps to discover innovative technologies, and the technological possibilities of media as they change and develop. To focus on bodies or media alone as determining the horizon for these rich interactions is to see only part of the picture. People and machines are both embodied, and the specificities of their embodiments can best be understood in the recursive dynamics whereby they coevolve with one another.

Let us now return to David Wellbery's insightful comments and recontextualize them to arrive at a conclusion different from the one he articulates. Decades of brilliant work by such poststructuralist thinkers as Derrida, Lacan, and Foucault taught us that Logos cannot be grounded in an absolute origin, that uncertainties in discourses render foundations untenable and *différance* unavoidable, and that discursive regimes define "so-called Man" rather than the other way around. For at least three decades, these well-known insights had the effect of opening inquiry and catalyzing critique across a range of disciplines. Building on them, Kittler arrived at his media theory, but at a cost; he replaced foundations with media horizons beyond which questions are forbidden to reach. Working

from a different but equally rich tradition that runs through Bergson, Deleuze, and Merleau-Ponty, Hansen arrived at his theory of embodiment but also at a cost; he replaced Kittlerian technodeterminism with a horizon of embodiment defined primarily by affectivity that must above all triumph over perception and especially vision. Hence the rhetoric of imperatives employed by Kittler ("must not think," "forbids the leap," and so on) finds its mirror opposite in Hansen's rhetoric of encapsulation ("subordination of technics," "from within the operational perspective of the organism," and the like). In contrast, the model herein proposed entangles body and machine in open-ended recursivity with one another. This framework mobilizes the effect recursivity always has of unsettling foundations while simultaneously catalyzing transformations as each partner in the loop initiates and reacts to changes in the other. In this model neither technological innovation nor embodied plasticity is foreclosed. The future, unpredictable as ever, remains open.

Revealing and Transforming

How Electronic Literature Revalues Computational Practice

When body and machine interact, intermediating dynamics between them give rise to emergent phenomena crucial to understanding the effects of electronic literature. The logic of coevolution implies, however, that just as networked and programmable media are transforming literature, so literary effects are revaluing computational practice. This chapter elucidates further a framework in which digital literature can be understood as creating recursive feedback loops among embodied practice, tacit knowledge, and explicit articulation. Forging connections between mind and body, performance and cognition, technical vocabulary and intuitive understanding, the works discussed in this chapter engage networked and programmable media not just as technical practices, but as integral components of understanding what it means to be human in a computational era. Evolving in active interplay with intelligent machines, the "human" neither encloses the technological nor is enclosed by it. Rather, human agency operates within complex systems in which nonhuman actors play important roles. In these systems, human language is interpenetrated by computer code, operating in architectures that mediate between

the human meanings and the binary code that is the only language computers can use to operate. The tension between the high-level meanings of human discourse and the cascading processes linked with executable code in machines is a major site for exploring how electronic literature stages the encounter so as to revalue computational practice.

To begin, consider this provocation: in developed societies almost all communication, except face-to-face talk, is mediated through some kind of digital code. Text messaging, email, cell phones, and video conferencing are obviously so, but even telephone landlines and snail mail, insofar as the former is routed through digital switching devices and the latter is composed and printed out from digital files, are also enmeshed with digital devices. What differences do these entanglements make to our sense of what it means to communicate with one another, long understood to be a fundamental component of human sociality and being? Or to put it another way, what does the intermediation between language and code imply for practices of signification?

To this first provocation I now add a second. Paraphrasing that well-known Zen poet Donald Rumsfeld, I propose that (some of) the purposes of literature are to reveal what we know but don't know that we know, and to transform what we know we know into what we don't yet know.[1] Literature, that is, activates a recursive feedback loop between knowledge realized in the body through gesture, ritual, performance, posture, and enactment, and knowledge realized in the neocortex as conscious and explicit articulations. As the French sociologist Pierre Bourdieu has shown, robust and durable knowledge can be transmitted through social practices and enactments without being consciously articulated.[2] Taking the Kabyle, a tribal people in northern Africa, as his case study, Bourdieu demonstrates that the physical arrangements of their villages,

as well as the layout of individual dwellings, instantiate the polarities around which their worldviews are structured (the "habitus," in his terminology).[3] "If agents are possessed by their habitus more than they possess it," Bourdieu writes, "this is because it acts within them as the organizing principle of their actions" (18). Moreover, this knowledge can be passed down through generations without ever being written down or explicitly formulated as a structural schematic. Bourdieu makes the further point that when this knowledge is transformed into a written analysis such as an anthropologist might make, the *kind* of knowledge it is changes. To know something in the body is not the same as to know it in the conscious mind, just as to know something consciously is not the same as knowing it in the body. To illustrate, consider the example I used in *How We Became Posthuman: Virtual Bodies in Cybernetics, Literature and Cybernetics*, knowing how to type.[4] One can study a typing manual showing the keyboard and the correct arrangement of the fingers striking them, but this conscious knowledge will likely not be very helpful in preventing one from getting one's fingers tangled up when trying to type for the first time. Conversely, someone who has a good deal of experience touch typing knows how to strike the keyboard but may be unable to draw the keyboard correctly when asked to render it through conscious introspection. Examples of this kind can be multiplied endlessly—the differences between knowing how to ride a bicycle and telling someone how to ride, swimming and coaching swimming, skiing and writing down a description of how to ski.[5]

Not only are bodily and conscious knowledge different ways of knowing, but they have different effects as well. Conscious knowledge lends itself to analysis, introspection, ratiocination, and written expression; bodily knowledge is directly tied in with the limbic system and the viscera, as Antonio

Damasio has shown, with complex feedback loops operating through hormonal and endocrine secretions that activate emotions and feelings.[6] Although conscious and bodily knowledge frequently operate in synchrony with one another, many instances occur in which the transmission pathways between them are interrupted or even severed. Traumatic events are understood in precisely this way, as disruptions that disconnect conscious memory from the appropriate affect. As Dominick LaCapra eloquently puts it, "Trauma brings about a dissociation of affect and representation: one disconcertingly feels what one cannot represent; one numbingly represents what one cannot feel."[7] In this context, literature can be understood as a semiotic technology designed to create—or more precisely, activate—feedback loops that dynamically and recursively unite feelings with ratiocination, body with mind.

As networked and programmable media move out of the box and into the environment with the spread of ubiquitous computing, embedded sensors streaming real-time data flows, and smart technologies such as RFID (radio frequency identification) tags and nanodevices incorporated in everything from clothing to surfactants, distributed cognitive systems in which human and nonhuman actors participate become an everyday condition of contemporary life in developed societies. Nigel Thrift has written about the psychological consequences of participating in technologically mediated environments in his thick descriptions of what he calls the "technological unconscious."[8] He argues that our everyday interactions with technological affordances, including mundane objects such as chairs, pencils, and bureaucratic forms, create preconscious and unconscious expectations, assumptions, and predispositions that have important consequences for influencing conscious thoughts and beliefs, particularly spatiality (an understandable focus, given his profession as a geographer).

While building on Thrift's insights, I prefer to use the term "technological nonconscious" to avoid confusing the sedimented embodied experiences he discusses with the Freudian unconscious. I also diverge from Thrift in my emphasis on computational technologies. If a pencil influences the technological nonconscious (and I accept that it does), then the effect of a word processor is even more intense because it has greater cognitive abilities and interactive potential. Indeed, I argue that while the technological nonconscious has been a factor in constituting humans for millennia, the new cognitive capabilities and agencies of intelligent machines give it greater impact and intensity than ever before.

With this background in mind, along with the arguments developed in chapters 2 and 3, I now construct a general framework for my argument. Electronic literature extends the traditional functions of print literature in creating recursive feedback loops between explicit articulation, conscious thought, and embodied sensorimotor knowledge. The feedback loops progress in both directions, up from embodied sensorimotor knowledge to explicit articulation, and down from explicit articulation to sensorimotor knowledge. While print literature also operates in this way, electronic literature performs the additional function of entwining human ways of knowing with machine cognitions. As I argued in chapter 2, electronic literature fashions *intermediations* between computer code and human-only language, digital and analogue processing, and print and electronic media forms.[9] Intermediation facilitates the recursive cycle by re-presenting material in a different medium, changing in the process the modes of sensory input. These changes involve differences in the *kinds* of knowledge represented (recalling Bourdieu's point about the differences between schematic analysis and embodied practice). The recursive cycle implies not only that *A* interacts with *B* but also

that this transformation feeds back so that *B* affects *A*, which change further modifies *B*, and so forth. Change anywhere catalyzes change everywhere, resulting both in new understanding of embodied responses and new valuations of technical practice.

This framework, while providing a general theoretical schematic, does not yet contain propositional content. A great many propositions might be located within this schematic, but for my purposes here I will focus on two and illustrate them with selected works of electronic literature. The first proposition asserts that *verbal narratives are simultaneously conveyed and disrupted by code*, and the second argues that *distributed cognition implies distributed agency*.

Why should literary works show narratives being disrupted as well as conveyed by code? Such disruptions are, of course, part of our everyday experiences of networked and programmable media. Static intervenes in a cell phone conversation and suddenly the call is lost; "404" errors leap onto the screen to inform us we are dangling unanchored in cyberspace; the ATM machine spits out the card we have slid down its throat, rejecting the invitation to hook us up with the bank computer; a UPC reader stubbornly refuses to give the "beep" signaling it has understood the bar code being swept across the scanner. These banal events signify that the everyday human–machine communications integrating us into a world in which virtuality and actuality seamlessly merge have been disrupted; somewhere, somehow, the interfaces connecting human action, intention, and language with code have momentarily broken down. Stuart Moulthrop, writing on "404" errors, notes that such episodes are not simply irritations but rather flashes of revelation, potentially illuminating something crucial about our contemporary situation.[10] The "errors," he suggests, are actually minute abysses puncturing (and punctu-

ating) the illusion that the human life-world remains unchanged by its integration with intelligent machines. Computer code, the symbolic system mediating between humans and intelligent machines, functions as a double-edged sword. On the one hand, code is essential for the computer-mediated communication of contemporary narratives; on the other, code is an infectious agent transforming, mutating, and perhaps even fatally distorting narrative so that it can no longer be read and recognized as such.[11]

The second proposition, that distributed cognition implies distributed agency, follows like the first from the intensely computational environments characteristic of developed societies. There is now a wealth of research regarding extended cognition as a defining human characteristic. In *Natural Born Cyborgs: Minds, Technologies, and the Future of Human Intelligence,* Andy Clark argues that we are "human-technology symbionts," constantly inventing ways to offload cognition into environmental affordances so that "the mind is just less and less in the head."[12] Edwin Hutchins makes similar points in *Cognition in the Wild.*[13] Human agency, he convincingly demonstrates, is not only articulated within complex technological systems but also is entrained by those systems, so that someone can correctly orient herself to their use without needing to think much about it. The mouse by my computer, for example, is shaped so that the tapered end fits neatly in my palm, and the buttons are positioned at just the right distance so that my fingers naturally rest on them. For habitual users, such devices rapidly become integrated by way of proprioceptive, haptic, and kinesthetic feedback loops into the mind-body, so that agency seems to flow out of the hand and into the virtual arena in which intelligent machines and humans cooperate to accomplish tasks and achieve goals. At the same time, however, unpredictable breaks occur that disrupt the

smooth functioning of thought, action, and result, making us abruptly aware that our agency is increasingly enmeshed within complex networks extending beyond our ken and operating through codes that are, for the most part, invisible and inaccessible.[14]

These aspects of our contemporary condition are known in different ways at different times and occasions. They can be objects of conscious thought, as when I am trying to resolve an incompatibility issue between my local machine and a piece of software I want to download and use, a task that might involve inspecting the source code and running various utilities to locate the problem. They can also be part of bodily knowledge, for example when my computer gives me the "beep" sound signifying that it has not understood a given input and I automatically move up the screen to click on the appropriate button instead of the incorrect one I had just tapped. These knowledges typically remain unevenly articulated with one another, heterogeneously distributed among different ways of knowing. My body knows things my mind has forgotten or never realized; my mind knows things that my body has not (yet) incorporated. These differentials can potentially serve as power reservoirs for aesthetic works, which by creating new pathways of communication among different kinds of knowledge open us to flashes of insight and illumination.

Although all literature can operate like this, especially potent opportunities exist for electronic literature, given the intensely cognitive environments of networked and programmable media. Electronic literature can tap into highly charged differentials that are unusually heterogeneous, due in part to uneven developments of computational media and in part to unevenly distributed experiences among users. Some users may come to electronic literature with sophisticated reading strategies developed within print traditions but with naïve ex-

pectations about computer code and little experience in computer games, persistent reality sites, and other computationally mediated art forms; other users may come to it with the inverse qualifications, having considerable experience with computer-mediated forms but little experience in reading and understanding print literature. These differences in background correlate with different kinds of intuitions, different habits, and different cognitive styles and conscious thoughts. An experienced video game player has an intuitive sense of game strategy that a print reader may lack; a print reader knows how to coordinate subvocalization with conscious realization in ways foreign to a video game player. These differentials, far from posing obstacles to understanding, constitute the uneven terrain on which electronic literature plays, its effects intensified by the diverse knowledges it mobilizes and the nascent connections it forges. If we knew everything uniformly, there would be much less to discover. Only because we do not know what we already know, and do not yet feel what we know, are there such potent possibilities for intermediations in the contemporary moment.

RECURSIVE INTERACTIONS BETWEEN PRACTICE AND ARTICULATION

William Poundstone's *Project for Tachistoscope*[15] is modeled after a technology developed for experimental psychology exploring the effects of subliminal images.[16] In its original form, the tachistoscope was a slide projector that flashed images too quickly to be consciously recognized but that were nevertheless subconsciously perceived. Slipping under the radar of conscious scrutiny, the subliminal images influenced how people thought, acted, and believed (although the extent of

this influence was a matter of considerable debate). Dating from 1859, the tachistoscope received renewed attention and notoriety during the Cold War era of the 1950s. In the context of the public preoccupation with Communist cells and entrenched spies plotting the government's overthrow, the tachistoscope functioned as a technological embodiment of covert intentions that could hijack conscious thought against its will. Tinged with anxiety, the tachistoscope had another dimension as well in allegations that advertisers could use subliminal messages to influence consumers to buy their products.[17] In historical context, then, the tachistoscope was associated with the nefarious uses to which subliminal perception could be put by Communists who hated capitalists and capitalists who egged on the persecution of "Reds" and "Commies."

In Poundstone's Flash remediation of the tachistoscope, a pulsating looping soundtrack provides the aural background for flashing words narrating the story of an immense abyss that suddenly rips open at a highway construction site, swallowing several pieces of heavy machinery and, tragically, some doomed workers. Underlying the words are easily recognized iconic white images whose relation to the verbal narrative is unclear, although some of them seem to suggest the conjunction of capitalism (money bags), belief (crosses), and consumption (knife and fork). Yet another information stream is provided by a pulsing blue circle of color surrounding the verbal and iconic images, its hypnotic effect intensified by synchronization with the sound loop. As the narrative progresses, fleeting phenomena appear. Golden spheres wander across the visual field, apparently at random, and words begin flashing underneath the black script and underlying white images at a pace too fast to be positively decoded, although not so fast that their presence is entirely unrealized. As the kinds and amounts of sensory inputs proliferate, the effect for verbally oriented

Figure 8. Screen shot, *Project for Tachistoscope*

users is to induce anxiety about being able to follow the narrative while also straining to put together all the other discordant signifiers. The user senses that channels are being opened between different sensory modalities and levels of perception, although the pace is too fast and the inputs too disjunctive for the conscious mind to integrate them into a unified message.

Yet glimmers of some kind of synthesis appear. The narrative tells the story of a surface that is suddenly rent to reveal depths too enormous to be measured; when a geologist probes the opening with instruments, he is unable to determine how deep the abyss actually is. The action takes place at a construc-

tion site, a place where humans are rearranging the topography to suit themselves, making it serviceable for the transport of goods, equipment, and people. Dwarfing these human endeavors, the abyss signifies that which cannot be tamed, refuses be known, and resists co-optation into the world of conscious human intentions. The proliferation of sensory inputs and subliminal messages enacts a performance that similarly disrupts the user's conscious decoding of the narrative. Consciousness reacts by attempting to screen out the "extraneous" information, but Poundstone's introduction to the work makes clear that this effort cannot succeed, for the work is designed to open channels of communication between consciousness and levels of perception below conscious awareness. Beneath the rationalizations that consciousness is sure to invent to reassure itself that it alone is the decider, master of the self, and arbiter of action, the unrecognized inputs stealthily work their effects, influencing how the narrative is interpreted and what it is taken to signify.

A further implication is embodied in the remediation of the tachistoscope as a Flash implementation. The work is paced by an algorithm that does not allow the user to adjust the timing or intervene in the narrative's progression, except by closing the window and starting over. Operating in this respect like a slide presentation with automatic timing, the Flash work adds additional sensory stimuli that make vividly apparent the computer's ability seamlessly to integrate words, images, sounds, and graphics. Programmed by a human in the high-level languages used in Flash (C++/Java), the multi-modalities are possible because all the files are ultimately represented in the same binary code. The work thus enacts the borderland in which machine and human cognition cooperate to evoke the meanings that the user imparts to the narrative, but these meanings themselves demonstrate that human con-

sciousness is not the only actor in the process. Also involved are the actions of intelligent machines. In this sense the abyss may be taken to signify not only those modes of human cognition below consciousness, but also the machinic operations that take place below the levels accessible to the user and even to the programmer.

Whereas Poundstone's *Project for Tachistoscope* explores the communication pathways between embodied understanding and conscious thought, Millie Niss's *Sundays in the Park* automates the processes of traditional literary reading to bring to conscious attention how literary language operates.[18] In *Reading Voices: Literature and the Phonotext,* Garrett Stewart tackles a question that has long intrigued theorists: what makes literary language literary?[19] His strategy is to approach the question not by asking how we read or why, but rather *where.* We read, he suggests, in the body, particularly in subvocalizations that activate for us a buzz of homophonic variants surrounding the words actually on the page. These clouds of virtual possibilities, Stewart argues, are precisely what give literary language its extraordinary depth and richness. Without subvocalization, which connects the activity of the throat and vocal cords with the auditory center in the brain, literary language fails to achieve the richness it otherwise would have. Stewart's argument implies that embodied responses operating below the level of conscious thought are essential to the full comprehension of literary language, a proposition enthusiastically endorsed by many poets.

Stewart's argument provides an appropriate theoretical context for *Sundays in the Park*, one of six elements of *Oulipoems* by Niss and Martha Deed (*Sundays* is, however, the work of Niss alone). The poem references the OuLiPo's techniques of writing under constraint by initially presenting a screen of scrambled and nonsyntactical black text imaged on a white

Sundays in the Park

is	tart	warren	baghdad	come	cheap	dyed	four	know	wee puns
of	master	ruction	know	manticore		in which	book	of	
my this	tickle	or so	loot in	four	scree	nor	page	in	nation
where	know won	reeds	fill awe sophies			choice tie	runs		
spy	gestation	burns	four	ash	ayes	in	croft	fair	swell
way	veer	low	bunk	cull	tom	conned	lisa		rise
over zion	kills	palestinians	imp	ants	swarm	seat	bud	dies	
bodies	in crust	sty ankle	men see	four	work	rim	in all	sorts	
on	ice	cream	sun	day	sin	the	ark		

Figure 9. Screen shot, *Sundays in the Park*

rectangle. The text's political content suggests that it was composed from snippets lifted from newspaper headlines, such as one might peruse while sitting on a park bench on Sunday afternoon. The user interacts with the work by clicking on word clusters, which then cycle through a series of homophonic variants while two female voices each "read" from different portions and versions of the text in a looping soundtrack. When the user clicks on "wee puns," for example, the text cycles to "weapons," and another click on "of mass ruction" brings to the surface "of mass destruction," and yet another click, "mass erection." Clicking "fill awe sophies" yields "phil law so fees," and then "philosophies," while "conned lisa rise" becomes "Condoleeza Rice." The witty puns create resonances between and among word clusters, so that the text is under-

stood as a constantly shifting multileveled work of which only a portion is visible (and audible) at any given time.

Automating the homophonic variants that are the stock in trade of literary language, *Sundays in the Park* brings to conscious attention the link between vocalization and linguistic richness. Having the puns appear explicitly on the screen while the automated voices articulate portions and versions of the text makes explicit the role that machine cognition plays in the process, for the computer can seamlessly generate both text and sound because both are ultimately represented in binary code.[20] Once again, channels are opened between embodied processing and conscious thought in ways that enmesh human perception with machine cognition, language with code, continuous analogue speech with digital processing.

My final example of recursive interaction comes from John Cayley's *Translation*, in collaboration with Giles Perring, who designed and produced the sound.[21] For several years, Cayley has been exploring what he calls "transliteral morphing," a computational procedure that algorithmically morphs, letter by letter, from a source text to a target text. Cayley has written eloquently about the implications of this technique, designed to explore the analogy between the discreteness of binary code and the discrete nature of alphabetic languages. (A sinologist and translator of Chinese poetry, Cayley is especially aware of the differences between alphabetic and morphographic systems of inscription.) In an essay on "Overboard" (a precursor of *Translation*), Cayley writes, "Iterative transliteral morphs between related texts—texts that might be seen, for example, as rewrites in differing styles—will reveal abstracted underlying structures supporting and articulating the 'higher-level' relationships between the texts."[22] Everyone would agree, of course, that different translations of the same source text have structural similarities. Whether the

translations are different versions in the same language or renderings in different languages, we would expect to find relationships that include conceptual, semantic, and syntactical similarities. Cayley conjectures that underlying these "higher-level" relationships are lower-level similarities that work not on the level of words, phrases, and sentences but individual phonemes and morphemes. These "literal" (a pun on "letter" and the "literal" materiality of letters) relationships are analogous, Cayley suggests, to the "literal" nature of assembly language and the discrete symbolic system of ones and zeros with which it correlates. In this sense his project resonates with the work of Maria Mencia, discussed in chapter 2, exploring the relation between alphabetic language and the transformation it undergoes when represented through the layers of interlinked computer code. Just as Mencia invokes the philological history of language as it moves from orality to writing to digital representation, so Cayley's transliteral morphs are underlain by an algorithm that reflects their phonemic and morphemic relations to one another.

Imagine a table, Cayley explains, in which the twenty-six letters are arranged in a circle. To get from a letter in the source text to the letter in the target text, the algorithm traces a route clockwise or counterclockwise around the table (whichever yields the shorter route), displaying each of the letters in turn as it moves from source to target. Moreover, to give the impression the text as a whole is in constant motion, the *rate* at which the letters are displayed moves faster when the route is longer, slower when it is shorter. Thus the transliteral morphing provides the user with a visual representation both of graphemic/phonemic relationships between the source and target texts and, through the speed at which a given letter sequence morphs, of the philological distance between the two texts. The complexity of these relationships as they evolve in

time and as they are mediated by the computer code, Cayley conjectures, are the microstructures that underlie, support, and illuminate the high-level conceptual and linguistic similarities between related texts.

The correlations between higher- and lower-level relationships can be revealed (watching the morphs) by activating channels of communication between embodied practice, tacit knowledge, and conscious thought. *Translation* evokes such connections through the multiple symbolic and semiotic systems it employs. On the screen's right side are source texts undergoing transliteral iterations that cycle through three different languages—French, German, and English—and through three different states, which Cayley tropes as floating (that is, momentarily existing in a fully legible state), surfacing (com-ing into legibility), and sinking (becoming illegible). The changes are discrete and happen letter by letter, as in all of Cayley's transliteral works, but here, in addition, they are coordinated with tonal changes in the ambient music. On the screen's left side are two different visual systems (one showing pieces of text as they are parsed by the algorithm and the other a series of abstract forms) that signal how the algorithm is proceeding. Cayley suggests that if a user watches these long enough while also taking in the transliteral morphs, she will gain an intuitive understanding of the algorithm, much as a computer game player intuitively learns to recognize how the game algorithm is structured. The music helps in this process by providing another sensory input through which the algorithm can be grasped.

While all this is happening through embodied and tacit knowledge, the conscious mind grapples with the significance of the transliterating text. The source texts include an early essay by Walter Benjamin, "On Language as Such and on the Language of Man,"[23] in which Benjamin suggests that "[t]here

Figure 10. Screen shot, *Translation*

is no event or thing in either animate or inanimate nature that does not in some way partake of language, for it is in the nature of all to communicate their mental meanings" (107). For Benjamin, the fact that every*thing* in the world has signifying powers implies the existence of God. Human language, for him, is an imperfect translation of a divine language implicit in things. "It is the translation of the language of things into that of man" (117). While Benjamin's essay thus posits a connection between divine agency and the signifying power of things, *Translation* subjects his language itself to the intermediating agency of the machine through transliteral morphs designed to reveal relationships between machine code and Benjamin's prose.

Revealing and Transforming

The technique would seem to be authorized by Benjamin himself, for in a passage that Cayley cites, Benjamin writes, "Translation is removal from one language to another through a continuum of transformations. Translation passes through continua of transformation, not abstract areas of identity and similarity" (117). It is important to note, however, that Cayley's interpretation of Benjamin's essay is a strong misreading in the Bloomian sense. For Benjamin the transcendent language associated with God ensures translatability of texts, while for Cayley the atomistic structures of computer and human languages are the correlated microlevels that ensure translatability. We might say that while Benjamin looks upward for the translating force, Cayley looks downward. Cayley elides this crucial difference by selectively quoting from Benjamin's essay. This can be seen in the passage immediately following the one that Cayley cites, where Benjamin writes:

> The translation of the language of things into that of man is not only a translation of the mute into the sonic; it is also the translation of the nameless into name. It is therefore the translation of an imperfect language into a more perfect one, and cannot but add something to it, namely knowledge. The objectivity of this translation is, however, guaranteed by God. For God created things; the creative word in them is the germ of the cognizing name, just as God, too, finally named each thing after it was created. (117–18)

The knowledge added by the correlated microstructures of philology and binary code, by contrast, interpolates computer language into the heart of human inscription. The "objectivity" of this translation is guaranteed not by God but by

the entwining of human and computer cognitions in our contemporary mediascapes.

Also correlated are human and machine enactments of time. Another source text for *Translation* is Marcel Proust's masterwork *In Search of Time Past*. The following quotation illustrates Cayley's transliteral technique. In English translation and in its "floating" state the passage reads, "What I want to see again is the way that I knew that landscape whose individuality clasps me with an uncanny power and which I can no longer recover." It thus evokes both the mnemonic power and the temporal ephemerality of an ambient landscape, qualities enacted in different ways by *Translation* as a time-based digital remediation of Proust's durably inscribed print work. In one of the fleeting transliteral morphs the passage becomes:

> what i want to cee again
> ic the vay that i kne
> that landccaqe whoca indivi uality
> slasps me with an unc nny power
> and whjsh i can no longe recover

The phonemic and graphemic relationships begin to emerge by following the sequence of transformations. Here, for example, "s" becomes "c," and "p" becomes "q" when it appears in the middle of a word but not (yet) at the beginning of a word. These transformations serve to correlate the user's attention with the algorithms determining how the transliterations work.

In his most recent variation of this work, titled *Imposition*, Cayley with his collaborators Giles Perring (sound) and Douglas Cape (digital images) has sonified the work further by adding vocalizations of the letters as they appear on screen. In

a performance at the OpenPort symposium at the Art Institute of Chicago,[24] Cayley enlisted audience members to download versions of the different states (English, French, and German) from a website. At the performance, laptops throughout the space began playing versions while Cayley projected the full implementation on the front screen. Vowels and consonants rang out from different locations while the ambient music played. Moreover, in this mutation Cayley emphasized the time element by having the text appear sequentially. At first only a few letters appeared; then, as more were added, the chorus of articulated letters swelled to a climax achieved when the full range of texts was reached, followed by a gradual diminution while a last plaintive letter was sounded and the screen went entirely dark. The stunning effect was to create a multimodal collaborative narrative distributed on laptops throughout the performance space, in which different sensory modalities and different ways of knowing entwined together with machine cognition and agency.

In other recent work, Cayley has focused on the ways in which our intuitive knowledge of letter forms can define space and inflect time. Working in the CAVE environment at Brown University, he and his collaborator Dmitri Lammerman created *Torus*, a virtual reality installation in which sixteen vanes of text are arranged like slices through a doughnut.[25] This torus shape is doubly virtual, for it is not imaged as such but rather is brought into existence by the text slices that implicitly define it for the user. The play between what the user's imagination constructs and what is actually visible transforms the typical situation in literature, in which the user decodes words to create an imaginative space in which the action takes place. By contrast, space actually exists in the CAVE room, and the user explores it through embodied actions such as walking, turning, and listening. At the same time, the user can also read

the text and recreate for herself the imagined world of Proust's *Remembrance of Time Past* that appears on the torus vanes.

Further complicating the writing surfaces is yet another dynamic—the relation between the virtual text and the massive computations generating it. Unlike durable ink inscription, here the text is a virtual image and so is capable of transformations impossible for print. In this installation, the text demonstrates its agency by moving in space, responding to the user's spatial orientation by always turning to face the viewer. Through this motion the user experiences a temporal dimension of the text—its motion so that it is always right-reading—acting in complex synchrony with the time of reading and the time of spatial exploration through the CAVE environment. These temporal interactions, as well as the virtual/actual spatiality of the textual surfaces, create an enriched sense of embodied play that complicates and extends the phenomenology of reading.

Influence can flow in the opposite direction as well, from the phenomenology of reading back into the installation. This effect was discovered when a glitch in the program caused letters that were proportionately smaller, and thus perceived as farther away, to be rendered over larger letters in the foreground. To reconcile the contradiction, users perceived the smaller letters as if they were inscribed on the back wall at the end of a corridor—a corridor that did not exist except in the user's perception. Cayley theorizes that our extensive experience with letter forms subconsciously affects perception, so users struggle to create a scene that preserves the integrity of letter forms while still making phenomenological sense. In this understanding, *Torus* becomes not only an experiment in the enriched phenomenology of reading but also in the complex interplay between our traditional experience with letter forms and our much more recent understanding of computa-

tion. Reading in this view becomes a complex performance in which agency is distributed between the user, the interface, and the active cognitions of the networked and programmable machine (or in Cayley's preferred terminology, the "programmaton").

Cayley further explores the phenomenology of reading in *Lens,* designed first as a CAVE installation and then transferred to a QuickTime maquette.[26] The pun suggested by the title hints that letter forms are not only figures we decode, but also the lens through which (and by means of which) we perceive spatiality. As Cayley remarks in distinguishing his "literal art" from Concrete, the print tradition of shaped language works by creating a visual correspondence between an object and letter forms, thus correlating the reader's decoding of text with the visual recognition of forms representative of real-world objects (*Lens*, 6). Concrete poetry typically does not investigate the phenomenology of letter forms as such, nor does it use our habitual experience with letter forms as a basis for experiments in perception such as Cayley carries out in *Torus* and *Lens.* By contrast, *Lens* creates a ground-figure reversal between large white letters spelling "lens" that, when zoomed into by the user, become the white ground against which dark blue letters become visible, previously unseen because they floated on a dark blue ground.[27] More zooming causes the blue letters in turn to become the dark ground against which more white letters become visible, and so on to infinity. Cayley summarizes the effect: "Literal graphic materiality is able to entirely and suddenly transform spatial perception and, at the same time, it creates an entirely new space for itself, for inscription and for reading. It creates the potential for a new experience of language" (*Lens*, 13).

These experiments in the phenomenology of reading are interpenetrated by another kind of exploration: what it means

for human cognition to come into contact with the cognition of the computer(s) generating the display. Cayley points to this interpenetration with a key question: "Is the display really a monitor of the programmaton's symbolic processing, or is it a window on computing's attempts to match and then exceed (through the incorporation of transactive or so-called interactive facilities) the illusionistic simulations of film and television?" (*Lens*, 6). The question suggests that the monitor screen functions simultaneously in two different modes: it can recreate filmic illusions, in which case the screen reflects and reinforces conventional visual assumptions; on the other hand, it can also perform as a dark window through which we can intuit the algorithms generating the display, as Cayley conjectured would be possible with *Translation*.

For text, the ability to function simultaneously as a window into the computer's performance and as a writing surface to be decoded puts into dynamic interplay two very different models of cognition. Traditionally, narrative text has been understood as a voice bringing into existence for the reader a richly imagined world. If that world is vibrant enough, a reader is apt to have the impression that the page has become a portal through which a world is called into being by the voice emanating from the book, a scenario Kittler associates with romantic poetry, as we saw in chapter 3, but that surely continues into the twenty-first century with the novel as it moves from realism to stream of consciousness to the disrupted continuities on display in *The Jew's Daughter*. The perceived voice connects the reader's own experience of interiority with a projected interiority of the author (and by extension, the narrator and characters), all of whom share a common bond in human perception and sense of self. The computer, by contrast, operates through commands often concealed from a user's direct inspection and that consequently must be intuited through the

computer's performance. However well a computer can simu-
late text and thereby recreate the voice characteristic of nar-
rative fiction, it remains a machine processing binary symbols
as specified by the logic gates. Mediating between the brute
logic of these machinic operations and human intentions is the
program that, when run, creates a performance partaking both
of the programmer's intentions and the computer's underlying
architecture as symbolic processor. In electronic literature, au-
thorial design, the actions of an intelligent machine, and the
user's receptivity are joined in a recursive cycle that enacts in
microcosm our contemporary situation of living and acting
within intelligent environments.

REVALUING COMPUTATIONAL PRACTICE

Brian Kim Stefans, in his extensive annotations to his com-
puter poem "Stops and Rebels" published in his print book
Fashionable Noise: On Digital Poetics, discusses the implica-
tions of entwining of computer and human cognition to cre-
ate literary language.[28] Following the observations of Veronica
Forrest-Thomson in her book *Poetic Artifice,* he notes that
every accomplished work of poetry (and I would generalize
this to every accomplished work of literary art) has elements
that resist totalizing interpretations—words and phrases that
stubbornly refuse to be assimilated into the interpretive frame-
work a critic proposes. This has implications, Stefans suggests,
for the critical project itself: "A critic trying to make a total
statement about a poem will be involved in a push-and-pull
with these non-meaningful elements, and no interpretation
is adequate if it does not bear the marks of this struggle" (69).
The critic's task, then, should not be to beat the refractory
elements into submission but rather to produce a work that,

within itself, enacts the struggle to achieve meaning that is the *agon* of interpretation. As Jerome McGann elegantly puts it in *Radiant Textuality: Literature after the World Wide Web*, meaning is not something literary texts produce but that for which they search.[29] It is the search, rather than a final or definitive interpretation, that the critic's writing should engage.

A randomizing algorithm such as Stefans employed to create his computer poem, by slicing, dicing, and mixing the source texts, makes unavoidable the confrontation with refractory elements. Although the juxtapositions created by the algorithm often result in serendipitous and witty combinations, just as often it creates combinations that no amount of critical exegesis can pound into sense. Yet these nonsensical elements are not without significance, for in their very nonsensicality they testify to the admixture of the nonhuman agency creating the text. Anthropomorphizing the computer program by calling it "the Demon," Stefans reads his computer poem as a performance enacting, in a highly visible way, the confrontation of human and nonhuman agency. He writes, "The ontological security of the self is constantly threatened by this prospect of limitless information and limitless recombination, turning anybody—even the nonprogrammer—into a version of the cyborg . . . timeless and placeless but still (in its residual humanity, its mortality) pursued by history" (145).

Stefans sees in this confrontation the possibility that the boundaries of the conscious self might be breached long enough to allow other kinds of cognitions, human and nonhuman, to communicate and interact. "The space between these poles—noise and convention—is what I call the 'attractor,' the space of dissimulation, where the ambiguity of the cyborg is mistaken as the vagary of an imprecise, but poetic, subjectivity. It is an inherently social space in which the reader is engaged with a bevy of forces: the demon (algorithmic process-

ing), language (mistakenly thought personal but now figured as information) and the social (mistakenly thought impersonal but now bearing on the everyday)" (151). Within this nexus, which is nowhere more entangled and intense than in electronic literature performed by networked and programmable media, ideas become more than disembodied concepts, emotions signify as more than irrational fleeting sensations, coded algorithms connect with human intuitions, and machine cognitions promiscuously mingle with conscious and embodied knowledges.

Through such intermediations, computation evolves into something more than a technical practice, though of course it is also that. It becomes a powerful way to reveal to us the implications of our contemporary situation, creating revelations that work both within and beneath conscious thought. Joining technical practice with artistic creation, computation is revalued into a performance that addresses us with the full complexity our human natures require, including the rationality of the conscious mind, the embodied response that joins cognition and emotion, and the technological nonconscious that operates through sedimented routines of habitual actions, gestures, and postures. Thus understood, computation ceases to be a technical practice best left to software engineers and computer scientists and instead becomes a partner in the coevolving dynamics through which artists and programmers, users and players, continue to explore and experience the intermediating dynamics that let us understand who we have been, who we are, and who we might become.

CHAPTER FIVE

The Future of Literature

Print Novels and the Mark of the Digital

Nothing is riskier than prediction; when the future arrives, we can be sure only that it will be different than we anticipated. Nevertheless, I will risk a prognostication: digital literature will be a significant component of the twenty-first century canon. Less a gamble than it may appear, this prediction relies on the fact noted earlier that almost all contemporary literature is *already* digital. Except for a handful of books produced by fine letter presses, print literature consists of digital files throughout most of its existence. So essential is digitality to contemporary processes of composition, storage, and production that print should properly be considered a particular form of output for digital files rather than a medium separate from digital instantiation. The digital leaves its mark on print in new capabilities for innovative typography, new aesthetics for book design, and in the near future new modes of marketing. Some bookstores and copy shops, for example, are investing in computerized xerography machines that produce books on the spot from digital files, including cover design, content, and binding.[1] Also available are electronic book-like devices that can be taken to a bookstore where the electronic files comprising the

text can be purchased, downloaded, and read at leisure on the device.

As these examples suggest, print and electronic textuality deeply interpenetrate one another. Although print texts and electronic literature—that is, literature that is "digital born," created and meant to be performed in digital media—differ significantly in their functionalities, they are best considered as two components of a complex and dynamic media ecology. Like biological ecotomes, they engage in a wide variety of relationships, including competition, cooperation, mimicry, symbiosis, and parasitism. These dynamic interrelations can be observed in the complex surfaces emerging in contemporary digital and print literature. As John Cayley remarks, "The surface of writing is and always has been complex. It is a liminal symbolically interpenetrated membrane, a fractal coast- or borderline, a chaotic and complex structure with depth and history."[2] Although complex surfaces are scarcely new, as Cayley reminds us, the surfaces created in the new millennium have a historical specificity that comes from their engagement with digitality. This engagement is enacted in multiple senses: technologically in the production of textual surfaces, phenomenologically in new kinds of reading experiences possible in digital environments, conceptually in the strategies employed by print and electronic literature as they interact with each other's affordances and traditions, and thematically in the represented worlds that experimental literature in print and digital media perform.

In discussing the surfaces of contemporary writing, Noah Wardrip-Fruin comments that "there is [always] something behind the surface." He continues, "Behind poetry, fiction, and drama on paper surfaces there are processes of writing, editing, paper and ink production, page design, printing and binding, distribution and marketing, buying and borrowing."[3]

Wardrip-Fruin's main interest lies in "works that might be regarded as especially inseparable from some of their processes," that is, digital literature (1). My focus here is on the other partners in the complex ecology of contemporary ligature—namely, the complex surfaces of print. Engaged in robust conversation with digital textuality, the print novels discussed here both acknowledge their position within the print tradition and reproduce on their surfaces the marks of digital processes that engendered them as material artifacts. As we know, the novel was instrumental in performing an interiorized subjectivity based on the relation between sound and mark. As literary technologies change, the subjectivities they perform and inform change as well. How does the mark of the digital relate to the subjectivities performed and evoked by today's experimental print novels? Print's engagement with contemporary media has been accompanied by a persistent anxiety among print authors that the novel is in danger of being superseded, with readers seduced away from books by television, blockbuster films, video games, and the vast mediascape of the World Wide Web. Analyzing this trend, Kathleen Fitzpatrick in *The Anxiety of Obsolescence: The American Novel in the Age of Television* has argued that the *perception* of risk is more important than the reality.[4] She convincingly documents that anxiety about obsolescence is widespread, especially among younger white male writers. Rather than asking if there is evidence that the "literary" novel may in fact be losing audience share to other entertainment forms, however, Fitzpatrick asks what cultural and social functions are served by pronouncements about the death of the print novel. She argues they have the advantage of establishing the novelists as an at-risk minority (a state that Bruce Sterling satirizes in his novel *Distraction*)[5] while still allowing this group to retain their hegemonic position as white male authors. In my

view, the situation is more complex than Fitzpatrick allows. As we have seen, empirical data indicate that young people are spending less time reading print books and more time surfing the Web, playing video games, and listening to MP3 files.[6] Nevertheless, Fitzpatrick is certainly correct in pointing to the perception of print authors that they are in danger of becoming obsolete.

This anxiety of obsolescence has a complex relation to the recent explosion of creativity in contemporary print novels. On the one hand, print authors fear that print might be regarded as old fashioned and boring in the face of new media, especially electronic texts that can dance to music, morph to suggestive shapes, and perform other tricks impossible for the durable inscriptions of print. On the other hand, print itself is capable of new tricks precisely because it has become an output form for electronic text. If the seductions made possible by digital technology are endangering print, that same technology can also be seen as print in the making: we have met the enemy and he is us.

The attempt of the print novel to one-up electronic textuality is thus inextricably entwined with the simultaneous recognition that electronic textuality makes possible many of its innovative developments. The complexity of this dynamic can be seen in the emergence of two apparently opposed but actually complementary strategies: *imitating* electronic textuality through comparable devices in print, many of which depend on digitality to be cost effective or even possible; and *intensifying* the specific traditions of print, in effect declaring allegiance to print regardless of the availability of other media. Recursively entwined, the two strategies often appear together in the same text. Moreover, they tend to morph into one another, much as a Möebius surface goes from inside to outside

to inside, so there is necessarily a certain amount of arbitrariness in labeling a given instance as either imitating electronic textuality or intensifying print traditions.

For the novels discussed below, digital technologies have completely interpenetrated the printing process. Moreover, the novels are located within a robust media ecology increasingly dominated by digital representations, including CG effects in films, audio CDs and video DVDs, digital projectors, the internet and the World Wide Web. Their historical specificity comes not only from the fact that digital technologies are deeply involved in their creation but also from the ways in which, as material signifying systems with graphic, textual, haptic, and kinesthetic components, they engage digital technologies on multiple levels while still insisting on their performance as print texts, specifically through strategies of imitation and intensification.

Below are listed the major characteristics of digital text around which the dance between imitation and intensification takes place.[7]

- *Computer-mediated text is layered.* As we saw in chapter 2, generating the text that appears on screen are cascading processes of interpretation, from the hypertext mark-up language tags that format text on the World Wide Web, to compiled/interpreted programming languages like C++, down to the mnemonics of assembler, and finally to binary code and the alternating voltages with which it is associated. Recalling the terminology of scriptons (strings that the user sees) and textons (strings in the text) introduced in chapter 1, we can say that in computational media, there are always texts that users (almost) never see, ranging from source code to object code to the

alternating voltages that correlate with assembly language. Hence the layered nature of code also inevitably introduces issues of access and expertise.

- *Computer-mediated text tends to be multimodal.* Because text, images, video, and sound can all be represented as binary code, the computer becomes, as Lev Manovich maintains, the medium that contains all other media within itself. The increasingly visual nature of the World Wide Web vividly illustrates the point, as well as the growing number of websites containing QuickTime movies and video clips.

- *In computer-mediated text, storage is separate from performance.* With print, storage and performance coalesce within the same object. When a book is closed, it functions as a storage medium, and when it is opened as a performance medium. By contrast, with computer-mediated text the two functions are analytically and practically distinct. Files played on a local computer may be stored on a server across the globe; moreover, code can never be seen or accessed by a user *while it is running*. As Alexander Galloway has pointed out, code differs from human-only language in that it is executable by a machine. (While it might be argued that humans "execute" language in the sense of processing it through sensory-cognitive networks, they do so in such profoundly different ways than machines run code that it seems wise to reserve the term "execute" for processing computer code).

- *Computer-mediated text manifests fractured temporality.* With computer-mediated text, the reader is not wholly (and sometimes not at all) in control of how quickly the text becomes readable; long load times, for example, might slow down a user so much that the screen is never read. Moreover, even when the screen text is visible, as Stepha-

nie Strickland has argued, the mouseovers, fine cursor movements, and other affordances of electronic display and reading fracture time into much more various and diverse scales than is the case with print texts.

To demonstrate how these characteristics provide focal points for the recursive dynamic between imitation and intensification, I will take as my tutor texts three contemporary novels, which despite (or perhaps because) of their wild strains of exuberant experimentation, have attracted mass audiences: Jonathan Safran Foer's *Extremely Loud and Incredibly Close,* Salvador Plascencia's *The People of Paper,* and Mark Danielewski's *House of Leaves.*[8] The strategies employed by these texts show print novels engaged in robust conversations with electronic textuality. In this sense they stoutly resist the tendency that Lev Manovich sees for the "cultural layer" to be converted into the "computer layer" in an accelerating curve of assimilation.[9] At the least, they complicate what assimilation might mean by reinterpreting how the computer layer signifies. Beyond this, they demonstrate the resilience of print culture by responding to the predations of computerization with bursts of anxious creativity.

DIGITALITY AND THE PRINT NOVEL

Imitations of the numerical representations of electronic texts appear in their most straightforward form when numerical codes appear as part of the linguistic surface of a print novel. In *Extremely Loud and Incredibly Close,* a particularly poignant moment arrives when Thomas Schell, now a grandfather who has lost his only son in the Twin Towers disaster, attempts to reconnect with his wife, whom he abandoned

when she told him she was pregnant. He has not seen or talked with her for forty years. Traumatized as a young man by the fire bombing of Dresden, Thomas has lost the ability to talk and communicates through written notes, gestures, and "yes" and "no" tattooed on his hands. After arriving in New York, still unable to speak, he telephones his estranged wife and in a procedure familiar to users of Moviefone taps out a numerical code using the key pad, in which a single digit can stand for any one of three letters (269–72). Cryptologists call this kind of code a "one-way algorithm": easy to construct, it is difficult (and sometimes impossible) to decrypt. Lacking any indication of where the breaks between words occur and faced with mounting uncertainties about which of the three letters is the correct choice, the reader is confronted with possible combinations that increase exponentially as the message grows in length. And this message does go on, for some three pages of single digits separated by commas. An extraordinary amount of patience is required to work through this code; I confess that I have decrypted only the first page and a half. Nevertheless, the code is positioned at a decisive juncture when Thomas seems to realize what a monumental mistake he made in abandoning his wife and unborn child. The stakes for the reader in understanding the dialogue, one might suppose, are considerable.

Why write it in code? Many reviewers have complained (not without reason) about the gimmicky nature of this text, but in this instance the gimmick can be justified. It implies that language has broken down under the weight of trauma and become inaccessible not only to Thomas but the reader as well (even when Thomas was unable to speak, the narrative shared his thoughts with readers). Moreover, what his wife hears are the beeps to which the numerical codes correspond; "Your telephone is not one hundred dollars," she says. The comment

hints that the text is performing a satiric inversion of Claude Shannon's information theory. As we saw in chapter 2, Shannon drew a sharp distinction between the informational *content* of a message and its *meaning*, insisting that his theory was not concerned with meaning because meaning could not be reliably quantified.[10] Even at this moment of imitating the computer's numerical representation, the text operates so as to deconstruct Shannon's famous diagram of the communication circuit (which proved crucially important to the emerging science of informatics).[11] The diagram shows a sender encoding the message so it can be sent as a signal through a channel, the channel being subjected to interference by a noise source, and a receiver decoding the signal to reconstitute the message. Although the formulations offered in chapter 2 suggest that meaning can nevertheless be associated with Shannon's probability equations, the traditional and long-standing interpretation of this communication diagram leaves meaning out of the picture, and it is to this reading that Foer's scene acts as a critique.

As Foer represents the situation, there is no problem with noise in the channel; the machine transmits the encoded message with complete accuracy. Rather, it is the message's *human* import that is at stake. Each component is freighted with meaning that resides in the text but outside the communication circuit as Shannon constructed it. The encoding is undertaken not in order to send a message through a channel—its presumed function for Shannon—but rather because the message is too associated with trauma to be directly articulated. The channel, which normally would be vulnerable to noise, sends the message through perfectly, but Thomas's wife interprets the encoded signal as meaningless static. The reader has a better chance of decoding the numerical signals to reconstitute the message, but the decryption process takes so long to

do by hand that it is probably feasible only if one were to create a computer algorithm that would correlate the letter groups with a dictionary to determine the possible words, and then use information about syntax and word order to decide on the most likely choices for the message content. Since writing such a program would take considerable effort and programming skill, it is likely that message will never be decrypted, an outcome that could be read as the triumph of numerical representation over analogue meaning.

Even without knowing precisely what the numerical code represents, however, we understand well enough the message's import: Thomas is laden with guilt, he wants to reconcile with his wife, and he wants to "reach YES" (in code, 7,3,2,2,4,9, 3,7) so he and she can share what life remains possible for them (269). Thus what initially appears as imitation of the numerical representation of language, the modus operendi of the digital computer, turns into intensification of techniques native to the print novel.

Layered text, another characteristic of the computer's hierarchical architecture, appears in Foer's novel at the climactic point when Oskar Schell, the precocious nine-year-old whose father died in the Twin Towers fire, makes contact with the man he knows only as his grandmother's "roomer," actually his grandfather Thomas Schell who has again taken up residence with his wife. Forbidden to reveal himself to Oskar, Thomas and the child nevertheless slowly begin to get to know one another. Eventually Oskar shares with him his terrible secret. On the fateful day of 9/11, he was let out of school early and returned alone to his apartment to find on the answering machine four messages from his father, desperate to reach his family. While Oskar was in the apartment, the phone rang a fifth time, but he was so traumatized by the knowledge of the events of that day that he was unable to answer. The an-

swering machine recorded his father repeatedly asking "Are you there?" as if he could intuit Oskar's listening.

When Oskar replays the messages for his grandfather, the text visually breaks up on the page, as if imitating the noisy call imperfectly recorded by the machine. As the grandfather's narration continues, the lines are crunched closer and closer together (281). They quickly become illegible but nevertheless continue on for several pages until the surfaces are almost completely black. The text, moving from imitation of a noisy machine to an intensification of ink marks durably impressed on paper, uses this print-specific characteristic as a visible indication of the trauma associated with the scene, as if the marks as well as the language were breaking down under the weight of the characters' emotions. At the same time, the overlapping lines are an effect difficult to achieve with letter press printing or a typewriter but a snap with Photoshop, so digital technology leaves its mark on these pages as well.

what I'd wanted, but if it was necessary to bring my grandson face to face with me, it was worth it, anything would have been. I wanted to touch him, to tell him that even if everyone left everyone, I would never leave him, he talked and talked, his words fell through him, trying to find the floor of his sadness, "My dad," he said, "My dad," he ran across the street and came back with a phone, "These are his last words."
MESSAGE FIVE.
10:22 A.M. IT'S DA S DAD. HEL S DAD. KNOW IF
 EAR ANY THIS I'M
 HELLO? YOU HEAR ME? WE TO THE
ROOF EVERYTHING OK FINE SOON
 SORRY HEAR ME MUCH
 HAPPENS, REMEMBER—

Figure 11. Noise as irregular spacing in *Extremely Loud and Incredibly Close*

The top lines (legible portions before text becomes overprinted):

el and be with her. It makes us worry so much," she said, unbuttoning her shirt, I un-
uttoned mine, she took off her pants, I took off mine, "We worry so much," I touched
er and touched everyone, "It's all we do," we made love for the last time, I was with her
nd with everyone, when she got up to go to the bathroom there was blood on the sheets
went back to the guest room to sleep, there are so many things you'll never know. The
ext morning I was awoken by a tapping on the window, I told your mother I was going
or a walk, she didn't ask anything, what did she know, why did she let me out of her sight?
Oskar was waiting for me under the streetlamp, he said, "I want to dig up his grave."
ve seen him every day for the past two months, we've been planning what's about to happen, down to the
mallest detail, we've even practiced digging in Central Park, the details have begun to remind me or rules, I can tel

Figure 12. Traumatic page in *Extremely Loud and Incredibly Close*

The recursive dynamic between print and digital technologies is apparent in the text's final pages. Oskar has found on the internet a grainy video of a man falling from the Twin Towers. Although the resolution is too fuzzy to make out the man's features, Oskar speculates it might have been his father. Having more or less come to terms with his father's death, he cannot resist indulging in a final fantasy. He imagines that his father, rather than falling, flies upward through the sky to land on top of the building, goes down through the elevators, and walks backward through the street until he flings open the door and returns to safety in the apartment. The novel remediates the backward-running video in fifteen pages that function as a flipbook, showing the fantasized progression Oskar has imagined (327–41). On the one hand the poor resolution makes clear the book is reproducing digital images, thus sug-

The Future of Literature

gesting that the book is imitating electronic text. On the other hand, the flipbook functionality recreates the distinction between storage and performance characteristic of digital media, but now in a form historically specific to the print book. Once again, imitation and intensification cohabit these pages.

My next set of examples comes from *The People of Paper*, beginning with the passage in which the thoughts of the mechanical tortoise are represented as a square block of ones and zeros (97). The reader is tempted by the possibility of decoding, for it is possible to take the series and, using the byte equivalents for ASCII, find out if it constitutes an intelligible message. That is probably not the point, however (how interesting are the thoughts of a mechanical tortoise likely to be?). Rather, as with the telephone key pad, the payoff comes precisely in *not* being able easily to decode the numbers, in the shock of discovering the witty and appropriate substitution of numerical code for human-only language. The mechanical tortoise enters the story because Federico de la Fe, disturbed that "Saturn" (the pseudonym by which the characters know the author) can read his thoughts, mobilizes a resistance movement that uses the tortoises' lead shells to shield the characters' consciousnesses from Saturn's prying surveillance. When the surviving tortoise's thoughts come under the same surveillance, we find they are in a sense already shielded because they register the bifurcation between human-only language and the binary code that is the only language intelligent machines can understand.

The introduction of the author-as-character sets up an ontological hierarchy dramatized within the text by Saturn's position in an upper world whose bottom forms the sky of the other characters. Disrupting this hierarchy, the lead shields reproduce within the story world the distinction between a linguistic surface and underlying symbols, hiding the characters'

language and thoughts as a computer screen of text hides the code generating it. The text thus enacts two different ways of ordering the chain of signifiers: on the one hand, an accessible linguistic surface; on the other, a layered hierarchy that makes language differentially accessible in a scheme that correlates access with power. This contrast provides the plot's central conflict, as Saturn tries to make Federico de la Fe's thoughts appear as a linguistic surface, whereas Federico de la Fe struggles to have them become subtextual and thus invisible on the page. The values associated with the different ordering schemes are complicated by the fact that Federico de la Fe, chief of the EMF (El Monte Flores) gang, interprets his "war" with Saturn as a fight for independence, understood by the EMF resistance movement as the quintessential human value.

Further complicating the ontology implicit in the book's materiality is the partitioning of some chapters into parallel columns, typically with three characters' stories running in parallel on a page spread, as if imitating the computer's ability to run several programs simultaneously. Significantly, the columns portraying Federico de la Fe's thoughts are typically headed not with his name but with Saturn's. When Saturn cannot see his thoughts, the column is blank. In columns headed by other characters' names, by contrast, the reader has access to the characters' thoughts even when Saturn does not. But one character is able to hide his thoughts from both author and reader even without a lead shell—a drooling infant boy so unresponsive that most people assume he is severely retarded. In actuality, we are told, he is the reincarnation of the prophet Nostradamus, gifted with the ability to see the past and future as well as the present. His consciousness appears within the text as a solid black column, a shield of ink hiding the text that presumably lies underneath, just as computer code is hidden by the text it generates.

While my father and Froggy loaded the
turtle shells into the bed of the truck,
I went to talk to the woman who shuffled
tarot cards. As I got closer to her table,
I realized that it was the Baby Nostra-
damus and his mother, except that her
arms were now raw and burnt.

I patted the Baby Nostradamus's head
and asked the mother what had happened
to her arms—they were not stars, just
burns without meaning.

She offered to tell my fortune with the
help of her baby. She grabbed my hands,
squeezing my fingers while I stared into
the eyes of the Baby Nostradamus.

As she traced my lifeline, the blister
on the tip of her index finger ruptured,
and the fluid channeled into the ruts of
my hand. The outer lines of my palm
became tributaries feeding into the main
river. I lifted my hand toward my face and
saw that I was holding the river of Las
Tortugas. As I looked closer I saw our old
adobe house and the orchard that lined the
river, the trees heavy with limes. A family
with goats and dinner doves had moved in
and planted maize on the dirt roof.

Downstream, at the cliff of my hand,

Figure 13. Baby Nostradamus's blacked-out thoughts, *The People of Paper*

Within the narrative world, however, this apparent imita-
tion of computer code's hierarchical structure is interpreted as
the baby's ability to hide his thoughts from the reader as well
as from Saturn, an interpretation that locates the maneuver
within the print novel's tradition of metafiction by playing
with the ontological levels of author, character, and reader.
Moreover, when Little Merced manages to communicate with
the baby and learns from him how to shield her thoughts as
well (a process visualized on the pages by uneven blobs of
black that slowly grow more regular and extensive as she be-
comes more proficient), the blobs are figured not as computer

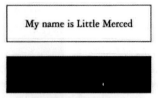

After the simple phrase, she hid compound sentences that utilized semicolons and commas, and soon could manage even full paragraphs. Her skill level increased, allowing her to take on complete, sophisticated thoughts. Thoughts that branched and strayed into tangents and then returned, only to split and sprawl again. She became so proficient that she was able to elude even the Baby Nostradamus:

When she succeeded and her thoughts were impenetrable, as a courtesy to her teacher Little Merced whispered the contents into the Baby Nostradamus's ear.

Figure 14. Little Merced practicing blacking thoughts, *The People of Paper*

layering but as the very human process of one child learning from another how to negotiate an adult world of differential power relations.

Another characteristic of electronic text that the narrative appears to imitate is mutability. In contrast to durable ink marks, electronic text can easily be deleted and replaced by other letters or spaces; with a touch of a key, it can appear in different fonts, sizes, and shapes. That the page can also be mutable (and mutilated) becomes apparent when Saturn en-

counters Liz, his ex-girlfriend, and hears her utter the name of the white man for whom she dumped Saturn. We never learn the rival's name, however, because the places on the pages where it would appear have been replaced by die-cut holes, Saturn's revenge on the name he cannot bear to hear. In a now-familiar pattern, a technique that at first appears to be imitating electronic text is transformed into a print-specific characteristic, for it would, of course, be impossible to eradicate a word from an electronic text by cutting a hole in the screen.

In *House of Leaves,* the recursive dynamic between strategies that imitate electronic text and those that intensify the specificities of print reaches an apotheosis, producing complexities so entangled with digital technologies that it is difficult to say which medium is more important in producing the novel's effects. All four characteristics of digital text are rampantly evident throughout. The text is richly multimodal, combining text, graphics, color, and nonlinguistic sound effects, along with many other media. Divided between Zampanò's critical commentary on the film *The Navidson Record* and Johnny Truant's footnotes to Zampanò's manuscript, it offers multiple data streams, including footnotes to Johnny's footnotes as well as interjections by the Editors, not to mention some two hundred pages of exhibits, appendices, and index. Layered text appears on many pages, for example as square brackets signifying indecipherable inscriptions or literal holes in the manuscript that hint at unseen text-behind-the-text; on other pages, text is overwritten onto other text, for example in Pelafina's letters in which overwritten words mimetically perform her disordered psychological state (623–28). Supposedly typed, these pages were obviously composed in a digital program such as Photoshop and printed from digital files, thus testifying to their previous existence as electronic text. Code also runs riot on the pages, including signal flag

was. I never meant to burn you. I never meant to mark you. You were only four and I was terrible in the kitchen. I'm sorry, so sorry, so so very sorry. Please forgive me please. Please. Please ForgiveforgivemeforgivemeforgivemeforgivemeforgiveForgivemeforgi vemeforgivemepleaseforgivemeforgivemeforgivemeforgive mepleaseforgivemeforgivemeforgivemeforgivemeforgi vemepleaseforgivemepleaseforgivemeforgivemeforgivemeforgivef orgivemeforgivemeforgivemepleaseforgivemepleaseforgiv emeforgivemeforgivemeforgivemeforgivemeforgivemeforgiv emepleaseforgivemeforgivemeforgivemepleaseforgivemefor givemeforgivemeforgivemeforgivemeforgivemepleaseforgive meforgivemeforgive... forgivemepleaseforgivemeforgivemepl easeforgivemefor... forgivemeforgivemefo rgivemeforgivemef... ive... pleaseforgiveme— ...

Figure 15. Pelafina's disordered "typed" thoughts, *House of Leaves*

codes used instead of Arabic numbers on some footnotes, astrological signs on other footnotes, dots and dashes of Morse code, and even a page of dots representing Braille. Responding to the digital environments that are affecting cognitive modes, this extremely complex book requires deep attention at the

same time that it titillates the most ravenous appetite for hyper attention multitasking.

As if positioning itself as a rival to the computer's ability to represent within itself other media, this print novel remediates an astonishing variety of media, including film, video, photography, telegraphy, painting, collage, and graphics, among others. This implicit rivalry came close to the surface in Danielewski's lengthy interview with Larry McCaffrey and Sinda Gregory.[12] Asked if the computer was important for the composition of this unusually designed text, Danielewski replied:

> I didn't write *House of Leaves* on a word processor. In fact, I wrote out the entire thing in pencil! And what's most ironic, I'm still convinced that it's a great deal easier to write something out by hand than on a computer. You hear a lot of people talking about how computers make writing so much easier because they offer the writer so many choices, whereas in fact pencil and paper allow you a much greater freedom. You can do anything in pencil! (117)

When McCaffrey pressed him on the issue, however, Danielewski admitted the necessity of digital technologies for the book's production:

> There's no doubt computers, new software, and other technologies play a big role in getting any book ready for production these days. They also make it easier for a publisher to consider releasing a book like mine that previously would have been considered too complicated and expensive to typeset by hand. Yet despite all the technological advantages currently available,

> the latter stages of getting *House of Leaves* ready for
> production involved such a great deal of work that
> Pantheon began to wonder if they were going to be
> able to publish it the way I wanted. So I wound up
> having to do the typesetting myself. (118)

Digital technology functions here like the Derridean *supplement;* alleged to be outside and extraneous to the text proper, it is somehow also necessary.[13] The construction suggests that at issue is the text's ability to posit its origin without digital technology and that, conversely, including digital technology would alter the text's fundamental view of its own ontology.

These suggestions become explicit in the text's consideration of how other media have been threatened, and implicitly transformed, by the interpenetration of digitality. Particularly revealing is Zampanò's discussion of digital photography. Distinguishing between documentaries and films representing fictional stories, Zampanò notes that documentaries "rely on interviews, inferior equipment, and virtually no effects to document real events. Audiences are not allowed the safety net of disbelief and so must turn to more challenging mechanisms of interpretation which, as is sometimes the case, may lead to denial and aversion" (139). The film at the book's center, *The Navidson Record,* purports to be a documentary, but the main object of its representation, the house on Ashtree Lane into which Will Navidson moves with his partner Karen Green and their two children in an attempt to shore up the couple's shaky relationship, turns out to be an impossible object whose inside is bigger than its outside. At first the surreal excess measures a mere quarter of an inch but then stretches into distances greater than the diameter of the earth and older than the solar system. With its shifting walls, ashen surfaces, and labyrinthine complexities, the house's interior is not only im-

possible to map but also impossible to inhabit, for it destroys any artifact left within it. Combining an unrepresentable topography with an uninhabitable space, the house confronts those who enter its mysterious interior with the threat of nothingness that, far from being mere absence, has a terrible ferocious agency, figured by the beast-like growls Will and others think they hear issuing from its interior. Moreover, even the film that putatively records this impossible object has an indeterminate status, for as Johnny Truant informs us in his introduction, the film probably does not exist—which does not, however, prevent Zampanò from writing some five hundred pages interpreting it.

In a brilliant article, Mark B. N. Hansen has equated the house's unrepresentable space with digital technology, arguing that the digital image, unlike photography, needs no original object to anchor its representation.[14] The digital in Hansen's terminology (following Bernard Stiegler) is "post-orthographic" because it is not compelled to represent actual events but can seem to record the past while not in fact doing so. (In this somewhat idiosyncratic terminology, orthography [or "straight writing]" designates "the capacity of various technologies to register the past as past, to inscribe the past in a way that allows for its exact repetition" ["Digital Topography," 603].) Simply put, Hansen's article sets up a kind of syllogism: the house is unrepresentable; digital technology does not need a preexisting object to create its representations; therefore the "house is nothing if not a figure for the digital: its paradoxical presence as the impossible absence at the core of the novel is a provocation that . . . is analogous in its effects to the provocation of the digital" ("Digital Topography," 609). The final twist is to argue that in the face of the abyss created by an unrepresentable object, meaning can be recovered only through the effects of the house on embodied

observers, effects registered first on the body as preconscious experience and then brought back into articulation as the characters' experiences.

In Hansen's argument, a slippage occurs in the equation of the house as an unrepresentable object with digital technology's ability to create simulacra; in his formulation, the house "reveals the digital to be a force resistant to orthothesis as such, to be the very force of fiction itself" ("Digital Topography," 611). Although it is true that digital technologies can create objects for which there is no original (think of Shrek, for instance), the technology itself is perfectly representable, from the alternating voltages that form the basis for the binary digits up to high-level languages such as C++. The ways in which the technology actually performs plays no part in Hansen's analysis. For him the point is that the house renders experience singular and unrepeatable, thus demolishing the promise of orthographic recording to repeat the past exactly. Because in his analogy the house equals the digital, this same property is then transferred to digital technologies.

Here one might object that, on the contrary, digital technologies render repetition more exact than has ever been possible before, allowing endless copies to be made with precision. If digital simulacra disrupt the tie between the object and its representation, thus breaking one-half of the orthographic promise to capture and repeat the past, it reinforces the other half, that is, exact repetition. The arrows of digitality's relation to orthothesis do not, then, all point in the same direction. More important, in my view, is an aspect of digital technology that Hansen's elision of its materiality ignores: its ability to exercise agency. In his account, meaning can be recovered only in the holistic effects of embodied experience because all that the digital can do is break the tie between representation and referent. In fact, however, the layered architec-

tures of computer technologies enable active interventions that perform actions beyond what their human programmers envisioned. In the field of artificial life, for example, programs have been constructed that produce species capable of mutating and evolving in unpredictable ways. Genetic algorithms go further in evolving not just the output of the programs but the programs themselves. Programmable gate arrays go further yet in evolving the hardware, changing the patterns of the logic gates to arrive at the most efficient way to solve certain problems.[15]

In *House of Leaves,* the house's agency occupies an indeterminate status figured by the beast whose presence (and absence) seem to haunt the house's interior. Never actually seen, the beast can be inferred from the deep claw marks that Johnny Truant finds beside Zampanò's body; the seeming growls recorded on *The Navidson Record;* and the "fingers of darkness [that] slash cross the lighted wall and consume Holloway" (338). Everywhere the beast is mentioned, the text wavers between representing it as an actually existing creature and a consensual hallucination created by the characters. In a typical passage, Johnny reproduces in the edited manuscript the unexplained burn holes that pepper Zampanò's notes, creating a play between the letters actually inscribed on the page and the absences signified by square brackets. "It seems erroneous to assert," Zampanò argues, "that this creat[]e had actual teeth and claws of b[]e (which myth for some reason [] requires). []t d[]d have claws, they were made of shadow and if it did have te[]th, they were made of darkness. Yet even as such the [] still stalked Holl[]way at every corner until at last it did strike, devouring him, even roaring, the last thing heard, the sound []f Holloway ripped out of existence" (338). Even as we reconstruct the noisy message for ourselves by supplying the missing letters, the brackets puncturing the text

evoke the nothingness that the beast paradoxically signifies in its very presence.

This play between the absence of presence and the presence of absence is intimately related to the house's ambiguous agency. Perhaps it acts on its own, or perhaps, as the fictional critic Ruby Dahl cited by Zampanò claims, the house merely reflects the personalities of those who venture inside it (165). Significantly, immediately after the beast consumes Holloway's body, the house goes crazy and eats Tom, as if infected by the psychosis that drove Holloway to hunt his comrades, murder one and wound another, and then commit suicide.

Following Hansen's key insight that there is a deep connection between the house and digital technologies, I arrive at a somewhat different explanation for its operation. Increasingly human attention occupies only the tiny top of a huge pyramid of machine-to-machine communication, including cell phones, networked computers, ATMs, and RFID (radio frequency identification) tags that give every indication of spreading faster than mold in New Orleans. Often these digital machines, ranging from the obvious to the nano scaled, are coupled with sensors and actuators that carry out commands, from something as mundane as raising a garage door to the world-shaking launch of a nuclear missile. We would perhaps like to think that actions require humans to initiate them, but human agency is increasingly dependent on intelligent machines to carry out intentions and, more alarmingly, to provide the data on which the human decisions are made in the first place. *House of Leaves* reflects these ambiguities in attributing the house's actions both to the humans who enter it and to the beast that can seemingly act on its own, a nonhuman creature whose agency is completely enmeshed with that of the characters, the author, and the reader.

For digital technologies, the initiation of action ultimately translates into binary code. From the brute simplicity of ones and zeros, the successive layers of code build up constructions of enormous complexity, from genetic algorithms that produce advanced circuit designs[16] to the digital typesetting programs that produced *House of Leaves* as a material artifact. Although humans originally created the computer code, the complexity of many contemporary programs is such that no single person understands them in their entirety. In this sense our understanding of how computers can get from simple binary code to sophisticated acts of cognition is approaching the yawning gap between our understanding of the mechanics of human consciousness—the neural structures, chemical transmitters, networked cells, and molecular interactions from which consciousness must emerge—and the apparent autonomy and freedom of human thought. The parallel with computers is striking. As Brian Cantwell Smith observes, the emergence of complexity within computers may provide crucial clues to "how a structured lump of clay can sit up and think."[17]

Yet human cognition is unlike machine cognition in being mediated through emotions and the complexities of bodily processing. Despite similarities in the cascading processes of interpretation instantiated in neural nets and coding languages, respectively, huge differences remain between human thought and machine processing. Computers process, store, and transmit data without any comprehension of their meaning in human terms, however complex its cascading processes are in their own right. Although creating computers that can achieve human meaning remains a research goal in such fields as artificial life, emotional computing, and artificial intelligence, it remains to be seen whether an intelligent machine

capable of sentience can ever be built. The nothingness with which the house—and the beast—are consistently associated in *House of Leaves* functions not only to deconstruct orthographic inscription but also to provide a figure for the differences between embodied human meaning and machine execution of code—differences that draw into question the stability of human autonomy and individuality and especially the unique status of human consciousness. So Daniel Dennett, in recognizing that consciousness must have emerged from non- and subcognitive processes in the course of evolution, acknowledges that others find this vision "so shocking" that they look desperately for arguments to retain the privilege of human thought and autonomy.[18] In *House of Leaves*, this possibility provokes textual strategies that hint at the absence of meaning and, paradoxically, others that engage in a riotous excess of meaning making.

As the litmus test separating human and machine cognition, meaning in *House of Leaves* may be recovered through the multiple layers of remediation that this print novel creates (as I have argued elsewhere),[19] and linked to embodied human reading (as Hansen argues). Yet another implication lurks in the layered complexities of this print novel. An ambiguous agent, the beast both threatens and mimics the agency of the human characters. Above all else, the characters in the text, like the humans who read the text, are meaning-seeking animals. Nevertheless, they (and we) cannot determine the meaning of the beast's actions, or even if it exists. Its elusive presence that, like an equivocal figure, takes only a slight shift in perspective to transform into absence, stands in for the digital technologies that, ignorant of human meanings, nevertheless generate their own senses of meaning through the processes that interpret information and initiate actions that often have consequences for humans across the globe.

Like the nothingness infecting the text's signifiers, a similar nothingness would confront us if we could take an impossible journey and zoom into a computer's interior while it is running code. We would find that there is no there there, only alternating voltages that nevertheless produce meaning through a layered architecture correlating ones and zeros with human language. From the nothingness of alternating voltages emerges the complexities of digital culture, just as from the nothingness at the house's center emerges the immense complexities of this digitally marked text. A double-sided sword, the confrontation with nothingness cuts in two directions at once: on the one hand, it draws into question the uniqueness of "transcendent" meanings for human consciousness through the analogy that likens ones and zeros to the non- and subcognitive processes that produce consciousness, making us wonder if similar emptiness infects "higher" cognition and thought; on the other hand, it can also be taken to gesture toward the fact that in humans, consciousness does emerge from such processes, while in intelligent machines it does not.

The instability of meaning here, at once reinforcing and subverting the uniqueness of humans in relation to intelligent machines, is figured in the ambiguities of the beast's agency, which may be only a reflection of human intentionality (as some philosophers argue about the intentionality of intelligent machines) or may be a terrible ferocious agency in its own right. In this sense *House of Leaves* performs within its fictional world the deep philosophical problems associated with intermediating dynamics, especially the idea that the meaning of information is given by the processes that interpret it. With this text we come full circle to the framework introduced in chapter 2, now significantly reinscribed in a print novel bearing the mark of the digital.

The subjectivity performed and evoked by this text differs from traditional print novels in subverting, in a wide variety of ways, the authorial voice associated with an interiority arising from the relation between sound and mark, voice and presence. Overwhelmed by the cacophony of competing and cooperating voices, the authority of voice is deconstructed and the interiority it authorized is subverted into echoes testifying to the absences at the center. Natural language is put into dynamic interplay with a wide variety of mechanical codes, and textual surfaces are littered with the marks of digital machines. As this text along with the others discussed above demonstrate, digital technologies do more than mark the surfaces of contemporary print novels. They also put into play dynamics that interrogate and reconfigure the relations between authors and readers, humans and intelligent machines, code and language. Books will not disappear, but neither will they escape the effects of the digital technologies that interpenetrate them. More than a mode of material production (although it is that), digitality has become the textual condition of twenty-first-century literature.

The Future of Literature

NOTES

READ ME

1. N. Katherine Hayles, *My Mother Was a Computer: Digital Subjects and Literary Texts* (Chicago: University of Chicago Press, 2005).

CHAPTER ONE. ELECTRONIC LITERATURE

1. Among many occasions for contemplating such questions, I single out one as particularly telling, a high-profile panel discussion in October 2006 in Paris, organized by the French government, to debate the following topic: "The Internet: A Threat to Culture?" Panelists included representatives from Virgin Records and AOL and the director of the Bibliothèque nationale de France.

2. See, e.g., Peter L. Galison, *Image and Logic: A Material Culture of Microphysics* (Chicago: University of Chicago Press, 1997), 47, 55.

3. Michael Joyce, *afternoon: a story* (Watertown, Mass.: Eastgate Systems, 1990). An earlier version was circulated in 1987; see Matthew Kirschenbaum, "Save As: Michael Joyce's *afternoons*," in *Mechanisms: New Media and Forensic Textuality* (Cambridge: MIT Press, 2008), for a detailed account of all the different versions and editions.

4. Stuart Moulthrop, *Victory Garden* (Watertown, Mass.: Eastgate Systems, 1995).

5. Shelley Jackson, *Patchwork Girl* (Watertown, Mass.: Eastgate Systems, 1995).

6. George P. Landow popularized the term "lexia" in *Hypertext: The Convergence of Contemporary Critical Theory and Technology* (Baltimore: Johns Hopkins University Press, 1991). Terry Harpold in *Exfoliations* (Minneapolis: University of Minnesota Press, 2008) objects to the term, arguing that in its original source, Roland Barthes's *S/Z*, it denoted textual divisions that the reader made as part of her

interpretive work. The term is now so well established, however, that it seems difficult to change. Moreover, the meanings of terms frequently change as they migrate across fields, disciplines, and media.

7. N. Katherine Hayles, "Deeper into the Machine: Learning to Speak Digital," *Computers and Composition* 19 (2002): 371–86; reprinted in revised form with images in *Culture Machine* 5 (Feb. 2003), http://culturemachine.tees.ac.uk/frm_f1.htm, and in *State of the Arts: The Proceedings of the Electronic Literature Organization's 2002 State of the Arts Symposium,* ed. Scott Rettberg (Los Angeles: Electronic Literature Organization), 13–38.

8. David Ciccoricco, in *Reading Network Fiction* (Tuscaloosa: University of Alabama Press, forthcoming 2007), takes issue with the first and second generation characterizations, arguing that the use of images is a matter of degree rather than an absolute break. My distinction, however, was concerned not only with the increased visuality of post-1995 works, but also with the introduction of sound and other multimodalities, as well as the movement away from a link-lexia structure into more sophisticated and varied navigational interfaces. The major factor in precipitating the shift, of course, was the huge expansion of the World Wide Web after the introduction of the Netscape and other robust and user-friendly browsers. In any construction of periods, there will always be areas of overlap and remediation, but it nevertheless seems clear that a major shift took place around 1995.

9. M. D. Coverley, *Califia* (Watertown, Mass.: Eastgate Systems, 2000); *Egypt: The Book of Going Forth by Day* (Newport Beach: Horizon Insight, 2007).

10. Scott Rettberg, William Gillespie, and Dirk Stratton, *The Unknown* (1998), http://www.unknownhypertext.com/.

11. Michael Joyce, *Twelve Blue*, in *Electronic Literature Collection,* vol. 1, ed. N. Katherine Hayles, Nick Montfort, Scott Rettberg, and Stephanie Strickland (College Park, Md.: Electronic Literature Organization, 2006), http://collection.eliterature.org (hereafter noted as *ELC* 1). When works are also available at other locations, these will be listed second; for *Twelve Blue* (Eastgate Hypertext Reading Room, 1996), http://www.eastgate.com/TwelveBlue/Twelve_Blue.html.

12. Caitlin Fisher, *These Waves of Girls* (2001), http://www.yorku.ca/caitlin/waves/.

13. Stuart Moulthrop, *Reagan Library* (1999), *ELC* 1 and http://iat.ubalt.edu/moulthrop/hypertexts/rl/pages/intro.htm.

14. Judd Morrissey in collaboration with Lori Talley, *The Jew's Daughter* (2000), *ELC* 1 and http://www.thejewsdaughter .com.

15. Talan Memmott, *Lexia to Perplexia* (2000), *ELC* 1 and http:// www.uiowa.edu/~iareview/tirweb/hypermedia/talan_memmott/index. html.

16. Richard Holeton, "Frequently Asked Questions about 'Hypertext,'" *ELC* 1.

17. Ciccoricco, intro., *Reading Network Fiction,* ms. 7.

18. An interesting illustration of the difference between narrative and game is provided by Natalie Bookchin's "The Intruder," in which she makes computer games from Jorge Luis Borges's fiction, http:// www.calarts.edu/~bookchin/intruder/.

19. Markku Eskelinen, "Six Problems in Search of a Solution: The Challenge of Cybertext Theory and Ludology to Literary Theory," *dichtung-digital* (2004), http://www.dichtung-digital.com/2004.3/ Eskelinen/index.htm.

20. Nick Montfort, *Twisty Little Passages* (Cambridge: MIT Press, 2003), vii–xi.

21. Emily Short, *Savoir-Faire* (2002), *ELC* 1 and http://mirror .ifarchive.org/if-archive/games/zcode/Savoir.z8.

22. Jon Ingold, *All Roads* (2001), *ELC* 1 and http://www .ingold.fsnet.co.uk/if.htm.

23. Donna Leishman, *Deviant: The Possession of Christian Shaw* (2003), *ELC* 1 and http://www.6amhoover.com/xxx/start.htm.

24. *Iowa Review Web* 8.3 (September 2006), http://www.uiowa .edu/~iareview/mainpages/new/september06/sept06_txt.html.

25. The move is, however, not without caveats. Aya Karpinska comments that "a screen is a screen. It's not space," anticipating that her future work would move into actual space through mobile technologies. Rita Raley, "An Interview with Aya Karpinska on 'mar puro,'" http://www.uiowa.edu/~iareview/mainpages/new/september06/ karpinska/karpinska_interview.html. Dan Waber comments, "I think the word and the letter have been three dimensional in many ways for a very long time. As long as there has been language there has been a way of looking at its materiality, and that way of looking at it adds a dimension automagically." Rita Raley, "An Interview with Dan Waber on 'five by five,'" http://www.uiowa.edu/~iareview/mainpages/new/ september06/wabere/waber_interview.html.

26. "Artist's Statement: Ted Warnell," http://www.uiowa.edu/ ~iareview/mainpages/new/september06/warnell/warnell.html.

27. Ted Warnell, *TLT vs. LL* (2006), http://www.uiowa.edu/~iareview/mainpages/new/september06/warnell/11x8.5.html.

28. David Knoebel, "Heart Pole," http://home.ptd.net/~clkpoet/htpl/index.html.

29. Janet Cardiff, *The Missing Voice (Case Study B)* (1999); print book edition, London: Artangel, 1999; for a description, see http://www.artfocus.com/JanetCardiff.html; *Her Long Black Hair* (2005), http://www.publicartfund.org/pafweb/projects/05/cardiff/cardiff-05.html.

30. Blast Theory, *Uncle Roy All Around You* (premiered London, 2003), http://www.blasttheory.co.uk/bt/work_uncleroy.html.

31. Joan Campàs in "The Frontiers between Digital Literature and Net.art" finds several areas of convergence, including emphasis on process, information and algorithm, "new perceptual situations, hybridization and simulation, the artistic and literary objectivization of the concept of the Net" and "software as work of art and as a text," among others. See *dichtung-digital* 3 (2004): 12, http://www.dichtung.com/2004/3/Campas/index.htm. She also has trenchant observations about how electronic literature is more often browsed than read; although, recently, in what we might call the "second generation" of hypertext criticism as practiced by such critics as David Ciccoricco, Terry Harpold, Matthew Kirschenbaum, and Jessica Pressman, electronic literature *is* read, and read very closely.

32. For a description of *Screen,* see Josh Carroll, Robert Coover, Shawn Greenlee, Andrew McClain, and Noah Wardrip-Fruin, http://www.uiowa.edu/~iareview/mainpages/tirwebhome.htm.

33. William Gillespie, with programming by Jason Rodriguez and David Dao, *Word Museum;* see documentation, http://www.uiowa.edu/~iareview/mainpages/new/september06/gillespie/wordmuseum.html.

34. Rita Raley, "Reading Spaces," presented at the meeting of the Modern Language Association, December 28, 2005, Washington, D.C.

35. Noah Wardrip-Fruin, "Playable Media and Textual Instruments," *dichtung-digital* 34 (January 2005), http://www.dichtung-digital.com/2005/1/Wardrip-Fruin.

36. See John Cayley's website, http://www.shadoof.net/in, for a download of *Lens* in a QuickTime maquette; the piece was originally designed for the CAVE.

37. Information from Robert Coover in an email dated September 25, 2006.

38. Paul Sermon, Steven Dixon, Mathias Fucs, and Andrea Zapp, *Unheimlich* (2006), http://creativetechnology.salford.ac.uk/unheimlich/.

39. Michael Mateas, *Façade* (2005), http://www.interactivestory.net/.

40. Janet Murray, *Hamlet on the Holodeck: The Future of Narrative in Cyberspace* (Cambridge: MIT Press, 1998), 40.

41. Marie-Laure Ryan, *Avatars of Story* (Minneapolis: University of Minnesota Press, 2006).

42. Deena Larsen, *Disappearing Rain* (2001), http://www.deenalarsen.net/rain/.

43. Electronic Poetry Center, http://epc.buffalo.edu/; Ubuweb, http://www.ubu.com/.

44. Loss Pequeño Glazier, *Digital Poetics: Hypertext, Visual-Kinetic Text and Writing in Programmable Media* (Tuscaloosa: University of Alabama Press, 2001).

45. Loss Pequeño Glazier, *White-Faced Bromeliads on 20 Hectares*, *ELC* 1 and http://epc.buffalo.edu/authors/glazier/java/costa1/00.html.

46. Generative art is, of course, a major category of digital arts generally. For example, Bill Seaman's ambitious installation work, *The World Generator* (1996), used images, sound, and spoken text to create a recombinant poetics that created emergent and synergistic combinations of all these modalities, http://digitalmedia.risd.edu/billseaman/poeticTexts.php.

47. Philippe Bootz, "The Functional Point of View: New Artistic Forms for Programmed Literary Works," *Leonardo* 32.4 (1999): 307–16. See also the earlier article "Poetic Machinations," *Visible Language* 30.2 (1996): 118–37, and the later "Reader/Readers," in *p0es1s: Ästhetik Digitaler Poesie/The Aesthetics of Digital Poetry*, ed. Friedrich W. Block, Christiane Heiback, and Karin Wenz (Berlin: Hatje Cantz Books, 2004), 93–122, which gives a further elaboration and refinement of the functional model. In "Digital Poetry: From Cybertext to Programmed Forms," *Leonardo Electronic Almanac* 14.05/06 (2006), http://leoalmanac.org/journal/lea_v14_n05-06/pbootz.asp, he slightly shifts terminology to technotexts and intermedia, with a focus on a procedural model of communication.

48. Philippe Bootz discusses the Web-based literary journal created by L.A.I.R.E. in "*Alire*: A Relentless Literary Investigation," *Electronic Book Review* (March 15, 1999), http://www.electronicbookreview.com/thread/wuc/Parisian.

49. Philippe Bootz, *La série des U*, *ELC* 1; *Alire* 12 (2004).

50. Noah Wardrip-Fruin with Brion Moss and Elaine Froehlich, *Regime Change* and *News Reader*, http://hyperfiction.org/rcnr.

51. Jim Andrews, *On Lionel Kearns*, *ELC* 1 and http://www.vispo.com/kearns/index.htm.

52. William S. Burroughs and his partner in crime, Brion Gysin, wrote extensively about the technique and philosophy of the cut-up that Burroughs pioneered in *Naked Lunch,* among other works. For more information and algorithms allowing you to cut up your own texts, see http://www.reitzes.com/cutup.html.

53. Jim Andrews and collaborators, *Stir Fry Texts,* http://www.vispo.com/StirFryTexts/.

54. Geniwate and Brian Kim Stefans, *When You Reach Kyoto* (2002), http://www.idaspoetics.com.au/generative/generative.html.

55. Millie Niss with Martha Deed, *Oulipoems* (2004), *ELC* 1 and http://www.uiowa.edu/~iareview/tirweb/feature/sept04/oulipoems/.

56. Patrick-Henri Burgaud, *Jean-Pierre Balpe ou les Lettres Dérangées* (2005), *ELC* 1.

57. John Cayley has a trenchant criticism of "code work" in "The Code is not the Text (unless it is the Text)," *Electronic Book Review* (2002), http://www.electronicbookreview.com/thread/electropoetics/literal.

58. For a fuller explanation of intermediating dynamics between language and code, see N. Katherine Hayles, "Making: Language and Code," in *My Mother Was a Computer: Digital Subjects and Literary Texts* (Chicago: University of Chicago Press, 2005), 15–88.

59. Diane Reed Slattery, Daniel J. O'Neil, and Bill Brubaker, *The Glide Project,* http://www.academy.rpi.edu/glide/portal.html. Slattery is also the author of *The Maze Game* (Kingston, N.Y.: Deep Listening Publications, 2003), a print novel that gives the backstory of the development, politics, and cultural significance of the Glide language.

60. Sha Xin Wei, *TGarden,* http://f0.am/tgarden/; see also Sha Xin Wei and Maja Kuzmanovic, "Performing Publicly in Responsive Space: Agora, Piazza, Festival and Street," presented at Worlds in Transition: Technoscience, EASST Conference: Citizenship and Culture in the 21st Century, September 2000, Vienna, http://www.univie.ac.at/Wissenschaftstheorie/conference2000.

61. Carrie Noland, "Digital Gestures," in *New Media Poetics: Contexts, Technotexts, and Theories,* ed. Adalaide Morris and Thomas Swiss (Cambridge: MIT Press, 2006), 217–44.

62. John Cayley, "Literal Art: Neither Lines nor Pixels but Letters," in *First Person: New Media as Story, Performance, and Game,* ed. Noah Wardrip-Fruin and Pat Harrigan (Cambridge: MIT Press, 2004), 208–17; see also John Cayley, "Literal Art," http://www.electronicbookreview.com/thread/firstperson/programmatology.

63. John Cayley, *riverIsland*, http://www.shadoof.net/in/.

64. Stephanie Strickland, with technical implementation by Janet Holmes (1999), "The Ballad of Sand and Harry Soot," http://www .wordcircuits.com/gallery/sandsoot/frame.html. The poem appeared first in print as the winner of the *Boston Review*'s second annual poetry contest.

65. Jason Nelson, *Dreamaphage*, version 1 (2003) and version 2 (2004), *ELC* 1 and http://www.secrettechnology.com/dreamaphage/ opening.html.

66. Stephanie Strickland, *V: WaveSon.nets/Losing L'una* (New York: Penguin, 2002); Stephanie Strickland with Cynthia Lawson, *V: Vniverse*, http://www.vniverse.com.

67. Lance Olsen, *10:01* (Portland: Chiasmus Press, 2005); Lance Olsen with Tim Guthrie, *10:01*, *ELC* 1.

68. Geoff Ryman, *253: The Print Remix* (London: St. Martin's Press, 1998); the Web version is at http://www.ryman-novel.com.

69. Gregory L. Ulmer, *Internet Invention: From Literacy to Electracy* (New York: Longman, 2002).

70. Alan Sondheim's writings are represented in a collection of texts made over a ten-year period in "Internet Text, 1994 [Through Feb. 2, 2006]," *ELC* 1; Brian Kim Stefans, *Fashionable Noise: On Digital Poetics* (Berkeley: Atelos Press, 2003); Stephanie Strickland, "Writing the Virtual: Eleven Dimensions of E-Poetry," *Leonardo Electronic Almanac* 14:05/06 (2006), http://leoalmanac.org/journal/ vol_14_n05-06/sstrickland.asp, and "Dali Clocks: Time Dimensions of Hypermedia," *Electronic Book Review* ll (2000), http://www.altx com/ebr/ebr11/11str.htm.

71. Florian Cramer, *Words Made Flesh: Code, Culture, Imagination* (Rotterdam: Piet Zwart Institute, 2005), http://pzwart.wdka .hro.nl/mdr/research/fcramer/wordsmadeflesh/); Rita Raley, *Tactical Media* (Minneapolis: University of Minnesota Press, 2008); Matthew Fuller, *Behind the Blip: Essays on the Culture of Software* (New York: Autonomedia, 2003); Ian Bogost, *Unit Operations: An Approach to Videogame Criticism* (Cambridge: MIT Press, 2006) ; Mark B. N. Hansen, *New Philosophy for New Media* (Cambridge: MIT Press, 2004); Adalaide Morris, "New Media Poetics: As We May Think/ How to Write," in *New Media Poetics*, ed. Adalaide Morris and Thomas Swiss (Cambridge: MIT Press, 2006), 1–46; Matthew Kirschenbaum, *Mechanisms: New Media and Forensic Textuality* (Cambridge: MIT Press, 2008).

72. Espen J. Aarseth, *Cybertext: Perspectives on Ergodic Literature* (Baltimore: Johns Hopkins University Press, 1997).

73. Stephanie Strickland, "Writing the Virtual: Eleven Dimensions of E-Poetry," *Leonardo Electronic Almanac* 14:05/06 (2006), http://leoalmanac.org/journal/vol_14_n05-06/sstrickland.asp.

74. Jim Rosenberg, *Diagram Series 6: 6.4 and 6.10, ELC* 1; see also *Diagram Poems,* http://www.well.com/user/jer/diags.html.

75. Raymond Queneau, *Cent mille milliards de poèmes* (Paris: Gallimard, 1961); John Cage, M: *Writings '67–'72 (*Middletown: Wesleyan University Press, 1973); Jackson Mac Low, *The Virginia Woolf Poems* (Providence, R.I.: Burning Deck, 1985).

76. Brian Kim Stefans, *Fashionable Noise: On Digital Poetics* (Berkeley: Atelos Press, 2003).

77. Ian Bogost, *Unit Operations: An Approach to Videogame Criticism* (Cambridge: MIT Press, 2006), esp. 4.

78. Stephanie Strickland and M. D. Coverley, "Errand upon Which We Came," http://www.thebluemoon.com/coverley/errand/home.htm.

79. Brian Kim Stefans, "The Dreamlife of Letters" (1999), http://www.chbooks.com/archives/online_books/dreamlife_of_letters/.

80. Robert Kendall, "Faith," *ELC* 1 and *Cauldron and Net,* 4 (Autumn 2002), http://www.studiocleo.com/cauldron/volume4/confluence/kendall/title_page.htm.

81. Young-hae Chang Heavy Industries, *Dakota,* http://www.yhchang.com/DAKOTA.html.

82. Jessica Pressman, "Digital Modernism: Making It New in New Media" (Ph.D. diss., UCLA, 2007).

83. Young-Hae Chang Heavy Industries, *Nippon,* http://www.yhchang.com/NIPPON.html.

84. Jay David Bolter, *Writing Space: The Computer, Hypertext, and the History of Writing* (New York: Lawrence Erlbaum, 1991); George P. Landow, *Hypertext: The Convergence of Contemporary Critical Theory and Technology* (Baltimore: Johns Hopkins University Press, 1991).

85. Aarseth, *Cybertext,* 77, 89, and passim.

86. Jay David Bolter, *Writing Space,* 147.

87. Richard Grusin and Jay David Bolter, *Remediation: Understanding New Media* (Cambridge: MIT Press, 2000).

88. George P. Landow, *Hypertext 2.0: The Convergence of Contemporary Critical Theory and Technology* (Baltimore: Johns Hopkins University Press, 1997), and *Hypertext 3.0: Critical Theory and New Media in an Era of Globalization* (Baltimore: Johns Hopkins University Press, 2006).

89. Espen J. Aarseth, "Textonomy: A Typology of Textual Communication," in *Cybertext*, 59–75.

90. Espen J. Aarseth has also taken a leading role in establishing game studies as an academic discipline, being one of the founders of the field and of the leading journal in the field, *The International Journal of Game Studies*.

91. Markku Eskelinen, "Six Problems in Search of a Solution: The Challenge of Cybertext Theory and Ludology to Literary Theory," *dichtung-digital* (March 2004), http://www.dichtung-digital.com/index.

92. Lev Manovich, *The Language of New Media* (Cambridge: MIT Press, 2000).

93. Ibid., 27–46.

94. For an example, see N. Katherine Hayles, "Traumas of Code," *Critical Inquiry* 33.1 (Autumn 2006): 136–57.

95. Alexander Galloway, *Protocol: How Control Exists after Decentralization* (Cambridge: MIT Press, 2004), 165.

96. Jerome J. McGann, *The Complete Writings and Pictures of Dante Gabriel Rossetti: A Hypermedia Archive,* http://www.rossettiarchive.org/.

97. Jerome McGann, *Radiant Textuality: Literature after the World Wide Web* (New York: Palgrave Macmillan, 2001).

98. For information on the computerized version of *The Ivanhoe Game,* see http://www.patacriticism.org/ivanhoe/; for information on the Speculative Computing Laboratory, see http://www.speculativecomputing.org/.

99. See Johanna Drucker, *The Ivanhoe Game,* http://www.iath.virginia.edu. ~jjm2f/old/Igamehtm.html.

100. Noah Wardrip-Fruin and David Durand, "*Cardplay,* a New Textual Instrument," presented at the meeting of the Association for Computers and the Humanities and Association for Literary and Linguistic Computing (ACH/ALLC), June 15–18, 2005, University of Victoria; mustard.tapor.uvic.ca:8080/cocoon/ach_abstracts/proof/paper_175_durand.pdf; Mark Bernstein, "Card Shark and Thespis: Exotic Tools for Hypertext Narrative," *Proceedings of the Twelfth ACM Conference on Hypertext and Hypermedia, Århus, Denmark* (New York: 2001), 41–50.

101. Hansen, *New Philosophy for New Media.*

102. Friedrich A. Kittler, *Discourse Networks 1800/1900* (Stanford: Stanford University Press, 1992); Friedrich A. Kittler, *Literature Media Information Systems,* ed. John Johnston (New York: Routledge, 1997).

103. Friedrich A. Kittler, preface, *Gramophone, Film, Typewriter* (Stanford: Stanford University Press, 1999), xxxix.

104. Morris, "New Media Poetics," 1–46.

105. Alan Liu, *The Laws of Cool: Knowledge Work and the Culture of Information* (Chicago: University of Chicago Press, 2004).

106. Especially pertinent to their discussion is Gilles Deleuze, "Postscript on Societies of Control," *October* 59 (Winter 1992): 3–7.

107. Michael Hardt and Antonio Negri, *Empire* (Cambridge: Harvard University Press, 2001); *Multitude: War and Democracy in the Age of Empire* (New York: Penguin, 2005).

108. Alexander Galloway and Eugene Thacker, *The Exploit* (Minneapolis: University of Minnesota Press, 2007).

109. Adrian Mackenzie, *Cutting Code: Software as Sociality* (London: Peter Lang, 2006).

110. Nick Montfort and Noah Wardrip-Fruin, "Acid-Free Bits," *Electronic Literature Organization* (June 14, 2004), http://eliterature .org/pad/afb.html.

111. Alan Liu, David Durand, Nick Montfort, Merrillee Proffitt, Liam R. E. Quin, Jean-Hughes Rety, and Noah Wardrip-Fruin, "Born Again Bits" (September 30, 2004), http://eliterature.org/pad/bab .html.

CHAPTER TWO. INTERMEDIATION

1. Mark Danielewski, *House of Leaves* (New York: Doubleday, 2000); Jonathan Safran Foer, *Extremely Loud and Incredibly Close* (New York: Houghton Mifflin, 2005); Salvador Plascencia, *The People of Paper* (San Francisco: McSweeney's, 2005).

2. Stephen Wolfram, *A New Kind of Science* (New York: Wolfram Media, 2002).

3. Nicholas Gessler, "Evolving Artificial Cultural Things-That-Think and Work by Dynamical Hierarchical Synthesis," http://www .sscnet.ucla.edu/geog/gessler/cv-pubs/03naacsos.pdf.

4. Harold J. Morowitz, *The Emergence of Everything: How the World Became Complex* (New York: Oxford University Press, 2002).

5. See, e.g., André Leroi-Gourhan, *Gesture and Speech* (Cambridge: MIT Press, 1993).

6. This argument has been published in various forms; see, e.g., John R. Searle, "Is the Brain's Mind a Computer Program?" *Scientific American* 262 (January 1990): 26–31.

7. Douglas Hofstadter, *Fluid Concepts and Creative Analogies: Computer Models of the Fundamental Mechanisms of Thought* (New York: Basic Books, 1995).

8. For a description of the Eliza program, see Joseph Weizenbaum, *Computer Power and Human Reason: From Judgment to Calculation* (New York: Freeman, 1976).

9. Edward Fredkin, "Informatics and Information Processing vs. Mathematics and Physics," presented at the meeting of the Institute for Creative Technologies, May 25, 2007, Marina Del Ray, Calif. Fredkin's work in what he calls "Digital Mechanics" is similar to Wolfran's work on cellular automata in that he postulates that the universe is fundamentally computational in nature. Unlike Wolfram, who works mostly on irreversible automata, Fredkin's recent work has focused on reversible three-dimensional cellular automata SALT models (the models take their name because they work in a three-dimensional lattice similar to the sodium chloride—that is, table salt—crystal). See Edward Fredkin, *Introduction to Digital Philosophy*, http://www.digitalphilosophy.org.

10. Daniel C. Dennett, *Kinds of Minds: Toward an Understanding of Consciousness* (New York: Basic Books, 1996).

11. Daniel C. Dennett, *Darwin's Dangerous Idea: Evolution and the Meanings of Life* (New York: Simon and Schuster, 1995), 401–27.

12. Claude Shannon and Warren Weaver, *The Mathematical Theory of Communication* (Urbana: University of Illinois Press, 1949).

13. Ibid.

14. Donald MacKay, *Information, Mechanism, Meaning* (Cambridge: MIT Press, 1969).

15. Mark B. N. Hansen, *New Philosophy for New Media* (Cambridge: MIT, 2004), 78–80.

16. Bernadette Wegenstein, *Getting under the Skin: Body and Media Theory* (Cambridge: MIT Press, 2006), 32.

17. Jorge Luis Borges, "The Book of Sand," in *Collected Fictions*, trans. Andrew Hurley (New York: Penguin Books, 1999), 404–78.

18. It is no accident that several electronic works inspired by "The Book of Sand" have been created; see, e.g., Maximus Clarke for an interactive game based on Borges's work, "The Book of Sand: A

Hypertext/Puzzle," http://artificeeterrnity.com/bookofsand/; and Giselle Beiguelman, "the book after the book/o livro depois do livro," http://www.desvirtual.com/giselle.

19. See, e.g., Loss Pequeño Glazier, *White-Faced Bromeliads on 20 Hectares,* http://epc.buffalo.edu/authors/glazier/java/costal1/00.html; and Emily Short, *Galatea,* http://www.mindspring.com/~emshort/galatea.htm. Both works can also be found in the *Electronic Literature Collection,* vol. 1, ed. N. Katherine Hayles, Nick Montfort, Scott Rettberg, and Stephanie Strickland (College Park, Md.: Electronic Literature Organization, 2006), http://collection.eliterature.org (hereafter *ELC* 1).

20. N. Katherine Hayles, *My Mother Was a Computer: Digital Subjects and Literary Texts* (Chicago: University of Chicago Press, 2005).

21. Michael Joyce, *afternoon: a story* (Watertown, Mass.: Eastgate Systems, 1990).

22. Michael Joyce, *Twelve Blue* (1991), http://www.eastgate.com/TwelveBlue/. Although *afternoon: a story* has a publication date from Eastgate of 1990, Joyce was circulating copies of it at conferences as early as 1987. It is reasonable to assume, then, that something like four years separates the composition of the two works. Matthew Kirschenbaum, in "Save As: Michael Joyce's *afternoons," Mechanisms: New Media and Forensic Textuality* (Cambridge: MIT Press, 2008), gives a detailed account of the different versions.

23. Particularly influential is Jane Yellowlees Douglas, "How Do I Stop This Thing?": Closure and Indeterminacy in Interactive Narratives," in *Hyper/Text/Theory,* ed. George P. Landow (Baltimore: Johns Hopkins University Press, 1994), 159–88; Jay David Bolter, *Writing Space: The Computer, Hypertext, and the History of Writing* (Hillsdale, N.J.: Erlbaum, 1991), 123–28; and Jill Walker, "Piecing together and tearing apart: finding the story in *afternoon,"* ACM Hypertext Conference (1999), http://jilltxt.net/txt/afternoon.html.

24. Robert Coover, "The Elevator," 125–37; and "The Babysitter," 206–39, in *Pricksongs and Descants: Fictions* (New York: Grove Press, 2000).

25. Noah Wardrip-Fruin in "Playable Media and Textual Instruments," *dichtung-digital* (2005), http://www.brown.edu/Research/dichtung-digital/2005/1/Wardrip-Fruin/, has an eloquent exposition of what it implies to consider a digital work as an instrument that can be played rather than simply a text to be read; such arguments have bestowed added resonance on "player" as the term of choice for one who interacts with a digital work that has playable characteristics.

26. "Riddle," 8_4. The lexias of *Twelve Blue* are named, but occasionally two different lexias share the same name. Confusion can be avoided by also citing the numbers displayed in the URL, which indicate the thread and bar numbers, in that order, as indicated in the above citation.

27. William H. Gass, *On Being Blue: A Philosophical Inquiry* (Boston: David R. Godine, 1991).

28. Vannevar Bush, "As We May Think," *Atlantic Monthly* 176.1 (July 1945): 101–8.

29. "Attack" here is an allusion to Marie-Laure Ryan's aggressive reading of *Twelve Blue* in *Narrative as Virtual Reality: Immersion and Interactivity in Literature and Electronic Media* (Baltimore: Johns Hopkins University Press, 2003), where she comments, "The attitude with which I initially attacked the text—and I mean *attack* to be taken in its full force—had much in common with the frame of mind of the player of a computer game or the reader of a mystery novel. I was determined to 'beat the text' by figuring out what the system of links and the multiple ambiguities were designed to hide from me" (238). Her "quest for coherence" (226) and signature critical strategy of classifying texts through typologies are clearly at odds with the text's aesthetic, so that she finds that the text's effect "is that of an amnesiac mind that desperately tries to grasp some chains of association but cannot hold on to them long enough to recapture a coherent picture of the past" (229), which is about as far from my own sense of the text as one could get. Nevertheless, she is too fine (and determined) a reader not to unearth many of the text's connections, and her reading is accurate and nuanced as far as it goes.

30. Anthony Enns, "Don't Believe the Hype: Rereading Michael Joyce's *Afternoon* [sic] and *Twelve Blue*," *Currents in Electronic Literacy* (Fall 2001), http://www.cwrl.utexas.edu/currents/fall01/enns/html; Frank Kermode, *The Sense of an Ending* (New York: Oxford University Press, 1968).

31. Gregory L. Ulmer, "A Response to *Twelve Blue* by Michael Joyce," *Postmodern Culture* 5.1 (September 1997), http://muse.jhu.edu/journals/postmodern_culture/toc/pmc8.1.html.

32. Maria Mencia, "Methodology," a brief explanation of the inspiration for her doctoral dissertation, "From Visual Poetry to Digital Art: Image-Sound-Text, Convergent Media and the Development of New Media Languages" (2003), www.m.mencia.freeuk.com/Methodology.html.

33. Maria Mencia, *Worthy Mouths* (n.p., n.d.), http://www.m.mencia.freeuk.com/WorthyMouths.swf.

34. Maria Mencia, *Audible Writing Experiments* (2004), www
.m.mencia.freeuk.com/AWE.html.

35. Maria Mencia, *Things come and go* . . . (1999), documenta-
tion at http://www.m.mencia.freeuk.com/video2.html.

36. Ibid.

37. Maria Mencia, *Birds Singing Other Birds' Songs*, Flash ver-
sion in *ELC* 1; documentation of the video version (2001) at http://
www.m.mencia.freeuk.com/birds.html.

38. Lori Emerson, in "Numbered Space and Topographic Writ-
ing," *Leonardo Electronic Almanac* 14.5–6 (2006), http://leoalmanac
.org/journal/Vol_14/lea_v14_n05-06/Lemerson.asp, engages similar
questions to those articulated here, asking "at what point . . . does
digital poetry cross a threshold and break away from book-bound con-
cerns, thereby also breaking away from the ways in which we normally
account for texts?" (2). She rightly cautions that print poetry has also
been concerned with movement, urging us not to extrapolate to digital
poetry as the simple fulfillment of its teleology. To make the point, she
instances Mencia's *Birds Singing Other Birds' Songs*; she finds that it
"does not go beyond a transposition of book-bound concerns . . . nei-
ther does it demonstrate what the [digital] medium allows." I suggest
that this reading, with its emphasis on spatiality, does not fully take
into account the sophisticated translation processes discussed above
and thus misses the play between different forms of cognition.

39. Judd Morrissey, *The Jew's Daughter*, http://www.thejews
daughter.com. The credits specify that the work was "programmed
and crafted by the author," Judd Morrissey, and that the "mechanics
of reconfiguration [were] designed in collaboration with Lori Talley."

40. Matthew Mirapaul, "Pushing Hypertext in New Directions,"
New York Times (July 27, 2000), cited in *The New York Times on the
Web*, http://partners.nytimes.com/library/tech/00/07/cyber/artsatlarge/
27artsatlarge.html.

41. James Joyce, *Ulysses* (New York: Vintage, 1990), 666–722.
Jessica Pressman analyzes the relation between *Ulysses* and *The Jew's
Daughter* in "*The Jew's Daughter:* Remediating, Remembering, and
Rereading," in "Digital Modernism: Making It New in New Media"
(Ph.D. diss., UCLA), 205–64. David Ciccoricco also has a fine detailed
reading of the work, including its relation to *Ulysses*, in "Mythology
Proceeding: Morrissey's *The Jew's Daughter*," in *Reading Network
Fiction* (Tuscaloosa: University of Alabama Press, forthcoming 2007),
ms. 205–46.

42. Thomas Nagel, in *The View from Nowhere* (New York:
Oxford University Press, 1989), popularized the phrase as representa-

tive of scientific objectivism, a position that was subsequently heavily criticized in science studies, for example by Donna Haraway, "Situated Knowledge: The Science Question in Feminism as a Site of Discourse on the Privilege of Partial Perspective," *Feminist Studies* 14.3 (1988): 575–99.

43. Daniel C. Dennett, *Consciousness Explained* (New York: Little, Brown, 1991).

44. Daniel Dennett, in "Are We Explaining Consciousness Yet?" comments that "as long as your homunculi [the neural processes that he likens to "hordes of demons"] are more stupid and ignorant than the intelligent agent they are composing, the nesting of homunculi within homunculi can be finite, bottoming out, eventually, with agents so unimpressive that they can be replaced by machines" (4), http://ase.tufts.edu/cogstud/papers/cognition.fin.htm.

45. Lutz Hamel, Judd Morrissey, and Lori Talley, "Automatic Narrative Evolution: A White Paper," http://www.errorengine.org/ane-white-paper.pdf.

46. Evolutionary coadaptation is also the point for a fantastic interactive book described in Neal Stephenson's *The Diamond Age: Or, a Young Lady's Illustrated Primer* (New York: Bantam 1996), 84–86, and passim. The *Primer* has the ability to sense the environment and Nell's reaction, changing its pages and stories to fit her situation. It serves as her tutor, reengineering her neural responses in definitive ways as she matures. For example, in her first encounter with the *Primer*, Nell corrects her name, in response to which "a tiny disturbance propagated through the grid of letters on the facing page" (84), a description that could well be applied to *The Jew's Daughter* during a mouseover.

47. Intermediation is of course not the only theoretical framework available. Influential contributions include: from film studies, Lev Manovich's "five principles of New Media" in *The Language of New Media* (Cambridge: MIT Press, 2002); from game studies, Espen Aarseth's functionalist cybertheory as "textology" in *Cybertext: Perspectives on Ergodic Literature* (Baltimore: Johns Hopkins University Press, 1997); from media theory, Friedrich A. Kittler's *Discourse Networks 1800/1900*, trans. Michael Matteer (Stanford: Stanford University Press, 1992), and *Gramophone, Film, Typewriter* (Stanford: Stanford University Press, 1999); and from phenomenology/embodiment theory, Mark B. N. Hansen's *New Philosophy for New Media* (Cambridge: MIT Press, 2006).

48. A good example is provided by Markku Eskelinen, using Espen Aarseth's cybertext to rethink narratology, "Six Problems in

Search of a Solution: The Challenge of Cybertext Theory and Ludology to Literary Theory," *dichtung-digital* (2004), http://www.dichtung-digital.com/2004.3/Eskelinen/index.htm.

49. *Vectors: Journal of Culture and Technology in a Dynamic Vernacular,* http://vectors.iml.annenberg.edu/.

50. Bob Stein, Institute for the Future of the Book, http://www.annenberg.edu/projects/project.php?id=84.

CHAPTER THREE. CONTEXTS FOR ELECTRONIC LITERATURE

1. Friedrich A. Kittler, "Gramophone, Film, Typewriter," in *Literature, Media, Information Systems,* ed. John Johnston (Amsterdam: Overseas Publishers, 1995), 35.

2. Friedrich A. Kittler, *Discourse Networks 1800/1900,* trans. Michael Metteer, with Chris Cullens (Stanford: Stanford University Press, 1990); *Gramophone, Film, Typewriter,* trans. Geoffrey Winthrop-Young and Michael Wutz (Stanford: Stanford University Press, 1999).

3. Geoffrey Winthrop-Young, "Drill and Distraction in the Yellow Submarine: On the Dominance of War in Friedrich Kittler's Media Theory," *Critical Inquiry* 28.4 (2002): 825–55.

4. Karin Knorr Cetina and Urs Bruegger, "Inhabiting Technology: The Global Lifeform of Financial Markets," *Current Sociology* 50.3 (May 2002): 389–405; Karin Knorr Cetina and Urs Bruegger, "Global Microstructures: The Virtual Societies of Financial Markets," *American Journal of Sociology* 107.4 (January 2002): 905–50; Karin Knorr Cetina and Urs Bruegger, "The Market as an Object of Attachment: Exploring Postsocial Relations in Financial Markets," *Canadian Journal of Sociology* 25.2 (2000): 141–68.

5. Gordon L. Clark, Nigel Thrift, and Adam Tickell, "Performing Finance: The Industry, the Media, and Its Image," *Review of International Political Economy* 11.23 (May 2004): 289–310.

6. Mark B. N. Hansen, *New Philosophy for New Media* (Cambridge: MIT Press, 2004).

7. See, e.g., Gerald M. Edelman, *Bright Air, Brilliant Fire: On the Matter of the Mind* (New York: Basic Books, 2001).

8. Mark B. N. Hansen, *Bodies in Code: Interfaces with Digital Media* (New York: Routledge, 2006).

9. For a discussion of this aspect of nanotechnology, see N. Katherine Hayles, *Nanoculture: Implications of the New Technoscience* (Bristol: Intellect Books, 2002).

10. In the context of an article by Francisco Varela that Hansen cites as the source for this idea of a "fissure" or "gap," the fissure is posited as a change of brain state such that new states can evolve without, as Valera puts it quoting J. Brough, "'tearing the ego to pieces.'" "The Specious Present: A Neurophenomenology of Time Consciousness," in *Naturalizing Phenomenology: Issues in Contemporary Phenomenology and Cognitive Science,* ed. Jean Petitot, Francisco. J. Varela, Bernard Pachoud, and Jean-Michel Roy (Stanford: Stanford University Press, 1999), 216–314; also available at http://www.franzreichle.ch/images/Francisco_Varela/Human_Consciousness_Article 02.htm. The chain of reasoning by which Hansen connects this unremarkable observation first to "technicity" (drawing on Bernard Steigler's sense of technicity as that which is recorded without our having experienced it) is already quite convoluted; even more tenuous is the extension in this passage from technicity to technologies, which Hansen wants to insert into the "fissure," an implication that is not in Valera's argument and that would in my view need empirical evidence to be plausible.

11. Stanley H. Ambrose, "Paleolithic Technology and Human Evolution," *Science* 291.5509 (March 2, 2001): 1748–53.

12. For a summary of synaptogenesis, see, e.g., S. G. Hormuzdi, M. A. Filippov, G. Mitropoulou, H. Monyer, and R. Bruzzone, "Electrical Synapses: A Dynamic Signaling System That Shapes the Activity of Neuronal Networks," *Biochemical Biophysics Acta* 1662.1–2 (March 23, 2004): 113–37.

13. Kaiser Family Foundation, *Generation M: Media in the Lives of 8–18 Year Olds,* http://www.kf.org/entmedia/7251.cfm.

14. For a summary of this research, see Wendy Cole, Sonja Steptoe, and Sarah Sturmon, "The Multitasking Generation," *Time* 167.13 (March 27, 2006): 48–55.

15. Mark James Baldwin, "A New Factor in Evolution," *American Naturalist* 30 (June 1896): 441–51, 536–553.

16. Terrence W. Deacon, *The Symbolic Species: The Co-Evolution of Language and the Brain* (New York: Norton, 1998).

17. Stephanie Strickland explores these aspects and their relation to temporality in "Dali Clocks: Time Dimensions of Hypermedia," *Electronic Book Review* 11 (Winter 2000/2001), http://www.altx.com/er/ebr11/11str.htm.

18. For research using fMRI to discern brain activity, see, e.g., Scott H. Johnson-Frey, Roger Newman-Norlund, and Scott T. Grafton, "A Distributed Left Hemisphere Network Active during Planning of Everyday Tool Use Skills," *Cerebral Cortex* 15.6 (2005):

681–95, online at http://cercor.oxfordjournals.org/cgi/content/full/15/6/681.

19. James R. Flynn, "The mean IQ of Americans: Massive gains 1932 to 1978," *Psychological Bulletin* 95 (1984): 29–51; see Steven Johnson's discussion of the Flynn Effect and its relation to media consumption in *Everything Bad Is Good for You: How Today's Popular Culture Is Actually Making Us Smarter* (New York: Riverhead Books, 2005), 139–44.

20. For a detailed analysis, see N. Katherine Hayles, "Hyper and Deep Attention: The Generational Divide in Cognitive Modes," *Profession* 2007 (New York: Modern Language Association, forthcoming December 2007).

21. Joshua S. Rubinstein, David E. Meyer, and Jeffrey E. Evans, "Executive Control of Cognitive Processes in Task Switching," *Journal of Experimental Psychology: Human Perception and Performance* 27.4 (August 2001): 763–97, available at http://www.apa.org/journals/releases/xhp274763.pdf.

22. John Cayley with Giles Perring, *Translation,* http://www.shadoof.net/in/translation.html; John Cayley with Giles Perring (ambient sound) and Douglas Cape (digital photographs), *Imposition,* performed at OpenPort, Art Institute of Chicago, February 24–25, 2007.

23. In conversation with Jay David Bolter in Mexico City, July 7, 2007, he confided that his students tell him they still subvocalize when reading a print text but not when reading on screen. This tantalizing anecdote, if substantiated by empirical studies, would have important implications for a range of topics, from Kittler's media theory to literary reception theory.

24. Robert Coover, "Literary Hypertext: The Passing of the Golden Age," keynote address, Digital Arts and Culture Conference, October 29, 1999, Atlanta, available at http://www.nickm.com/vox/golden_age.html.

25. Talan Memmott, *Lexia to Perplexia* (September 2000), http://www.altx.com/ebr/ebr11/11mem/.

26. Young-Hae Chang Heavy Industries, *Nippon,* http://www.yhchang.com/NIPPON.html.

27. Scott Bukatman, *Terminal Identity: The Virtual Subject in Postmodern Science Fiction* (Durham: Duke University Press, 1993).

28. Jessica Pressman, "Making It New in New Media: Digital Modernism," (Ph.D. diss., UCLA, June 2007).

29. For a description of the device and related ones developed for the "XFR: Experiments in the Future of Reading" exhibit, see M. J. Beck, R. Gold, A. M. Balsamo, M. D. Chow, M. Gorbet, S. R. Harri-

son, D. W. MacDonald, and S. L. Minneman, "Designing Innovative Reading Experiences for a Museum Exhibit," *Computer Magazine* (IEEE), 34.1 (January 2001): 80–87.

CHAPTER FOUR. REVEALING AND TRANSFORMING

1. See "War Is Peace: The Zen Master Poet," in *Pieces of Intelligence: The Existential Poetry of Donald H. Rumsfeld,* ed. Hart Seely (New York: Free Press, 2003), 1–20. In the poem titled "The Unknown," Seely quotes Rumsfeld as follows: "As we know, / There are known knowns. / We also know / There are known unknowns. / That is to say / We know there are things / We do not know. / But there are also unknown unknowns, / The ones we don't know we don't know." Department of Defense news briefing, February 12, 2002, 2.

2. Pierre Bourdieu, *Outline of a Theory of Practice,* trans. Richard Nice (Cambridge: Cambridge University Press, 1977).

3. See esp. Pierre Bourdieu, "Structures and the Habitus," in ibid., 72–95.

4. N. Katherine Hayles, *How We Became Posthuman: Virtual Bodies in Cybernetics, Literature, and Informatics* (Chicago: University of Chicago Press, 1999), 199–200.

5. The distinction between bodily knowledge and conscious articulation has affinity with what Michael Polanyi in *Personal Knowledge: Towards a Post-Critical Philosophy* (Chicago: University of Chicago Press, 1974) called "tacit knowledge," a practice-based intuition that is not explicitly articulated but nevertheless is essential for many kinds of laboratory operations. Tacit knowledge can be seen as a kind of borderland between bodily knowledge and conscious articulation, for it is part of a technician's working knowledge and in this sense can be partially articulated, but it resists full explication because it contains preconscious and unconscious elements.

6. Antonio Damasio, *Descartes' Error: Emotion, Reason, and the Human Brain* (New York: Penguin, 2005); *The Feeling of What Happens: Body and Emotion in the Making of Consciousness* (New York: Harvest Books, 2000).

7. Dominick LaCapra, *Writing History, Writing Trauma,* Parallax: Re-Visions of Culture and Society (Baltimore: Johns Hopkins University Press, 2000), 57.

8. Nigel Thrift, "Remembering the Technological Unconscious by Foregrounding Knowledges of Position," *Environment and*

Planning D: Society and Space 22.1 (2004): 175–90; see also his book *Knowing Capitalism* (London: Sage, 2005).

9. N. Katherine Hayles, *My Mother Was a Computer: Digital Subjects and Literary Texts* (Chicago: University of Chicago Press, 2005), 15–38.

10. Stuart Moulthrop, "Traveling in the Breakdown Lane: A Principle of Resistance for Hypertext," *Mosaic* 28/4 (1995): 57–77. See also his related comments in "Error 404: Doubting the Web," in *The World Wide Web and Contemporary Cultural Theory: Magic, Metaphor, Power,* ed. Andrew Herman (New York: Routledge, 2000), 259–76; also online at http://iat.ubalt.edu/moulthrop/essays/404.html.

11. The implications of code as an infectious agent as well as a necessary mediation are explored more fully in N. Katherine Hayles, "Traumas of Code," *Critical Inquiry* 33.1 (2006): 136–57.

12. Andy Clark, *Natural-Born Cyborgs: Minds, Technologies, and the Future of Human Intelligence* (New York: Oxford University Press, 2004), 3, 4.

13. Edwin Hutchins, *Cognition in the Wild* (Cambridge: MIT Press, 1996).

14. Matthew Kirschenbaum, in *Mechanisms: New Media and Forensic Textuality* (Cambridge: MIT Press, 2008), goes to extraordinary lengths to show that the code can be made accessible, using an editor to look at the hexademical code and even trekking to a research laboratory to look at an image of a bit as shown by an atomic force microscope (an instrument capable of imaging phenomena smaller than the resolution possible in optical instruments). His dedication and brilliant analysis notwithstanding, it is still true that code cannot be accessed while it is being executed, so even with these extraordinary measures, only the records of code that has run or will be run can be examined. Most users, of course, will never go to these lengths, and so it remains the case that some or many levels of computer code remain unknown and inaccessible. John Cayley also writes on the importance of code to the generation of digital text in "The Code is not the Text (unless it is the Text)," *Electronic Book Review* (2002), http://www.electronicbookreview.com/thread/electropoetics/literal.

15. William Poundstone, *Project for Tachistoscope*, in *Electronic Literature Collection,* vol. 1, ed. N. Katherine Hayles, Nick Montfort, Scott Rettberg, and Stephanie Strickland (College Park, Md.: Electronic Literature Organization, 2006), http://collection.eliterature.org (hereafter *ELC* 1).

16. Ruth Benschop, "What Is a Tachistoscope? Historical Explorations of an Instrument," *Science in Context* 11.1 (Spring 1998): 23–50.

17. See, e.g., Vance Oakley Packard, *The Hidden Persuaders* (New York: Random House, 1957).

18. Millie Niss, *Sundays in the Park*, in Millie Niss and Martha Deed, *Oulipoems*, ELC 1; also online at *Iowa Review Web* (September 2004), http://www.uiowa.edu/%7Eiareview/tirweb/feature/sept04/index.html.

19. Garrett Stewart, *Reading Voices: Literature and the Phonotext* (Berkeley: University of California Press, 1990).

20. In an email dated October 3, 2006 Millie Niss commented that the soundtrack "was made overlaying 2 . . . sound files made up of me reading the entire screen (each file used different versions of the text made by clicking on the words in between readings). The resulting sound file . . . simply loops."

21. John Cayley with Giles Perring, *Translation*, ELC 1. The piece is available for download on John Cayley's website, http://www.shadoof.net/in/.

22. John Cayley, "Overboard: an example of ambient time-based poetics in digital art," *dichtung-digital* 32 (2004), http://www.dichtung-digital.com/04/2-Cayley.htm.

23. The version that Cayley cites in "Between Here and Nowhere" (http://www.shadoof.net/in/translit/transl.html) is Walter Benjamin, "On Language as Such and on the Language of Man," in *One-Way Street and Other Writings*, trans. Edmund Jephcott and Kinsley Shorter (London: Verso, 1979), 107–23.

24. John Cayley, *Imposition*, programmed with assistance from Giles Perring (sound) and Douglas Cape (digital images), performed at the OpenPort Symposium, Art Institute of Chicago, February 23, 2007.

25. *Lens* and *Torus* are described in John Cayley with Dmitri Lemmerman, "Lens: The Practice and Poetics of Writing in Immersive VR: a Case Study with Maquette," *Leonardo Electronic Almanac* 14.5–6 (2006), http://leoalmanac.org/journal/Vol_14/lea_v14_n05-06/cayley.asp.

26. A QuickTime maquette of *Lens* is available for download at John Cayley's website, http://www.shadoof.net/in/?lens.html.

27. As Rita Raley reminded me, the effect is reminiscent of Janet Zweig's print artist book *Scheherazade: A Flip Book* (n.p., 1988), where each successive narrative emerges from zooming into the previous image and finding within it another image and another story.

28. Brian Kim Stefans, *Fashionable Noise: On Digital Poetics* (Berkeley: Atelos, 2003).

29. Jerome McGann, *Radiant Textuality: Literature after the World Wide Web* (London: Palgrave, 2001).

CHAPTER FIVE. THE FUTURE OF LITERATURE

1. Examples of such machines are Xerox Docutech and Kodak Lionheart. For a summary of the state of the art, see "Seybold Report on Publishing Systems," 24.4, http://www.seyboldreports.com/SRPS/free/0ps24/P2404003.htm.

2. John Cayley, "Writing on Complex Surfaces," *dichtung-digital* 35 (February 2005), http://www.dichtung-digital.com/2005/2-Cayley.htm.

3. Noah Wardrip-Fruin, "Surface, Data, and Process," ms. 1 (Ph.D. diss., Brown University, 2006).

4. Kathleen Fitzpatrick, *The Anxiety of Obsolescence: The American Novel in the Age of Television* (Nashville: Vanderbilt University Press, 2006).

5. Bruce Sterling, *Distraction* (New York: Spectra, 1999).

6. In "Generation M: Media in the Lives of 8–18 Year-olds," a report by the Kaiser Family Foundation, "a nationally representation sample of more than 2,000 3rd through 12th graders who completed questionnaires [were surveyed], including nearly 600 self-selected participants who also maintained seven-day media diaries." The study found that on the average young people spend 3:51 (hours:minutes) a day watching television and videos, 1:44 listening to music, 1:02 using computers, 0:49 playing video games, and 0:43 reading. A summary and the full report is available at http://www.kff.org/entmedia/entmedia030905nr.cfm.

7. This list can be seen as an adaptation with significant departures from Lev Manovich's well-known "five principles of new media" of numerical representation modularity, automation, variability, and transcoding (that is, computerization of culture). My discussion of computer-mediated text includes numerical representation and automation; variability mutates into a recursive dynamic between imitation and intensification; and transcoding is seen here as a dynamic interaction between electronic text and print rather than a one-way

movement of the "cultural layer" into the "computer layer." See Lev Manovich, *The Language of New Media* (Cambridge: MIT Press, 2002), 27–47.

8. Jonathan Safran Foer, *Extremely Loud and Incredibly Close* (New York: Houghton Mifflin, 2005); Salvador Plascencia, *The People of Paper* (San Francisco: McSweeney's, 2005); Mark Danielewski, *House of Leaves* (New York: Pantheon, 2000).

9. Manovich, *The Language of New Media*, 45 and passim.

10. For a discussion of Shannon's information theory, see N. Katherine Hayles, *How We Became Posthuman: Virtual Bodies in Cybernetics, Literature, and Informatics* (Chicago: University of Chicago Press, 1999), chap. 3, 50–83.

11. See Claude Shannon and Warren Weaver, *The Mathematical Theory of Information* (Urbana: University of Illinois Press, 1949), 3.

12. Larry McCaffrey and Sinda Gregory, "Haunted House: An Interview with Mark Z. Danielewski," *Critique: Studies in Contemporary Fiction* 44.2 (Winter 2003): 99–135.

13. Mark Danielewski participated as an assistant in the film *Derrida* and is listed in the credits, so it is virtually certain that he not only knows Derrida's works but has a more than casual acquaintance with them, a surmise that the references to Derrida within *House of Leaves* support.

14. Mark B. N. Hansen, "The Digital Topography of Mark Z. Danielewski's *House of Leaves*," *Contemporary Literature* 45.4 (2004): 597–636, also included as the final chapter in Hansen's book *Bodies in Code: Interfaces with Digital Media* (New York: Routledge, 221–52. The sharp break between analogue photography and digital technologies that Hansen constructs, building on a quotation by Roland Barthes to the effect that photography requires a body before the camera for its representations, is more complex than his argument allows. Long before digital technologies changed the nature of photography, photographers were manipulating the material to create images of nonexistent phenomenon, notoriously, for example, in the "fairy" photographs and similar occult subjects popular in the early years of the twentieth century.

15. For an account of these fields, see Hayles, *How We Became Posthuman*, 222–46.

16. The process of creating genetic programs that can design circuits is described in John R. Koza, Matthew J. Streeter, William Mydlowec, Jessen Yu, and Guido Lanza, *Genetic Programming IV: Routine Human-Computer Machine Intelligence* (New York: Spring, 2005).

17. Brian Cantwell Smith, *On the Origin of Objects* (Cambridge: Bradford Books, 1996), 76.

18. Daniel C. Dennett, *Darwin's Dangerous Idea: Evolution and the Meanings of Life* (New York: Simon and Schuster, 1995), 426.

19. N. Katherine Hayles, "Saving the Subject: Remediation in House of Leaves," *American Literature* 74 (2002): 77–806.

INDEX

code
 broken, 123
 computer, xi
 and creolization, 123
 executable, 35, 132
 in *Extremely Noisy and
 Incredibly Close*, 166–69
 hierarchical structure and *The
 People of Paper*, 173
 in *House of Leaves*, 175–76
 in interplay with language, 84,
 131
 JavaScript, in *Lexia to
 Perplexia*, 126
 layers of, 163–64
 mediating between humans and
 intelligent machines, 137
 Morse, in *House of Leaves*,
 176
 and nothingness, 185
codelets, 49–50
code work, 20, 21
coevolution
 adaptive, in *The Error Engine*,
 82–83
 between humans and intelligent
 machines, 84
 of technology and embodiment,
 102–20, 129,130
cognition
 as cognitive system, 51
 computer, 149–50
 distributed, 136
 human, 154
 human and machine, 142, 183
 mechanical, 54, 145
 models of, 154
 nonhuman, 156
 as recognition, 48–49
Collection Management, xiii
College of Letters and Science,
 University of California, Los
 Angeles, xiii
complexity
 emergent, 45–46
 — in *Twelve Blue*, 70

temporal, in *The Jew's
 Daughter*, 79
Concrete
 and literal art, 153
 poetry, 28, 153
consciousness. *See also* Dennett,
 Daniel
 emergent, in humans, 185
 and evolution, 52–54
 multiple drafts of, 80
 representation of, in *The Jew's
 Daughter*, 81–82
convergence, digital, 87
Coover, Robert, xii
 "The Babysitter," 62
 CAVE works, 12–13
 "The Elevator," 62
 Screen, 12–14
 and voice in electronic
 literature, 118
Coverley, M. D. (Margie Luese-
 brink). *See also* Luesebrink,
 Margie
 Califia, 7, 17, 23
 *Egypt: The Book of Going
 Forth by Day*, 23
 "Errand upon Which We
 Came," 28
 M Is for Nottingham, 15
Cramer, Florian, 20, 24
 *Words Made Flesh: Code,
 Culture, Imagination*, 26
Creative Commons, license for
 *Electronic Literature
 Collection*, vol. 1, xi
creole
 code work as, 20, 21
 and creolization, 123
criticism, Anglo-American, 91
culture, digital, 2
cycle, feedback, in *Lexia to
 Perplexia*, 122. *See also*
 recursivity

Damasio, Antonio, emotion as
 cognition, 134

Goldsmith, Kenneth, Ubuweb, 17
Greenlee, Shawn, *Screen*, 12–14
Gregory, Sinda, interview with
 Mark Z. Danielewski, 177
Grusin, Richard, *Remediation: Un-
 derstanding New Media*, 32
Guthrie, Tim, *10:01*, 23

Hamel, Lutz, *The Error Engine*, 82
Hansen, Mark B. N., x, 24, 119,
 209n14
 Bodies in Code, 108–13
 "The Digital Topography of
 Mark Z. Danielewski's
 House of Leaves," 179–83
 discussion of information,
 55
 and embodied perceiver, 36
 *New Philosophy for New
 Media*, 104–8
 and Varela, 203n10
Harpham, Geoffrey, xiii
Hayles, N. Katherine
 *How We Became Posthuman:
 Virtual Bodies in Cybernetics,
 Literature, and Informatics*,
 101, 133
 *My Mother Was a Computer:
 Digital Subjects and Literary
 Texts*, x, 59
Hebert, Jean Pierre, 22
heterarchical dynamics
 in computers, 48–51
 definition, 45
Hofstadter, Douglas, *Fluid Con-
 cepts and Creative Analogies:
 Computer Models of the
 Fundamental Mechanisms of
 Thought*, 48–51
Holeton, Richard, *Frequently
 Asked Questions about
 Hypertext*, 7–8
Hutchins, Edwin, *Cognition in the
 Wild*, 137
hyperlink, in electronic literature,
 31

hypertext
 European context and, 18
 fiction, 6, 7, 16
 link as distinguishing feature, 6

IATH (Institute of Advanced Tech-
 nology in the Humanities), 35
identity, as I-terminal, 121–22.
 See also Bukatman, Scott
Ingold, Jon, *All Roads*, 9
Institute for the Future of the
 Book, 84
instruments, textual, 19
intentionality, as aboutness, 52–53
interactive drama
 Façade, 16
 M Is for Nottingham, 15
 Unheimlich, 15
interactivity, in electronic litera-
 ture, 60
interiority, of author, 154
intermediation, x, 201n47. *See
 also* cycle, feedback
 between body and machine, 131
 between code and language,
 135
 and computer versus book, 58
 and computation, 83
 dynamics of, 45–46, 157
 and electronic literature, 51
 between embodied subject and
 computational machine,
 87–88
 in *The Error Engine*, 82
 in Maria Mencia's work, 74
 and meaning in *House of
 Leaves*, 185
 and recursive cycle, 135
 and signification, 132
 in *Twelve Blue*, 70
I-terminal, in *Lexia to Perplexia*,
 122

Jackson, Shelley, *Patchwork Girl*,
 6, 7
 allusions to, 77

Index

temporality (*cont.*)
 in *The Jew's Daughter*, 74–82
 as space, 96
 and spatiality, 96, 126–27
text
 digital, major characteristics of,
 163–65
 electronic, and mutability, 174
 in *House of Leaves*, layered,
 175
 multimodal, 176
 view of ontology, 178
 as weaving, 63
textons. *See* Aarseth, Espen J.,
 scriptons and textons
textuality
 electronic, 58
 print and electronic inter-
 penetrating, 160–86
Thacker, Eugene, *The Exploit*,
 38
Thrift, Nigel, and the techno-
 logical unconscious,
 134–35
time
 communities of, 96–97
 relative, 97
 as spatialized, 97
 universal, 97
 traders, currency, 94–102, 122
 ethics of, 102
 gender stereotypes in, 101–2
 and hypermasculinization, 100
tradition
 literary, 3
 print, 43–44, 161–85
transcoding, 34
trauma
 and Dominick LaCapra, 134
 in *Extremely Noisy and Incredi-
 bly Close*, 165–71

Ulmer, Gregory L., electracy, 23
 and *Twelve Blue*, 70
University of California, Los
 Angeles, xii

unconscious. *See also* Thrift, Nigel
 Freudian, 135
 technological, 134–5

Varela, Francisco, 105, 202n10
Vectors, 84
Virilio, Paul, machine vision,
 104
virtual reality
 and CAVE at Brown University,
 12
 goggles, 12
voice
 authority of, deconstructed,
 186
 in electronic literature, 118
 and homophonic variants,
 143–45
 in Kittlerian media theory,
 89–90
 in Maria Mencia's works,
 71–74
 as presence, in contemporary
 novels, 186
 subvocalization and, 118, 127,
 143

Waber, Dan, 16
Wald, Carol, xii
war
 and Kittlerian media theory,
 92–94, 100–101
 as metaphor in currency trading,
 100–101
Wardrip-Fruin, Noah, 3, 20,
 198n25
 "Acid-Free Bits," 40–41
 "Born-Again Bits," 40–41
 Cardplay, 36
 CAVE works, 12
 News Reader, 19
 playable media, 12
 Regime Change, 19
 and surface of writing,
 160–61
 and textual instruments, 19

N. KATHERINE HAYLES

is John Charles Hillis Professor of Literature and
Distinguished Professor in the departments of English
and Design/Media Arts at the University of California,
Los Angeles. She is the author of a number of books,
including *My Mother Was a Computer: Digital Subjects and
Literary Texts*.

ELECTRONIC LITERATURE

Co-editors:

N. Katherine Hayles • Scott Rettberg • Nick Montfort • Stephanie Strickland

Sponsors:

—Center for Programs in Contemporary Writing at the University of Pennsylvania

—Division of Arts and Humanities, Richard Stockton College of New Jersey

—ELINOR: Electronic Literature in the Nordic Countries

—MITH: Maryland Institute for Technology in the Humanities at the University of Maryland

—The School of Journalism and Mass Communication at the University of Minnesota

—College of Letters and Science and the English Department, University of California, Los Angeles

—Creative Commons: Attribution-NonCommerical-NoDerivs 2.5 License

—

Also available at http://collection.eliterature.org

Author List:

Jim Andrews	Tim Guthrie	Lance Olsen
Ingrid Ankerson	Richard Holeton	Giles Perring
babel	Daniel C. Howe	Jason Pimble
Giselle Beiguelman	Jon Ingold	Mary Pinto
Philippe Bootz	Shelley Jackson	William Poundstone
Patrick-Henri Burgaud	Michael Joyce	Kate Pullinger
J. R. Carpenter	Aya Karpinska	Melinda Rackham
Douglas Cape	Robert Kendall	Aaron A. Reed
John Cayley	Deena Larsen	Shawn Rider
M. D. Coverley	Kerry Lawrynovicz	Jim Rosenberg
Martha Deed	Donna Leishman	Megan Sapnar
David Durand	Brian Lennon	Dan Shiovitz
escha	Bill Marsh	Emily Short
Damien Everett	Pauline Masurel	Alan Sondheim
Sharif Ezzat	Talan Memmott	Will Stauffer-Norris
Edward Falco	Maria Mencia	Brian Kim Stefans
Mary Flanagan	Judd Morrissey	Reiner Strasser
Marcel Frémiot	Brion Moss	Lori Talley
Elaine Froehlich	Stuart Moulthrop	Dan Waber
geniwate	Jason Nelson	Noah Wardrip-Fruin
Loss Pequeño Glazier	Marko Niemi	Rob Wittig
Kenneth Goldsmith	Millie Niss	Nanette Wylde

DATE DUE